HOW TO FOLD

MÉTHODES DE PLIAGE • COMO DOBRAR • METODI PER PIEGARE
MÉTODOS DE PLIEGUE • FALTEN, FALZEN, FORMEN
怎樣折疊 • フォールディング方法

THE PEPIN PRESS / AGILE RABBIT EDITIONS
AMSTERDAM • SINGAPORE

All structural designs in this book are by Laurence K. Withers,
and were previously published by the Art Direction Book Company.

For The Pepin Press/Agile Rabbit Editions, the designs were adjusted
to fit in our series, and the die-cut patterns were redrawn and stored
in eps vector format.

The Pepin Press/Agile Rabbit Editions
P.O. Box 10349
1001 EH Amsterdam, The Netherlands

Tel +31 20 4202021
Fax +31 20 4201152
mail@pepinpress.com
www.pepinpress.com

ISBN 90 5768 039 4

Drawings by Laurence K. Withers
Concept & cover design by Pepin van Roojen
Layout by Joost Hölscher and Joost Baardman

10 9 8 7 6 5 4 3
2005

Manufactured in Singapore

Contents

Free CD-Rom in the inside back cover

Introduction in English

Legend

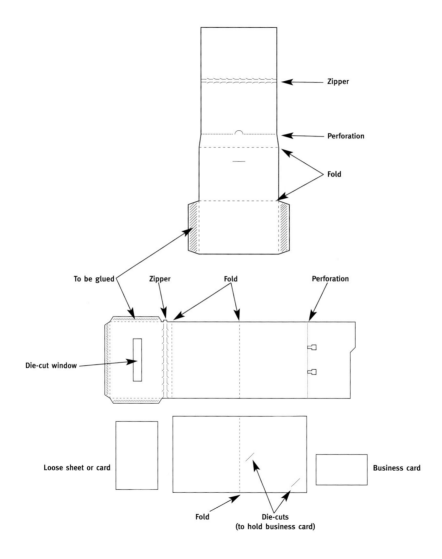

Zipper

Perforation

Fold

To be glued

Zipper

Fold

Perforation

Die-cut window

Loose sheet or card

Business card

Fold

Die-cuts
(to hold business card)

Folding

An introduction to **How to Fold** and **Folding Patterns for Display and Publicity**

The guiding principle in the design of this book is to make each design idea clear and easily understandable. For that reason, a visual step-by-step approach has been chosen from flat sheet(s) on each left hand page, to finished product on each right hand page.

The flat patterns are all in die-cut outline. Folding lines are indicated with long dots, perforation lines with small dots, and die cuts within the model with thin, straight lines.

Glueing is often needed, and sometimes optional. The choice of glue is often subject to preference and technical capabilities; possibilities are plain, liquid glue, (double-sided) tape, and wafer seals. In designs where glueing is essential, areas to be glued are indicated with shading.

Die-cut

The die-cut form of each design is stored on the accompanying CD-Rom in eps vector format, both for Mac and Windows. Software programs in which images can be imported, will allow you to access, scale and print the designs from the CD-Rom.

However, greatest flexibility to work with the designs digitally is offered by illustration programmes, such as Adobe Illustrator, Aldus Freehand and others, as these allow you to adapt the dimensions of the digital files completely to your own specific requirements.

Material

The choice of material for the designs featured in this book depends on the size and application of the design. For example, a large pocket folder meant to carry a heavy report would be made of a sturdy type of board, whereas for a small flyer a light paper could be used.

Folding

Many of the designs in this collection can be done on a folding machine, others are too elaborate and must be folded by hand. Standard folding machines can make four separate folds in one go. Furthermore, with additional folding machine extensions, the number of folds that can be completed automatically is considerable. In addition, there are folding machines that can score, perforate and glue at the same time as they fold. A successful fold is determined in two ways: fold quality and fold strength. The quality of the fold refers to its appearance, while the strength is measured by how many times a piece of paper can be folded back and forth before breaking. There are several factors in achieving the highest quality and strongest folds. These

'Buckler' folding machine

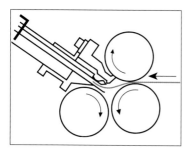 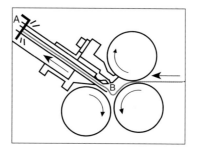 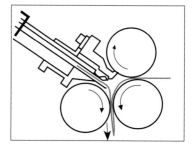

The paper travels through the machine...

Hits the deflector (**A**) and begins to buckle (**B**)...

The paper is then caught in the rollers and is pulled through, thus creating the fold.

'Knife' folding machine

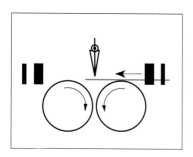 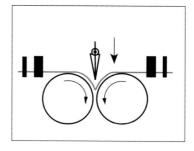 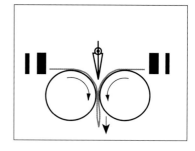

The paper travels through the machine...

The knife comes down at a precise moment and hits the paper, buckling it...

The paper is then caught in the rollers and is pulled through, thus creating the fold.

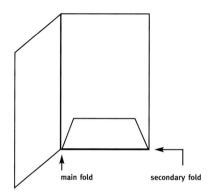

main fold secondary fold

include the following:

Paper Grain

Wood pulp used in making paper and board contains fibres. At the beginning of the process the pulp is in a liquid state, but as the paper goes from a liquid to a solid state the fibres tend to align themselves in one particular direction. This direction is referred to as the grain. It is generally recommended that paper be folded with the grain, meaning that the length of the fold runs parallel with the grain. Folding against the grain can result in cracking, where the fibres wrapping around the fold break in two, resulting in a rough jagged edge along the fold.

Not only can you avoid cracking by folding with the grain, but when binding booklets, perfect bound and saddle stitched signatures tend to lie flatter when the paper is folded with the grain.

Often, folding against the grain is unavoidable. In the case of folders with pockets, it is generally recommended that the main fold be made with the grain and the secondary fold against the grain.

Fibre Content

The fibre content is a significant factor in fold strength. The greater the number of fibres, the stronger the fold. Coated papers generally contain less fibres and therefore do not fold as well. Coated paper also tends to crack more easily since the coated surface of the paper is less elastic than the paper itself.

Moisture

Moisture content of the paper is also an important factor. If paper is too dry and brittle it tends to crack; if it is too moist, it tends to pull and buckle, and will not hold a crisp, accurate fold.

Printing

After printing, allow time for the ink to set up and dry before folding. Printing dark inks over folds tends to accentuate the folds, especially if the paper has a tendency to crack, so design your piece accordingly.

Scoring

To reduce the stress that folding puts on paper, it may be scored before being folded. Scoring also helps to reduce the risk of cracking, and for some types of board scoring is even necessary to create a clean, well-defined fold.

While there are several types of scoring devices, all work on a common principle: a rounded rule pressing the paper into a channel. The width of the rule and channel will depend on the thickness of the paper; the rule should never be thinner than the paper.

Contrary to what you might think, the paper is folded away from the score to create three stress points, rather than one.

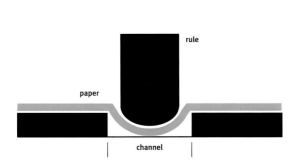

The principle of scoring

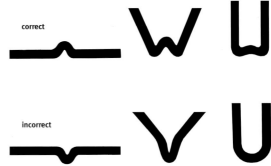

Correct and incorrect folding after scoring

Scoring should be considered in the following situations:

• Coated papers: fewer fibres and hard coating are prone to crack
• High velocity printing uses hot air to dry inks. This makes inks brittle and susceptible to cracking
• Thick paper and all types of board
As the weight of the paper increases so does its tendency to crack
• Folding against the grain
• Heavy ink coverage at the fold
• Whenever a job requires multiple folds

Production

Folding is one of the last operations in the printing process, so mistakes can be very costly. Therefore, it is essential that you consult with your printer, bindery, and possibly your paper supplier, regarding the technical aspects of producing your design. Apart from scoring and folding, pay attention to printing bleed requirements, and to glueing; it is not advisable to print surfaces that have to be glued. Before production, it is strongly recommended that you have a mock-up made, using the final material, with the exact measurements of the final work.

Einführung auf deutsch

Legende

Aufreißlasche

Perforierung

Falz

Klebelasche

Aufreißlasche

Falz

Perforierung

ausgestanztes Fenster

loser Bogen

Geschäftsvisitenkarte

Falz

Stanzschnitte
(zur Aufnahme der Visitenkarte)

Falzen

Eine Einführung in **Falten, falzen, formen** und **Falzdesigns für Display und Werbung**

Dieses Buch folgt der Maxime, jede Designidee leicht verständlich und klar zu beschreiben. Deshalb haben wir uns für eine schrittweise bildliche Darstellungsform entschieden. Auf der linken Seite sind plan jeweils die zu stanzenden Formen abgebildet, auf der rechten das gefaltete, bzw. im technischen Sprachgebrauch 'gefalzte', Endprodukt.

Die Stanzzuschnitte für jedes Falzmuster sind als Umrisse dargestellt. Innerhalb der Umrisse sind Falzlinien gestrichelt eingezeichnet, Stanzschnitte innerhalb der auszustanzenden Form mit durchgezogenen dünnen Linien, Perforationslinien gepunktet.

Oft sind Klebeverbindungen nötig, teils sind sie optional. Die zu verwendenden Klebstoffe werden normalerweise nach den technischen Gegebenheiten und anderen Kriterien ausgewählt. Zur Auswahl stehen einfache Flüssigkleber, doppelseitig haftendes Klebeband und Wafer seals. Bei Falzmustern, für die Klebungen unbedingt erforderlich sind, sind die zu verklebenden Flächen diagonal schraffiert markiert.

Stanzzuschnitt

Die Stanzzuschnitte sämtlicher Falzdesigns sind auf der beiliegenden CD-Rom in EPS-Vektor-Format für MAC und Windows gespeichert. Die Designs lassen sich mit jeder Software, die Bilddateien importieren kann, von der CD-Rom laden, skalieren und ausdrucken.

Wesentlich flexibler lassen sie sich mit Grafikprogrammen wie Aldus Freehand und Adobe Illustrator digital weiterverarbeiten, da es mit solchen Anwendungen möglich ist, die Proportionen der Zuschnitte dem eigenen Bedarf konkret anzupassen.

Material

Die Wahl der Materialien für die in diesem Band enthaltenen Falzdesigns richtet sich nach der Größe und der Verwendung der einzelnen Objekte. Eine große Dokumentenmappe, in der ein umfangreicher Bericht Platz finden soll, wird beispielsweise aus stabilem Karton oder aus Pappe angefertigt, während man für einen kleinen Flyer eher leichtes Papier wählen wird.

Falzen

Viele der hier gezeigten Falzzuschnitte lassen sich auf Falzmaschinen produzieren, andere wiederum sind so komplex, dass sie manuell gefalzt werden müssen. Die meisten Falzmaschinen schaffen vier Falzungen in einem Durchlauf. Mit entsprechenden Erweiterungen lässt sich die Zahl der Falzungen pro Durchlauf erheblich erhöhen. Es gibt auch Falzmaschinen, die nicht nur falzen, sondern gleichzeitig auch rillen, perforieren und verkleben. Einen guten Falz beurteilt man anhand von zwei Faktoren: Falzqualität und Falzfestigkeit. Falzqualität

Taschenfalzmaschine

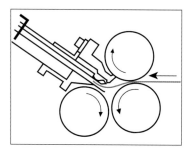 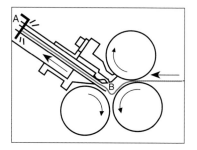 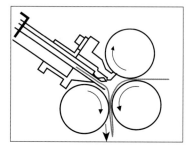

Das Papier läuft durch die Maschine, ...

trifft auf den Anschlag (**A**) und beginnt sich seitlich (**B**) wegzubiegen; ...

dabei wird es von den Walzen erfasst und zwischen zwei Walzen durchgezogen, so dass schließlich ein Falz entsteht.

Messerfalzmaschine

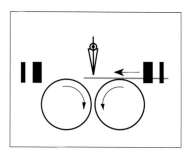 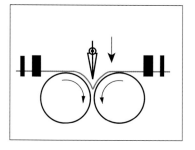 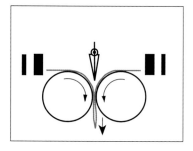

Das Papier durchläuft die Maschine; ...

zu einem ganz bestimmten Zeitpunkt senkt sich das Messer und stößt auf das Papier, das daraufhin nachgibt und ...

von den Walzen erfasst und zwischen ihnen durchgezogen wird, so dass schließlich ein Falz entsteht.

Einführung auf deutsch

Hauptfalz Nebenfalz

Oft lässt sich das Falzen quer zur Laufrichtung aber nicht vermeiden. Bei Mappen mit Taschen wird generell empfohlen, den Hauptfalz parallel zur Laufrichtung und den Nebenfalz quer zur Laufrichtung zu falzen.

Fasergehalt
Der Fasergehalt bestimmt die Festigkeit eines Falzes maßgeblich. Je größer die Anzahl der Fasern, desto fester ist der Falz. Gestrichene Papier- oder Kartonsorten enthalten generell weniger Fasern und sind deshalb schwieriger zu falzen. Gestrichene Papiere und Kartons neigen außerdem eher zum Brechen, da die gestrichene Oberfläche nicht so elastisch ist wie die darunterliegende Trägerschicht.

Feuchtigkeit
Der Feuchtigkeitsgehalt ist ein weiterer wichtiger Faktor. Wenn das Papier oder der Karton zu trocken und spröde sind, neigen sie zur Brüchigkeit; sind sie zu feucht, verziehen oder wellen sie sich, und es lassen sich keine akkuraten, geraden Falze herstellen.

Drucken
Nach dem Drucken muss man warten, bis die Druckfarbe aufgenommen und getrocknet ist, erst dann sollte man falzen. Über Falze gedruckte dunkle Druckfarben ergeben oft dunkle Linien - vor allem bei Material, das leicht brüchig wird -, was schon beim Entwurf des Endprodukts berücksichtigt werden sollte.

Rillen

Will man die Materialbeanspruchung reduzieren, die das Falzen mit sich bringt, so kann man die Bogen vor dem Falzen rillen. Das Rillen trägt auch dazu bei, das Risiko des Brüchigwerdens zu vermindern, und bei einigen Kartonarten ist Rillen grundsätzlich erforderlich, um

bezeichnet das Erscheinungsbild des Falz; Falzfestigkeit wird daran gemessen, wie oft sich ein Stück Papier bzw. Karton oder Pappe hin und her biegen lässt, bevor es bricht. Für die Falzqualität und -festigkeit spielen verschiedene Faktoren eine Rolle, wie:

Faserlaufrichtung
Der zur Papier- und Kartonherstellung verwendete Holzzellstoff enthält Fasern. Am Anfang des Herstellungsprozesses ist der Zellstoff noch flüssig, doch während sich der Papierbrei verdickt und vom flüssigen in den festen Zustand übergeht, richten sich die Fasern im Allgemeinen in eine bestimmte Richtung aus. Diese Richtung wird als Faserlaufrichtung bezeichnet. Generell wird empfohlen, mit der Faserlaufrichtung zu falzen, d. h. so, dass der Falz parallel zur Faserlaufrichtung verläuft. Falzen quer zur Laufrichtung kann zu rauen, brüchigen Falzkanten führen, wenn Fasern beim Umfalzen reißen oder brechen.
Falzen entlang der Laufrichtung hilft nicht nur brüchige Falze vermeiden - auch beim Binden von Broschüren liegen klebegebundene oder im Falz geheftete Druckbogen flacher.

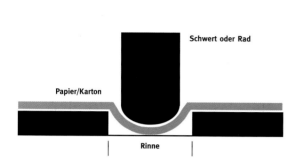

Das Prinzip des Rillens

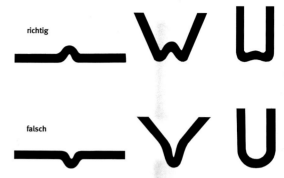

Korrektes bzw. inkorrektes Falzen nach dem Rillen

überhaupt einen sauberen, geraden Falz herstellen zu können.

Es gibt unterschiedliche Rillwerkzeuge und -maschinen, doch arbeiten alle nach ein und demselben Prinzip, nämlich mit einem abgerundeten Schwert oder Rad, die den Bogen in eine Rinne drücken. Die Breite von Schwert bzw. Rad und Rinne richtet sich nach der Materialdicke, wobei das Rillwerkzeug keinesfalls dünner sein sollte als der Bogen. Anders als man vielleicht annehmen würde, wird der Bogen von der Rille weg gefalzt, um so die Beanspruchung von einer einzigen Stelle auf drei Stellen zu verteilen. Rillen sollte in folgenden Fällen in Betracht gezogen werden:

- bei gestrichenen Papier- oder Kartonsorten, da diese weniger Fasern haben und die aufgestrichene Beschichtung hart ist und deshalb schnell bricht.

- bei Schnelldruckverfahren, bei denen Heißluft zum Trocknen der Druckfarbe verwendet wird. Die Druckfarbe wird dadurch spröde und neigt zu Brüchigkeit.

- bei dickeren Papier- und allen Kartonsorten.

Je schwerer das Material, desto brüchiger ist es.

- wenn quer zur Faserlaufrichtung gefalzt wird.
- wenn der Druckfarbauftrag am Falz sehr dick ist.
- bei allen Mehrfachfalzen.

Produktionsplanung

Falzen ist einer der letzten Arbeitsgänge bei der Herstellung von Druckerzeugnissen, Fehler können also sehr kostspielig werden. Sprechen Sie deshalb vor der Herstellung Ihrer Produkte auf jeden Fall die technischen Aspekte mit der Druckerei, der Buchbinderei und gegebenenfalls dem Materiallieferanten ab. Neben den technischen Voraussetzungen für das Rillen und Falzen müssen auch die technischen Konsequenzen des Beschnitts und der Klebungen bedacht werden. Beispielsweise sollte man keine Flächen bedrucken, die später verklebt werden. Deshalb sollte man vor der eigentlichen Herstellung unbedingt ein genaues 1:1-Modell aus dem vorgesehenen Material herstellen.

Introduction en français

Légende

glissière

perforation

pli

à coller

glissière

pli

perforation

fenêtre à l'emporte-pièce

feuille ou carte libre

carte de visite

pli

fentes (pour tenir
une carte de visite)

Pliage

Introduction aux **Méthodes de pliage** et **Modèles de pliage pour les présentations et la publicité**

Le principe de ce livre est de rendre chaque idée claire et facile à comprendre. Pour cette raison, une démarche visuelle étape par étape a été choisie pour les patrons se trouvant sur chaque page de gauche, menant au produit fini sur chaque page de droite. Les patrons sont tous tracés à l'emporte-pièce. Les lignes de pliage sont indiquées par des points allongés, les perforations par des points courts et les perforations à l'emporte-pièce, à l'intérieur du patron, par des lignes pleines.

Un collage est souvent demandé, parfois facultatif. Le choix de la colle dépend surtout des préférences et des moyens techniques disponibles ; on peut utiliser un collage plat, de la colle liquide, du ruban adhésif à deux faces ou autre. Dans les modèles où un collage est essentiel, les zones devant être collées sont ombragées.

Formes à l'emporte-pièce

Les formes à l'emporte-pièce de tous les modèles sont disponibles sur le cédérom au format vectoriel EPS, pour Mac et Windows. Les logiciels à l'intérieur desquels les images peuvent être importées vous permettront d'ouvrir, de redimensionner et d'imprimer ces modèles à partir du cédérom.

Toutefois, des logiciels d'illustrations, tels que Adobe Illustrator, Aldus Freehand et autres vous offrent de multiples fonctions pour manipuler les modèles. Ils vous permettent ainsi d'adapter complètement les documents à vos propres besoins.

Matériel

Le choix des matériaux concernant les modèles présentés dans ce livre dépend de la taille et de l'usage du montage. Par exemple, une pochette destinée à contenir un gros dossier devrait être faite dans un carton épais, alors qu'un petit porte-document pourrait être fait d'un papier plus léger.

Pliage

Bon nombre de modèles de cette collection peuvent être réalisés sur une plieuse, tandis que d'autres sont plus élaborés et devront être pliés à la main. Les plieuses standard peuvent effectuer quatre plis séparés à la fois. De plus, le nombre de pliages automatiques est considérablement augmenté si des rallonges sont ajoutées à la machine.

Un pliage réussi se reconnaît de deux manières : la qualité et la force du pli. La qualité du pli correspond à son aspect, alors que la force du pli est fonction du nombre de fois qu'une pièce de papier peut être dépliée et

Plieuse par ondulation

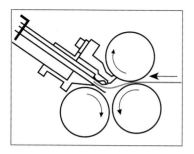

Le papier passe dans la machine...

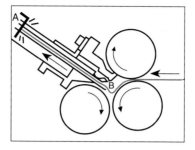

Il touche le déflecteur (**A**) et commence à onduler (**B**)...

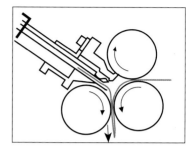

Le papier est alors pris entre les rouleaux et tiré, ce qui crée le pli.

Plieuse à lame

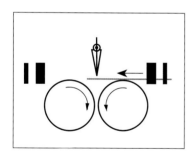

Le papier passe dans la machine...

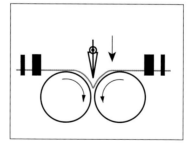

La lame s'abaisse au moment précis et ondule le papier...

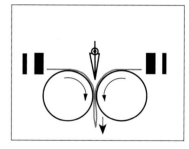

Le papier est alors pris entre les rouleaux et tiré, ce qui crée le pli.

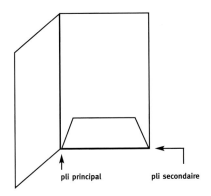

pli principal pli secondaire

repliée sans se rompre. Plusieurs facteurs entrent en ligne de compte dans la réussite d'un pliage fort et de qualité, dont :

Le grain du papier

La pulpe de bois utilisée dans la fabrication du papier et du carton contient des fibres. Au début du processus, la pulpe est dans un état liquide, mais au fur et à mesure que le papier se solidifie, les fibres ont tendance à s'aligner dans un sens précis nommé grain. Il est généralement recommandé de plier le papier dans le sens du grain, c'est à dire que le pli soit en parallèle avec le grain. Un pliage dans le sens contraire du grain peut provoquer des craquelures : les fibres entourant le pli se brisent en deux et provoquent une fissure le long du pli.

En plus d'éviter les craquelures, vous obtiendrez un relié et une couture de l'arrondissure plus plate lors de la reliure de feuillets pliés dans le sens du grain. Parfois, un pliage dans le sens contraire du grain est néanmoins inévitable. Dans le cas de porte-documents avec pochettes, il est généralement recommandé que le pli principal soit effectué dans le sens du grain et que

le pli secondaire soit fait dans le sens contraire du grain.

Teneur en fibres

La teneur en fibres est un facteur important de la force d'un pli. Plus le nombre de fibres sera élevé, plus le pli sera solide. Le papier couché contient généralement moins de fibres et ne se plie pas bien. Il a par ailleurs tendance à se craqueler davantage puisque sa surface est moins élastique que la base.

Humidité

L'humidité du papier est aussi un facteur important. Si le papier est trop sec et cassant, il a tendance à se craqueler ; s'il est trop humide, il a tendance à retrousser et à onduler et ne produit pas un pli fort et net.

Impression

Après l'impression, laissez le temps à l'encre de se fixer et de sécher avant de plier. L'application d'encre foncée accentue le pli, notamment si le papier a tendance à se craqueler ; préparez votre pièce en conséquence.

Rainage

Pour réduire la tension exercée sur le papier lors du pliage, celui-ci peut être rainuré avant d'être plié. Le rainage aide à prévenir le craquelage et s'avère parfois nécessaire afin de créer un pliage propre et précis dans certains types de cartons.

Les divers types d'outils de rainage fonctionnent tous selon un principe commun : un filet arrondi presse le papier dans un canal. La largeur du filet et du canal dépend de l'épaisseur du papier, le premier ne devant jamais être plus mince que le papier.

Contrairement à ce que vous pourriez penser, le papier n'est pas plié sur la rainure, mais sur trois points de tension au lieu d'un.

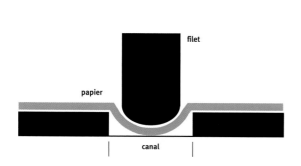

Fonctionnement du rainage

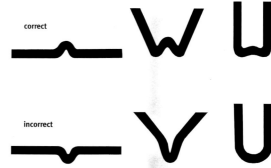

Pliages corrects et incorrects après le rainage

Le rainage doit être envisagé dans les situations suivantes :

- Papier couché : faible teneur en fibres et enduit épais sont propices aux craquelures.
- L'impression haute vitesse utilise de l'air chaud pour sécher l'encre. Cette dernière devient cassante et risque de casser.
- Papier épais et tous types de cartons. Le risque de craquelure est proportionnel au grammage.
- Pliage dans le sens contraire du grain.
- Forte couverture d'encre à l'endroit du pli.
- Lorsqu'un travail requiert plusieurs plis.

Production

Le pliage étant l'une des dernières opérations du processus d'impression, toute erreur peut s'avérer coûteuse. Il est donc préférable de consulter votre imprimeur, votre relieur et votre fournisseur de papier à propos des aspects techniques de la production de votre modèle. Outre le rainage et le pliage, portez attention aux conditions de débordement des couleurs et au collage ; il est déconseillé d'imprimer sur les surfaces devant être collées. Avant la production, il est fortement recommandé d'établir une maquette utilisant le matériel requis et aux dimensions exactes du produit final.

Introducción en Español

Leyenda

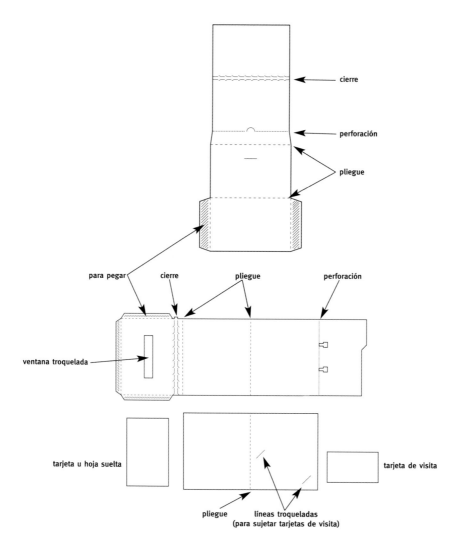

cierre

perforación

pliegue

para pegar

cierre

pliegue

perforación

ventana troquelada

tarjeta u hoja suelta

tarjeta de visita

pliegue

líneas troqueladas
(para sujetar tarjetas de visita)

Pliegues

Introducción a **Métodos de pliegue** y **Diseños de pliegues para presentaciones y publicidad**

El objetivo principal de este libro es exponer cada diseño de forma clara y sencilla. Para ello, se ha adoptado un enfoque visual que muestra paso a paso el proceso mediante el cual la(s) hoja(s) que aparecen en las páginas de la izquierda se convierten en el producto terminado de las páginas de la derecha.

Todos los diseños aparecen troquelados. Las líneas de pliegue se indican con rayas, las líneas de perforación, con puntos, y las partes troqueladas del interior del modelo, con líneas rectas y finas.

A menudo es preciso pegar algunas partes, aunque otras veces es opcional. La elección del pegamento suele depender de las preferencias o de las necesidades técnicas; se puede utilizar pegamento líquido común, cinta adhesiva de doble cara o lacre. En aquellos diseños en los que el pegado resulta esencial, las partes que deben pegarse aparecen sombreadas.

Troquelado

Las formas troqueladas de todos los diseños están guardadas en el CD-Rom adjunto en formato vectorial EPS, compatible tanto con Mac como con Windows. Los programas de software desde los que se pueden importar imágenes le permitirán acceder a los diseños del CD-Rom, modificar su escala e imprimirlos.

Sin embargo, la máxima flexibilidad para trabajar digitalmente con los diseños se consigue con programas de dibujo, como Adobe Illustrator, Aldus Freehand y otros, que le permiten adaptar las dimensiones de los archivos digitales para adecuarlos a sus necesidades concretas.

Material

La elección del material para realizar los diseños que aparecen en este libro dependerá del tamaño y de la finalidad del diseño. Por ejemplo, una carpeta con bolsillo grande para llevar muchos papeles deberá hacerse con una cartulina resistente, mientras que para un folleto pequeño puede utilizarse un papel ligero.

Pliegues

Muchos de los diseños de esta colección pueden realizarse en una máquina plegadora; otros son demasiado elaborados y deben doblarse a mano. Una máquina plegadora estándar puede hacer cuatro pliegues separados a la vez y, si se utilizan ampliaciones adicionales, el número de pliegues que pueden realizarse de forma automática aumenta considerablemente. Asimismo, hay máquinas plegadoras que pueden realizar hendiduras, perforar y pegar a la vez que doblan.

Máquina plegadora por deformación

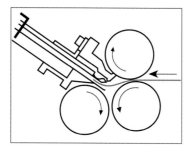

El papel pasa por la máquina...

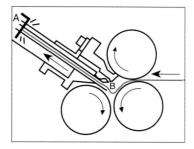

Llega hasta el deflector (A) y empieza a deformarse (B)...

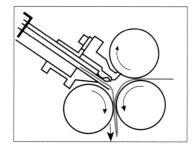

El papel es prensado por los rodillos de modo que queda hecho el pliegue.

Máquina dobladora de cuchilla

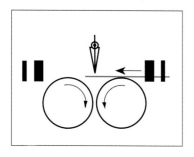

El papel pasa por la máquina...

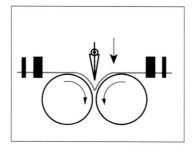

La cuchilla desciende en el momento preciso y empuja el papel doblándolo...

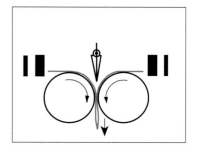

El papel es prensado por los rodillos de modo que queda hecho el pliegue.

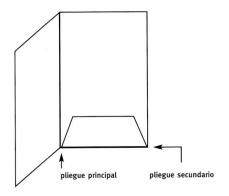

pliegue principal pliegue secundario

Un buen pliegue se caracteriza por dos elementos: su calidad y su resistencia. La calidad del pliegue se refiere al aspecto, mientras que para medir la resistencia se comprueba cuántas veces se puede doblar y desdoblar un papel antes de romperse. Existen diversos factores que permiten alcanzar la máxima calidad y resistencia en los pliegues. Entre ellos, destacan los siguientes:

Grano del papel

La pulpa de madera que se utiliza para elaborar el papel y la cartulina contiene fibras. Al comienzo del proceso, la pulpa está en estado líquido, pero conforme el papel pasa de estado líquido a sólido, las fibras tienden a alinearse en una dirección concreta. A esta dirección se la denomina grano. Es recomendable doblar el papel en el sentido del grano, de modo que el pliegue vaya paralelo al mismo. El hecho de realizar pliegues en sentido contrario al grano puede provocar roturas, ya que las fibras que rodean el pliegue se rompen en dos y hacen que el borde de éste presente una textura áspera y desigual.

Las roturas no sólo pueden evitarse realizando los pliegues en el sentido del grano, sino también al encuadernar folletos. Los cuadernillos cosidos y encuadernados

por el lomo suelen ser más planos cuando el papel está doblado en el sentido del grano.

A menudo, resulta inevitable doblar el papel en sentido contrario al grano. En el caso de carpetas con bolsillos, se recomienda realizar el pliegue principal en el sentido del grano y el secundario en sentido opuesto.

Contenido de fibras

El contenido de fibras es un factor importante para la resistencia del pliegue. Cuantas más fibras haya, más resistente es el pliegue. El papel estucado suele contener menos fibras y por eso no se dobla tan bien. Este papel también tiende a romperse más fácilmente ya que la superficie estucada del papel es menos elástica que su base.

Humedad

La humedad del papel es otro factor importante. Si el papel es demasiado seco y quebradizo, tiende a romperse; y si es demasiado húmedo, tiende a doblarse y combarse, con lo cual no resiste un pliegue limpio y preciso.

Impresión

Tras la impresión, deje que la tinta se asiente y se seque antes de doblar el papel. La impresión de tintas oscuras en los pliegues suele acentuarlos, especialmente si el papel tiende a romperse, de manera que conviene diseñar la pieza teniendo esto en cuenta.

Hendido

Para reducir la presión que un pliegue pone en el papel, se pueden realizar hendiduras antes de doblarlo. El hendido también permite reducir el riesgo de rotura, y con algunos tipos de cartulina resulta incluso necesario para lograr un pliegue limpio y nítido.

Aunque existen diversos tipos de dispositivos de hendido, todos se basan en un principio común: una regla

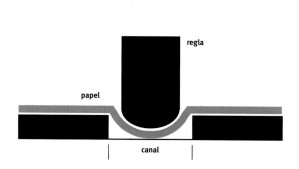

El principio del hendido

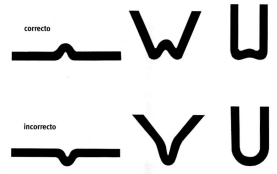

correcto

incorrecto

Pliegues correctos e incorrectos tras el hendido

redonda empuja el papel por un canal. La anchura de la regla y del canal dependerá del grosor del papel; la regla nunca debería ser más fina que el papel.

Contrariamente a lo que se podría pensar, el papel se dobla por la parte opuesta al pliegue, de modo que se logran tres puntos de tensión en lugar de uno.

El hendido resulta conveniente en los siguientes casos:

- Papeles estucados: el menor número de fibras y el estucado hacen que este tipo de papeles tienda a romperse.
- En la impresión de alta velocidad se utiliza aire caliente para secar las tintas. Esto hace que las superficies cubiertas con tinta sean quebradizas y puedan romperse.
- Papeles gruesos y todo tipo de cartulinas. Cuanto más pese el papel, mayor será su tendencia a romperse.
- Pliegues en sentido contrario al grano.
- Gran cantidad de tinta en los pliegues.
- Trabajos que requieran múltiples pliegues.

Producción

El plegado es una de las últimas operaciones del proceso de impresión, de modo que los errores pueden salir muy caros. Por consiguiente, es esencial consultar al impresor, al encuadernador y, posiblemente, al proveedor de papel los aspectos técnicos de la producción del diseño. Además del estriado y del plegado, hay que tener en cuenta los requisitos del sangrado y del pegado; no es aconsejable imprimir superficies que vayan a pegarse. Antes de llevar a cabo la producción, es muy recomendable realizar una maqueta con el material final y con las medidas exactas del trabajo definitivo.

Introduzione in Italiano

Leggenda

chiusura

perforazione

piega

da incollare

chiusura

piega

perforazione

foro nella sagoma

biglietto o foglio sciolto

biglietto da visita

piega

intagli (in cui inserire
il biglietto da visita)

Piegatura

Un'introduzione a **Metodi per piegare** e **Modelli da piegare per esposizione e pubblicità**

La chiarezza e la facilità di comprensione di ogni progetto costituiscono il principio fondamentale seguito per la realizzazione del presente volume. Per questo motivo abbiamo optato per delle illustrazioni dettagliate che partono dagli schemi piani riportati su ogni facciata sinistra e si concludono con il prodotto finito sulla facciata destra. Tutti gli schemi geometrici sono rappresentati sotto forma di sagome. Le linee di piegatura sono indicate dai punti a tratto lungo, le linee di perforazione, dai puntini e le sagome all'interno del modello, dalle linee sottili e diritte. Molto spesso è necessario fare uso di colla, che in alcune situazioni è facoltativa. Nella maggior parte dei casi la scelta del tipo di colla è personale, da effettuarsi in base alle preferenze e alle capacità tecniche. Le varie possibilità includono la colla liquida di tipo comune, il nastro biadesivo e gli autoadesivi ultrasottili. Per i progetti in cui è essenziale utilizzare la colla, le aree da incollare sono quelle ombreggiate.

Sagome

Gli schemi delle sagome di tutti i modelli sono memorizzati in formato vettoriale EPS nel CD-Rom accluso e sono compatibili sia con i programmi software Windows che Mac, in cui possono essere importati per essere aperti, ingranditi o rimpiccioliti e stampati a partire dal CD-Rom. Altri programmi per immagini, come ad esempio Adobe Illustrator, Aldus Freehand ecc., offrono comunque una maggiore flessibilità di manipolazione digitale dei modelli in quanto consentono di modificare le dimensioni dei file digitali in base alle particolari esigenze di ognuno.

Materiale

La scelta dei materiali per i progetti presentati in questo volume dipende dalla grandezza e dall'applicazione cui è destinato il modello. Una cartella di grandi dimensioni, realizzata per contenere una serie di documenti di un certo peso, dovrà – ad esempio – essere realizzata con un cartone resistente, mentre per un volantino si può impiegare un tipo di carta leggero.

Piegatura

Molti degli schemi inclusi in questa raccolta possono essere realizzati con una piegatrice, mentre altri sono troppo elaborati e devono essere necessariamente fatti a mano. Con una piegatrice standard è possibile eseguire quattro pieghe in un unico ciclo, ma con l'uso di ulteriori accessori la piegatrice è in grado di completare automaticamente un numero di piegature molto elevato. Sono in commercio, inoltre, delle piegatrici capaci di tagliare, perforare e incollare mentre piegano.

Piegatrice a pressione

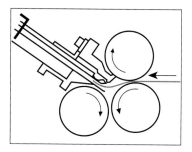

La carta passa attraverso la macchina...

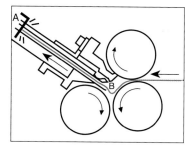

Urta il deflettore (**A**) e inizia a piegarsi (**B**)...

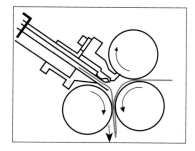

Poi la carta viene afferrata nei cilindri che la tirano, realizzando la piega vera e propria.

Piegatrice a coltello

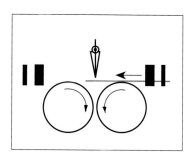

La carta passa attraverso la macchina...

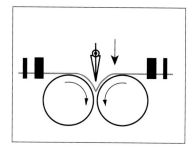

Il coltello si abbassa con tempismo perfetto e colpisce la carta, piegandola...

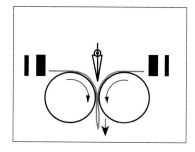

I rulli afferrano la carta e la spingono, realizzando la piega vera e propria.

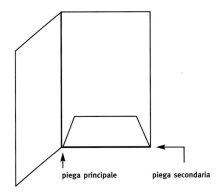

piega principale piega secondaria

L'accuratezza con cui viene eseguita una piega si valuta in due modi: la qualità della piegatura e la sua resistenza. La qualità della piegatura riguarda il suo aspetto esterno, mentre la resistenza si misura in base al numero di volte in cui è possibile piegare in un senso e nell'altro un pezzo di carta prima che si rompa. Sono molteplici i fattori che concorrono a ottenere il massimo in fatto di qualità e resistenza delle piegature, incluso quelli indicati avanti.

Grana della carta

La pasta di legno impiegata per fabbricare la carta e il cartone contiene delle fibre. All'inizio della lavorazione, la pasta è in stato liquido, ma durante la fase di solidificazione della carta, le fibre tendono ad allinearsi in base a una particolare direzione. Questa direzione è nota come grana. Di solito si consiglia di piegare la carta secondo la grana, cioè facendo in modo che la piegatura sia parallela alla direzione della grana. Le piegature che non seguono il senso della grana finiscono con lo spaccarsi in quanto le fibre circostanti la piega si spaccano a metà, con conseguente formazione di un bordo irregolare e seghettato lungo la piega.

Con una piegatura eseguita lungo la grana, non solo si evita di spaccare la carta ma – se si devono rilegare dei piccoli tomi – si ottengono cuciture perfette e segnature centrate che tendono più facilmente a restare piatte. In molte situazioni, però, la piegatura contro la grana è inevitabile, ad esempio per delle cartelline munite di tasche; in questi casi si consiglia di solito di realizzare la piega principale nel senso della grana e la piega secondaria nel senso opposto.

Contenuto di fibre

Il contenuto di fibre è un fattore importante per la resistenza della piegatura: quanto maggiore è il numero di fibre, tanto più resistente sarà la piega. Di solito la carta patinata ha un contenuto di fibre inferiore e, quindi, non si piega molto bene. La carta patinata tende, inoltre, a spaccarsi con più facilità in quanto la superficie patinata della carta è meno elastica rispetto allo strato interno.

Umidità

Anche il contenuto di umidità della carta è un fattore importante. Se la carta è troppo asciutta e fragile tende a spaccarsi, mentre se è troppo umida tende a espandersi e piegarsi, senza mantenere una piegatura precisa e intatta.

Stampa

Prima di eseguire una piega dopo la stampa, attendere che l'inchiostro si assesti e si asciughi. Se si esegue la stampa sulle pieghe utilizzando degli inchiostri scuri, la piega risulta accentuata, soprattutto se la carta tende a spaccarsi; è quindi opportuno tenere in considerazione questi fattori quando si progetta il lavoro.

Cordonatura

Per ridurre la sollecitazione che la piegatura impone alla carta, quest'ultima può essere cordonata prima di eseguire la piega. La cordonatura riduce, inoltre, il rischio

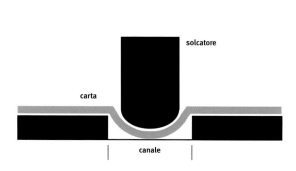

Il principio della cordonatura

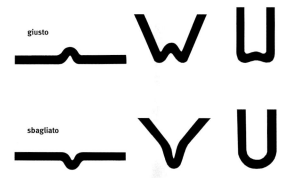

Pieghe corrette e non corrette dopo la cordonatura

di spaccatura e, per alcuni tipi di cartone costituisce un elemento essenziale per ottenere una piega pulita e ben definita.

Anche se esistono molteplici dispositivi di cordonatura, tutti funzionano su un principio comune: un solcatore arrotondato che spinge la carta in un canale. La larghezza del solcatore e del canale dipende dallo spessore della carta. In ogni caso il solcatore non deve mai essere più sottile della carta. La carta va piegata in senso opposto al solco, in tre punti separati invece che in uno solo. La cordonatura dovrebbe essere eseguita nei seguenti casi:

- La carta patinata: la quantità ridotta di fibre e la patinatura rigida tendono a spaccarsi.
- La stampa ad alta velocità, che utilizza l'aria per asciugare l'inchiostro. L'inchiostro diventa fragile e suscettibile alle spaccature.
- La carta doppia e tutti i tipi di cartone. La tendenza a spaccarsi aumenta all'aumentare del peso della carta.
- Piegature non nel senso della fibra.

- Spessa copertura d'inchiostro sull'area della piega.
- Ogni volta che un modello impone delle pieghe multiple.

Produzione

La piegatura costituisce una delle ultime fasi del processo di stampa, per cui gli errori possono risultare notevolmente costosi. Ecco perché è fondamentale consultare il fornitore della stampante, il rilegatore e, possibilmente, il fornitore presso il quale si acquista la carta per discutere gli aspetti tecnici connessi alla produzione del progetto. Oltre alla cordonatura e alla piegatura, occorre fare attenzione alle caratteristiche di espansione dell'inchiostro e all'incollaggio; non è consigliabile stampare su superfici che sono state incollate. Prima della produzione, si suggerisce vivamente di eseguire un prototipo utilizzando il materiale prescelto e con le misure esatte del prodotto reale.

Introdução em Português

Legenda

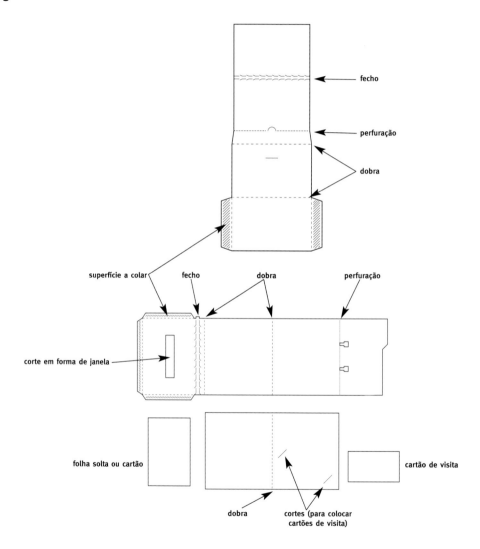

fecho

perfuração

dobra

superfície a colar · fecho · dobra · perfuração

corte em forma de janela

folha solta ou cartão

cartão de visita

dobra · cortes (para colocar cartões de visita)

Dobras

Uma introdução sobre **Como dobrar** e **Modelos de dobras para exibição e publicidade**

O princípio utilizado na concepção deste livro consiste em tornar cada modelo claro e facilmente compreensível. Por esta razão, escolheu-se uma introdução visual passo a passo que vai desde a(s) folha(s) plana(s), apresentadas nas páginas do lado esquerdo, até ao produto final, que se apresenta nas páginas do lado direito. Os padrões planos apresentam-se com os contornos de corte. As linhas de dobra estão indicadas por meio de pontos mais longos, as de perfuração por pontos pequenos e os cortes a realizar no modelo por meio de linhas rectas e finas. Por vezes é também necessário aplicar cola; outras vezes a aplicação de cola é opcional. A escolha da cola depende muitas vezes das preferências pessoais e das capacidades técnicas disponíveis; as possibilidades englobam a utilização de simples cola líquida, de fita adesiva por ambos os lados e de pequenas lâminas aderentes. Naqueles modelos em que a utilização de cola é essencial, as áreas a colar estão indicadas por zonas sombreadas.

Corte

As formas de corte de todos os modelos estão guardadas no CD-ROM que acompanha este manual e apresentam-se em formato vectorial EPS, tanto para Mac como para Windows. Os programas de software que permitem importar imagens permitem aceder, aumentar/reduzir e imprimir os modelos guardados no CD-ROM.

Existem programas de ilustração que oferecem uma maior flexibilidade para trabalhar digitalmente com os modelos, tais como Adobe Illustrator, Aldus Freehand e outros, pois permitem adaptar as dimensões dos ficheiros digitais às exigências específicas do utilizador.

Material

A escolha do material a utilizar nos modelos apresentados neste livro depende do tamanho e da aplicação final do modelo. Por exemplo, uma pasta com bolso relativamente grande, concebida para conter um relatório volumoso deverá ser construída a partir de um tipo de cartão robusto, enquanto que para um pequeno panfleto se poderá usar um papel leve.

Dobra

Muitos dos modelos desta colecção podem ser construídos utilizando uma máquina de dobrar; existem porém outros modelos demasiado elaborados que deverão ser dobrados manualmente. As máquinas de dobrar comuns podem efectuar quatro dobras diferentes duma só vez. Além disso, se se utilizam extensões adicionais da máquina de dobrar, o número de dobras que se podem fazer de forma automática pode ser bastante considerável.

Máquina de dobrar por deformação

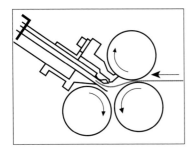 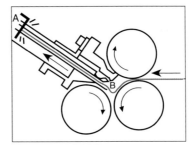 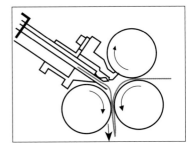

O papel passa pelo interior da máquina...

Atinge o deflector (**A**) e começa a deformar-se (**B**)...

O papel é então preso nos rolos e puxado o que, efectivamente, produz a dobra.

Máquina de dobrar com faca

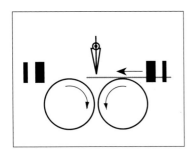 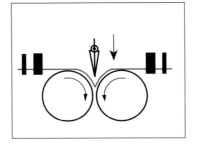 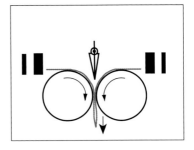

O papel passa pelo interior da máquina...

A faca baixa no momento exacto e atinge o papel, deformando-o...

O papel é então preso nos rolos e puxado o que, efectivamente, produz a dobra.

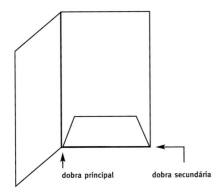

dobra principal dobra secundária

Adicionalmente, existem máquinas de dobrar capazes de marcar, perfurar e colar ao mesmo tempo que dobram. A realização com êxito de uma dobra define-se através de dois parâmetros: a qualidade da dobra e a força da dobra. A qualidade da dobra refere-se ao seu aspecto, enquanto que a sua força se mede pelo número de vezes que um pedaço de papel se pode dobrar para um e outro lado antes de se romper. Existem vários factores a ter em consideração para conseguir dobras mais fortes e de alta qualidade. Estes factores são os seguintes:

Orientação das fibras de papel

A pasta de madeira utilizada para produzir o papel e o cartão contém fibras. No início, a pasta encontra-se no estado líquido, mas à medida que o papel passa do estado líquido ao estado sólido, as fibras têm tendência a orientar-se. A esta direcção de orientação chama-se normalmente *orientação*. Recomenda-se dobrar o papel segundo a orientação das fibras pelo que a longitude da dobra deverá ser paralela à orientação das fibras do papel. Dobrar contra a orientação das fibras pode conduzir a que o material estale, pois as fibras que existem à volta da dobra rompem dando origem a uma aresta irregular.

O facto de dobrar segundo o sentido de orientação das fibras não serve somente para evitar que o material estale. De facto, ao encadernar pequenos livros, consegue-se uma perfeita encadernação e uma impressão mais plana quando o papel está dobrado segundo a orientação das fibras. Outras vezes, não é possível evitar dobrar contra a orientação das fibras. No caso de pastas com pequenos bolsos recomenda-se que a dobra principal se faça segundo a orientação das fibras enquanto que a dobra secundária se deverá fazer contra a orientação das fibras.

Conteúdo em fibras

O conteúdo em fibras é um factor importante no que toca à força da dobra. Quanto maior for o número de fibras mais forte será a dobra. Os papéis com revestimento contêm geralmente menos fibras e não se dobram tão bem. Além disso, têm tendência a estalar mais facilmente uma vez que o revestimento da superfície do papel é menos elástico que a base de papel.

Humidade

O teor de humidade do papel é também um factor importante. Se o papel estiver demasiado seco e quebradiço, terá tendência a estalar; se estiver demasiado húmido, terá tendência a rasgar-se e a deformar-se e nesse caso não se conseguirá uma dobra bem definida.

Impressão

Depois de imprimir e antes de dobrar, deve-se esperar algum tempo para que a tinta se fixe e se seque. A impressão de tintas escuras sobre as dobras tende a acentuar a dobra, especialmente naqueles casos em que o papel tenha tendência a estalar.

Marcação

Para reduzir as tensões que a dobra imprime ao papel, deve-se marcar o papel antes de o dobrar. A marca serve

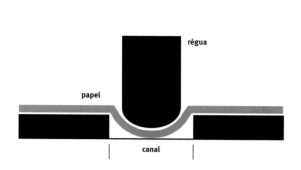

régua

papel

canal

Princípio utilizado para marcar o papel

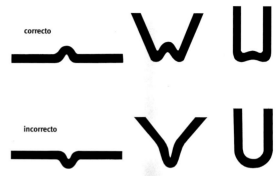

correcto

incorrecto

Dobras correctas e incorrectas depois de marcar o papel

também para prevenir que o papel estale. No caso de alguns tipos de cartões, estas marcas são inclusivamente necessárias para criar uma dobra perfeita e bem definida. Embora existam vários tipos de instrumentos para marcar o papel, todos funcionam segundo um princípio comum: uma régua arredondada pressiona o papel criando um canal. A largura da régua e as dimensões do canal dependerão da espessura do papel; a régua nunca deverá ser mais fina que o papel. Contrariamente ao que se possa pensar o papel é dobrado fora da zona da marca originando três pontos de tensão em vez de um só. Deve-se considerar marcar o papel nas seguintes situações:

- Papéis com revestimento: a existência de poucas fibras e o revestimento rígido são susceptíveis de fazer estalar o papel.
- A impressão a altas velocidades utiliza ar quente para secar as tintas. Este processo torna as tintas quebradiças e susceptíveis de estalar.
- Papéis grossos e todos os tipos de cartões.

- A tendência do papel a estalar é tanto maior quanto maior for o seu peso.
- Dobras feitas contra a direcção de orientação das fibras do papel.
- Grande quantidade de tinta sobre a dobra.
- Sempre que determinada aplicação requeira múltiplas dobras.

Produção

Dobrar é uma das últimas operações do processo de impressão, o que faz com que um erro neste ponto se torne caro. É fundamental que consulte o seu impressor, encadernador e o seu fornecedor de papel sobre os aspectos técnicos envolvidos na produção do modelo. Além das operações de marcar e dobrar, deve-se prestar atenção aos requisitos de escorrimento da impressão e à colagem; não é recomendável imprimir superfícies que se destinem a ser coladas. Antes da produção, recomenda-se construir uma imitação do modelo, utilizando o mesmo material e com as medidas exactas do trabalho final.

日本語での紹介

各部名称

ジッパー

パーフォレーション

折り目

糊付け部　　ジッパー　　折り目　　　　パーフォレーション

ダイカットウィンドウ

ばらの紙またはカード

名刺

折り目　　　ダイカット
　　　　（ビジネスカード立て）

フォールディング

『フォールディング方法』と『陳列／宣伝用フォールディングパターン』の解説

本冊子の製作にあたっては、各デザインアイデアを明確で理解しやすいものとすることを主眼に置いています。従って、それぞれ左ページの展開図にはじまり、右ページの最終製品にいたるまで、図を用いてステップバイステップで解説をすすめていきます。

平面パターンはすべてダイカットのカットラインです。フォールディングラインは長い点線、パーフォレーションラインは短い点線、タイプ別のダイカットは細い直線で示してあります。

糊付けは、必要な場合がよくありますが、任意の場合もあります。どの接着剤を使うかは、好みや技術的な接着性によって異なることがあり、普通の液状接着剤、（両面）テープ、薄いシールなどを利用することができます。接着が必要となるデザインの場合、糊付け部は陰影で示してあります。

ダイカット

付属の CD-ROM（Windows / Macintosh 対応）には、EPS ベクトルフォーマットで全デザインのダイカットフォームが収録されています。画像をインポートできるソフトウェアを使用すれば、CD-ROM のデザインにアクセスして、寸法を測り、印刷することができます。

ただし、デジタル方式でデザインを使用する際に最大限のフレキシビリティが発揮されるのは、Adobe Illustrator や Aldus Freehand などのイラストレーション用ソフトウェアを使用した場合です。こうしたソフトウェアでは、独自の仕様に合わせて、デジタルファイルの寸法を変えることができます。

材　料

本冊子で紹介するデザインに使用する材料のタイプは、デザインのサイズや用途によって異なります。例えば、重さのあるリポート類収納用の大きなポケットフォルダには丈夫なボール紙を使い、小さなフライヤー用には軽い板紙を使用するといった具合です。

フォールディング

収録されているデザインコレクションの多くはフォールディングマシンでフォールディングを行うことができますが、あまりに手の込んだデザインでは手作業でしか折れないものもあります。標準的なフォールディングマシンは、一度に 4 つの折り目を処理できます。さらに、フォールディングマシンをつなげて数を増やせば、多くの折り目を自動処理することが可能です。そのほか、スコアリング（溝線付け）、パーフォレーション（目打ち）、糊付けの各作業をフォールディング（折り）と同時に行うことができるフォールディングマシンもあります。フォールディングの出来は、フォールディング品質とフォールディング強度の二面から判断します。フォールディング品質は外観に関するもので、フォールディング強度は紙が破れるまでに何度フォールディングを繰り返せるかで決まります。最高水準のフォールディング品質とフォールディング強度の達成には、次のような幾つかの要因が関ってきます。

「バックル式」フォールディングマシン

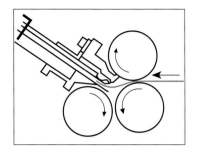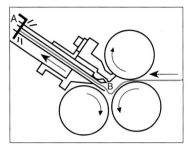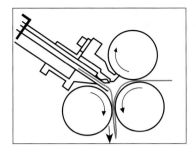

紙が機械を通過します…

デフレクタ（A）に当たって、曲がりはじめます（B）…

紙がローラーにはさまり、引っ張られて、これによりフォールディングが行われます。

「ナイフ式」フォールディングマシン

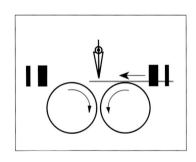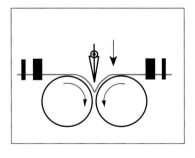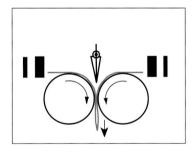

紙が機械を通過します…

正確な時間間隔でナイフが降下して紙に当たり、紙を曲げはじめます…

紙がローラーにはさまり、引っ張られて、これによりフォールディングが行われます。

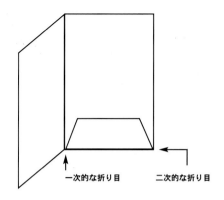

一次的な折り目　　　　二次的な折り目

ペーパーグレーン（原料繊維の方向）

板紙やボール紙の製造に使用される木材パルプには繊維が含まれています。製紙工程の初めにはパルプは液状ですが、液状から固形状態に変わっていくときに、繊維はある特定の方向にそろうようになります。この方向がグレーンと呼ばれるものです。通常は、折り目の全長がグレーンと平行になるように、グレーンに沿ってフォールディングを行うことをお勧めします。グレーンと逆方向にフォールディングを行うと裂け目が生じ、繊維が折り目にかかる部分で二つに破れ、折り目に沿って粗いぎざぎざの切れ端が生じることになります。

グレーンに沿ってフォールディングを行うことにより、裂け目が生じるのを防ぐことができるばかりでなく、小冊子を綴じる際に、グレーンに沿って折った場合、綴じが正確になり、背綴じの折り丁をきちんとしたものに仕上げることができます。

しばしば、グレーンと逆方向のフォールディングを避けられないこともあります。ポケット付きのフォルダの場合は、一般に、一次的な折り目をグレーンの向きにそろえ、二次的な折り目をグレーンと逆方向にすることをお勧めします。

繊維の含有量

繊維の含有量は、フォールディング強度を決める重要な要因となります。繊維の数が多ければ多いほど、フォールディングの強度が高まります。一般にコーティング紙は繊維の量が少なく、上手くフォールディングできません。コーティング紙はまた、ベースペーパーに比べてコーティング処理面の弾力性に欠けるため、裂けやすくなります。

水 分

紙の水分含有量もまた、重要な要因となります。紙が乾燥しすぎで堅くてもろいと、裂けやすくなります。逆に水分が多すぎると、引っ張られてゆがみやすくなり、正確できちんとしたフォールディングを維持できません。

印 刷

印刷後は、フォールディングを行う前に、インクが固まって乾燥するまで時間をおいてください。濃い色のインクを折り目の上に印刷すると、紙が裂けやすい場合は特に折り目部分で問題が大きくなるため、状況に応じてデザインを考えてください。

スコアリング

フォールディングによって紙に加わる力を減少させるために、フォールディング前にスコアリングと呼ばれる溝線付け処理を行うこともできます。スコアリングは、紙が裂ける危険を減少させるのに役立つほか、あるタイプのボール紙では、きちんとしたフォールディングを実現するのにスコアリングが必要な場合さえあります。

スコアリング装置には幾つかのタイプがありますが、いずれも、丸みの付いたルール（定規）で紙をチャネル（溝）の中に押し込むという共通の原理で作動します。ルールとチャネルの幅は紙の厚さによって異なりますが、紙より薄いルールは使用しないでください。

意外かもしれませんが、1ヶ所でなく3ヶ所で応力点が生まれるように、紙はスコアリングで付けられた溝線から離れた位置でフォールディングされます。

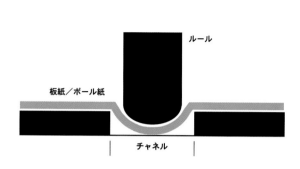

スコアリングの原理

スコアリング処理後の正しいフォールディングと正しくないフォールディング

次のような場合に、スコアリング処理を考える必要があります。

- コーティング紙：繊維数が少なくてコーティングが固いと、紙が裂けやすくなります。
- 高速作動の印刷機はインクを乾かすのに温風を使い、このため、インクが堅くてもろくなり、紙が裂けやすくなります。
- 厚い板紙と全タイプのボール紙：紙の重量が増すと、紙の裂けやすさも高まります。
- グレーンと逆方向にフォールディングする場合。
- 折り目部分に大量にインクを使用する場合。
- 複数のフォールディング作業が必要となる場合。

生 産

フォールディングは印刷工程における最後のプロセスのひとつとなるため、ここでミスが起こるとコストが高くつくことになります。従って、印刷業者、製本業者、場合によっては板紙供給業者も含めて、デザインの生産に関る技術的な側面について相談することをお勧めします。スコアリングとフォールディング以外にも、印刷の裁ち切り図版の要件や糊付け作業にも注意を払ってください。糊付けを行う部分に印刷することはお勧めしません。生産を開始する前に、最終的な材料を使い、最終製品の正確な測定寸法で、原寸模型を作ることを強くお勧めします。

中文簡介

圖 例

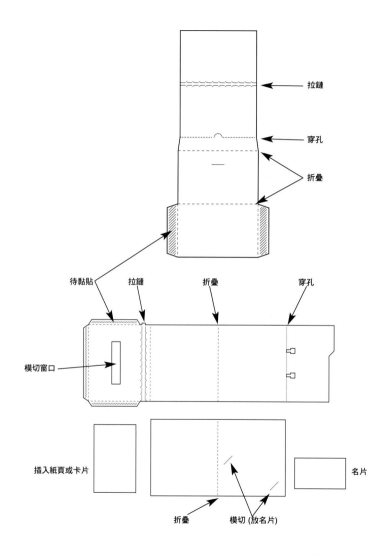

拉鏈

穿孔

折疊

待黏貼　　　拉鏈　　　　折疊　　　　穿孔

模切窗口

插入紙頁或卡片

名片

折疊　　　模切 (放名片)

折　疊

《怎樣折疊》和《用於展示與宣傳的折疊形狀》引言

本書中設計的指導原則是清晰介紹每一個設計思想，使之易於理解。為此，我們挑選了一種直觀的，逐步講解的方法，左邊的每一頁上是平面圖，右邊一頁則顯示成品。

平面形狀以模切輪廓標出。折疊線以長虛點標出，穿孔線以小點標出，模型中的模切則以細直線標出。

折疊時經常需要黏貼，但有時則可用可不用。對黏結劑的選擇常常取決於喜好和材料的技術性能；可以選用普通液體膠水、(雙面) 膠帶以及封緘紙。在需要黏貼的設計中，黏貼部位以弧線標出。

折疊時經常需要黏貼，但有時則可用可不用。對黏結劑的選擇常常取決於喜好和材料的技術性能；可以選用普通液體膠水、(雙面) 膠帶以及封緘紙。在需要黏貼的設計中，黏貼部位以淡暗色標出。

模　切

所有設計的模切形式均以 eps 向量格式儲存在隨附的 CD-Rom 上，供 Mac 和 Windows 使用。軟體程式可以輸入圖像，並將使你能夠從 CD-Rom 上存取、擴縮及列印各種設計。

然而，演示程式，如 Adobe Illustrator、Aldus Freehand 等，還可以透過數位方式對設計進行靈活的調整，因為這些程式能使數位文檔的尺寸完全適合你自己的特定要求。

材　料

本書中各種設計所用材料的選擇取決於設計的大小和用途。譬如，用於裝載沉重報告的大型口袋形文件夾應當用結實的紙板製作，而裝載小傳單的夾子則可用輕質紙張製作。

折　疊

這個集子中的許多設計可在折疊機上製作，有些設計過於復雜，必須用手工折疊。標準的折疊機一次能製作四個不同的褶子。而且，如果採用附加的折疊裝置，自動完成的褶子數目將會更多。此外，還有能夠在折疊的同時進行劃線、穿孔和黏貼的折疊機。

褶子的成功與否取決於兩個方面：褶子品質與褶子強度。褶子品質指的是它的外觀，而褶子強度則是根據一張紙能來回折疊多少次才會斷裂來測定的。若要獲得最高的品質和最牢固的褶子，應考慮幾個因素，其中包括：

彎曲式折疊機

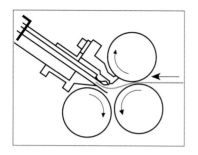

紙張通過折疊機 ...

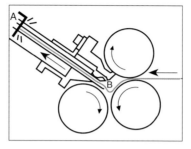

紙張碰到反射器(A)，開始彎曲 (B)...

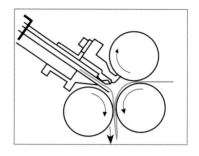

紙張然後被卷到滾筒之間，形成褶子。

刀刃式折疊機

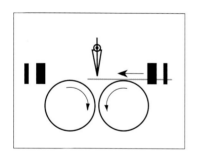

紙張通過折疊機 ...

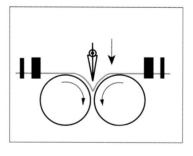

刀刃在精確的時間自上而下運動，壓在紙張上，使之折疊 ...

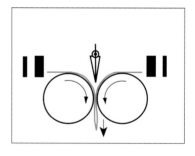

紙張然後被卷到滾筒之間，形成褶子。

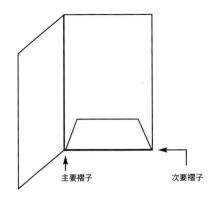

主要褶子　　　　　次要褶子

紙張紋理

用於製造紙張和紙板的木漿含有纖維。在造紙工藝的開頭，木漿呈液態，但當紙張從液態變為固態時，纖維往往會排列成一個特定的方向。這個方向叫作紋理。一般建議順著紋理折疊紙張，即褶子的長度與紋理平行。逆著紋理折疊會引起開裂，出現開裂時纖維會在褶子周圍斷成兩段，致使褶子旁有一條粗糙不平的邊。

你不僅可以透過順著紋理折疊來避免開裂，而且在裝訂小冊子時，如果紙張是順著紋理折疊的，裝訂完好和書脊縫合的書冊往往更加平整。

逆紋理折疊常常是不可避免的。在口袋形文件夾的情況中，一般建議主要褶子順著紋理折疊，而次要褶子逆著紋理折疊。

纖維含量

纖維含量是褶子強度的一個重要因素。纖維含量越高，褶子越牢固。塗層紙一般含有較少的纖維，因此折疊起來不怎麼好。塗層紙還往往容易開裂，因為紙上的塗料表面不如紙的底層有彈性。

水 份

紙張的水份也是一個重要因素。如果紙張太乾太脆，紙張往往容易開裂；如果紙張太濕，紙張往往會收縮和皺曲，而且不能保持挺括、精確的褶子。

印 刷

在印刷之後，讓油墨有時間凝固並變乾，然後再進行折疊。在褶子上印深色油墨會突出褶子，尤其是在紙張容易開裂的情況下。因此應根據情況進行設計。

劃 線

為了減少折疊對紙張造成的應力，在折疊之前可作一些劃線。劃線還有助於減少開裂的可能性。就某些種類的紙板而言，劃線甚至是為折出均勻整齊、輪廓分明的褶子所必需的步驟。

雖然劃線設備有好幾種，但它們都按照一個共同的原理工作：一把圓劃規把紙壓入一條凹縫。劃規和凹縫的寬度取決於紙的厚度；劃規決不可以比紙薄。

與你想象的情形相反，紙張是從劃痕處折疊開去，形成三個應力點，而不是一個。

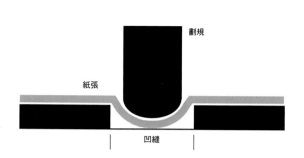

劃線原理

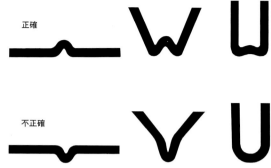

劃線以後正確與不正確的折疊

在下述情況中應考慮劃線：

* 塗層紙：纖維較少和硬性塗料容易造成開裂
* 高速印刷使用熱風吹乾油墨。
 這使得油墨變脆而且容易開裂
* 厚紙和各種紙板
 當紙的重量增加時，
 紙張開裂的可能性也會增大
* 逆著紋理折疊
* 褶子處油墨多
* 作業需要多個褶子時

生 產

折疊是印刷工藝中最後一道操作，因此錯誤的代價可能是很高的。所以，應該就設計的技術問題與印刷商、裝訂商或紙張供貨商進行咨詢。除了劃線和折疊之外，還要注意印刷切裁要求以及黏貼；在需要黏貼的表面進行印刷是不可取的做法。在生產之前，我們極力建議先用最後的材料，根據最終成品的準確尺寸做一個實體模型。

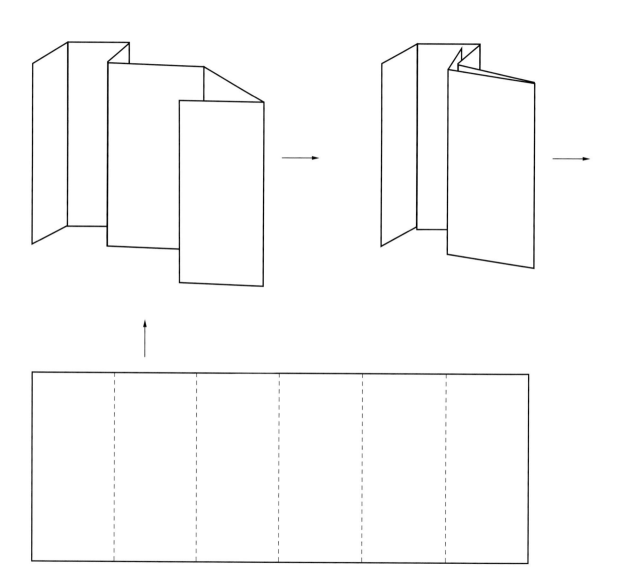

54 Triple parallel fold

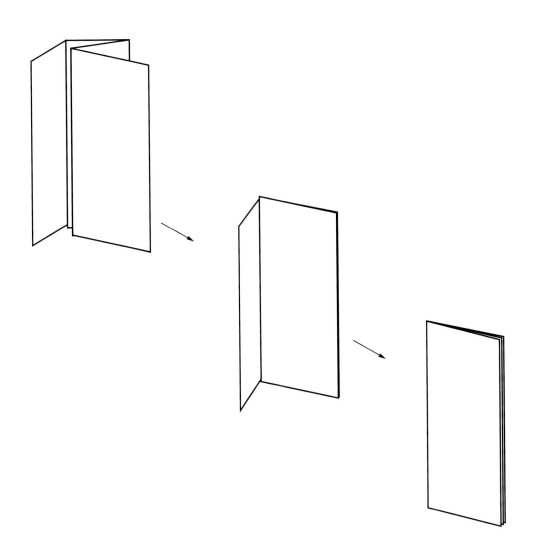

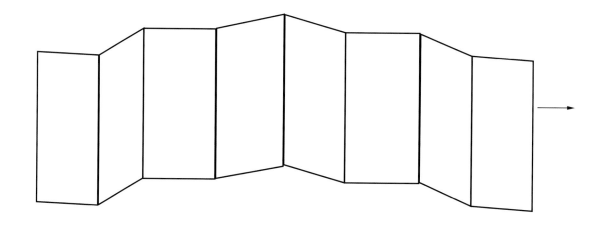

Double gate folder

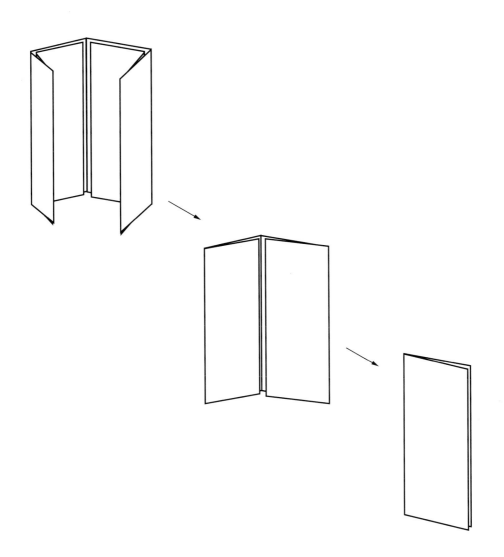

Dueling 'Z' fold

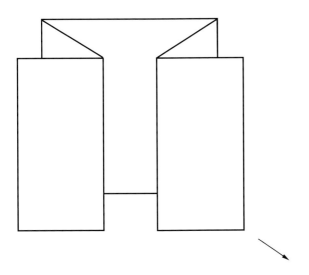

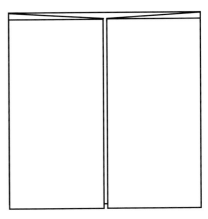

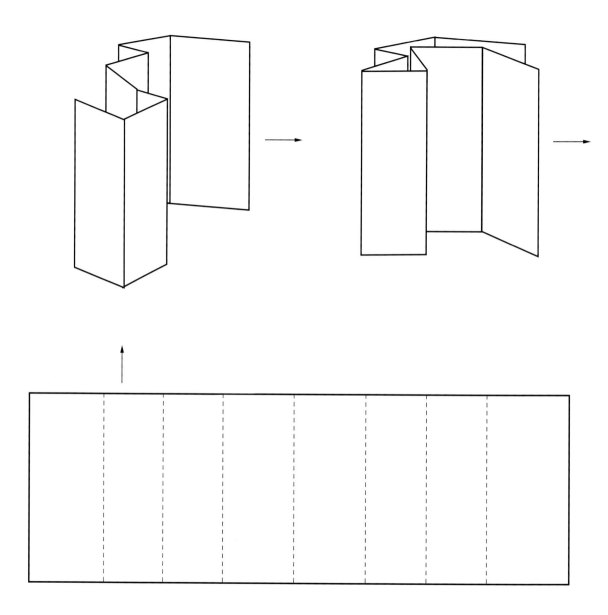

'Gordian knot' folder

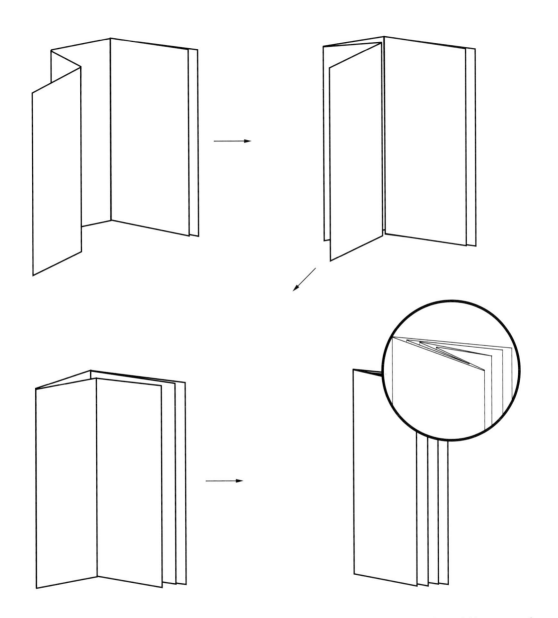

'Gordian knot' folder 61

Double accordion folder

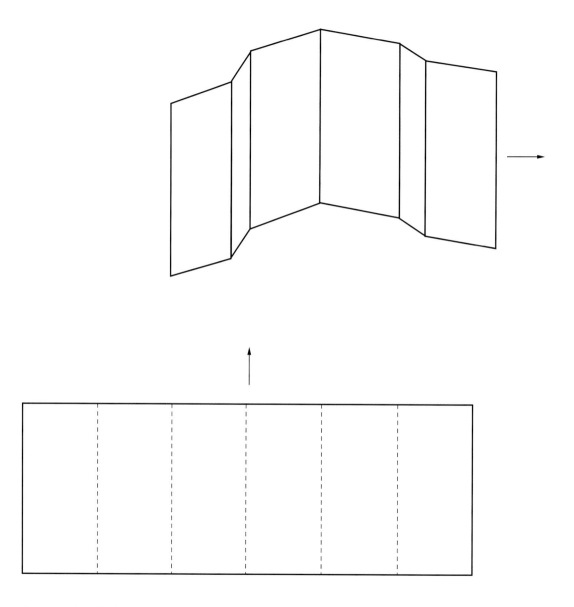

64 Front/back accordion folder

Mock-book folder

Back/front folder

70 Come from behind half cover

Come from behind half cover 71

| 4 | 4 | 3 3/4 | 3 3/4 | 3 3/4 | 3 3/4 | 3 3/4 | 3 3/4 |

Self-cover harmonica folder

Self-cover harmonica folder 73

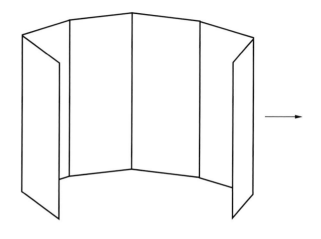

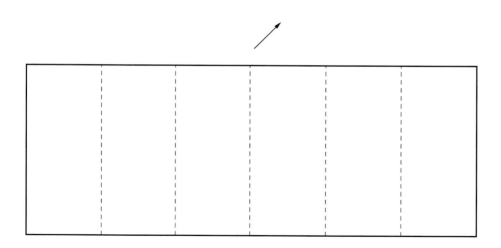

Front/back gate fold

Front/back gate fold 75

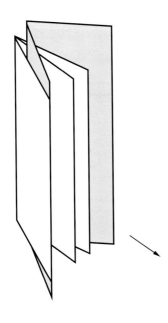

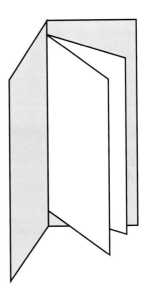

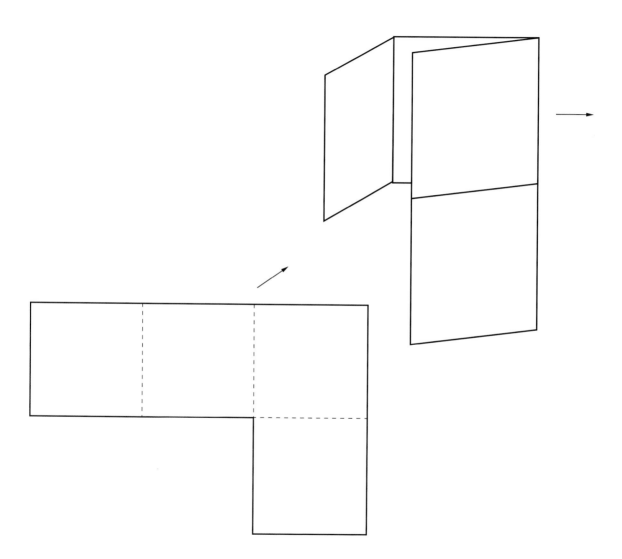

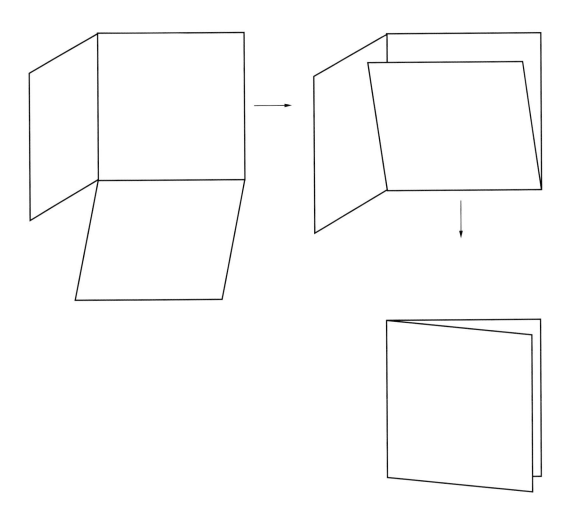

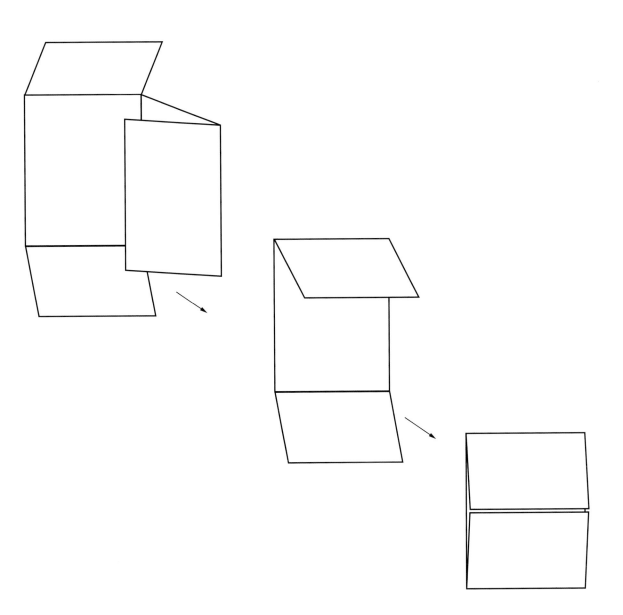

Folder

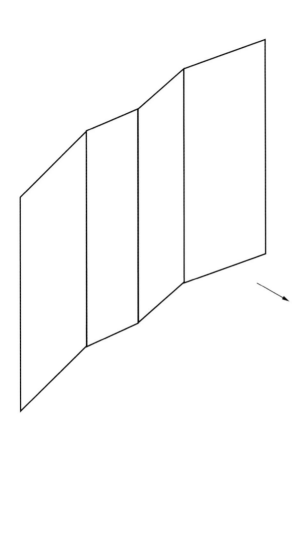

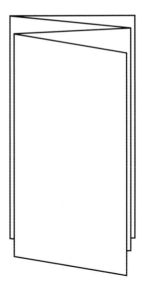

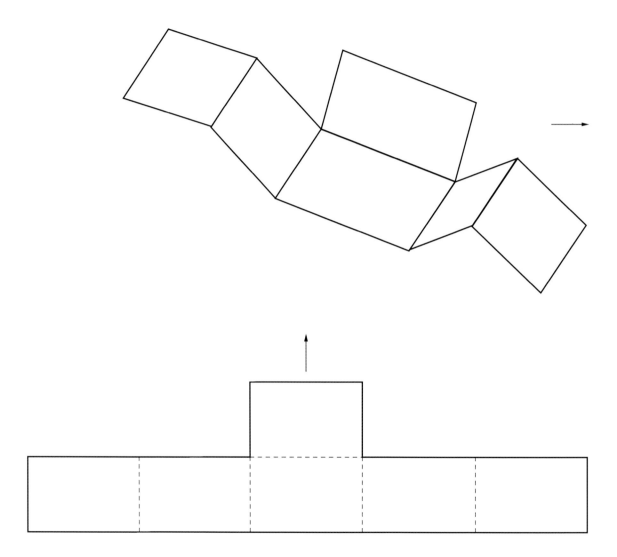

Double harmonica folder

Double harmonica folder 89

Folder

Map fold

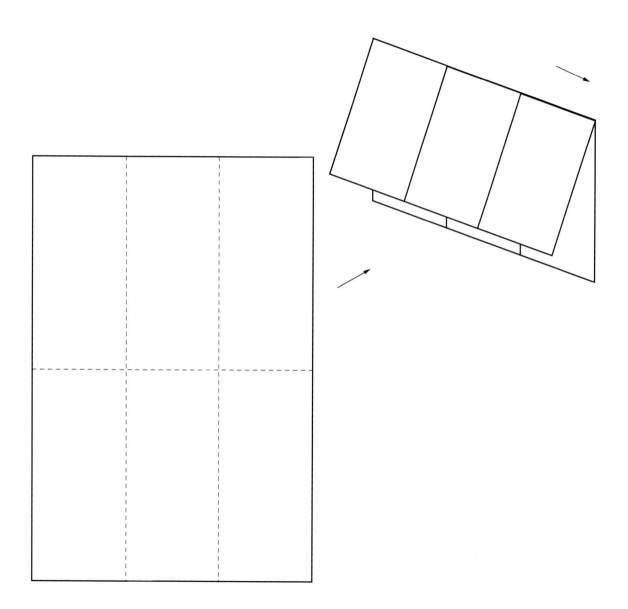

Self-locking map fold

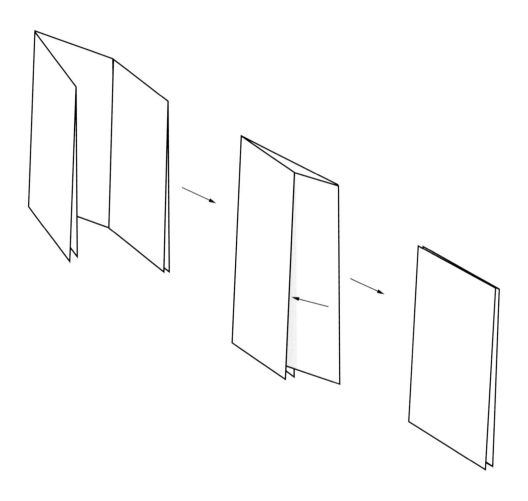

Map fold

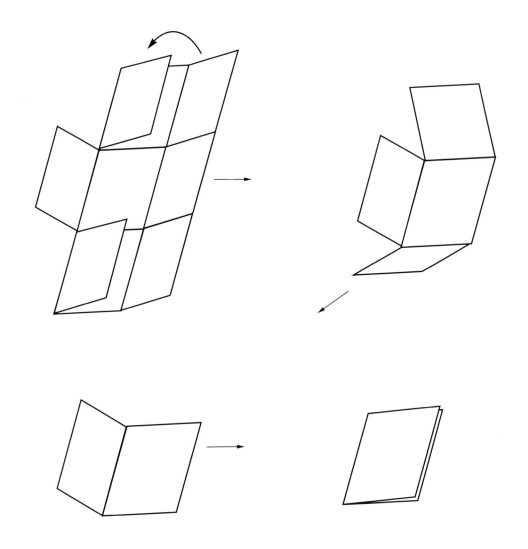

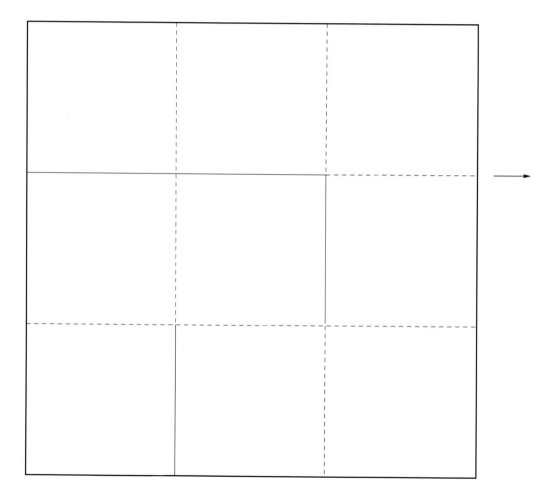

The maze map

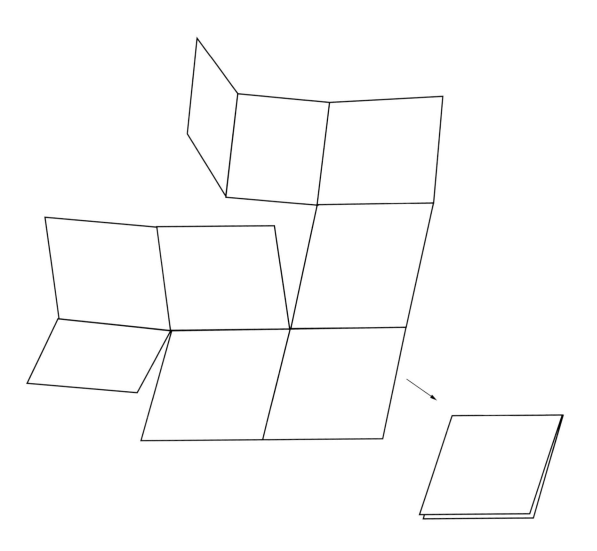

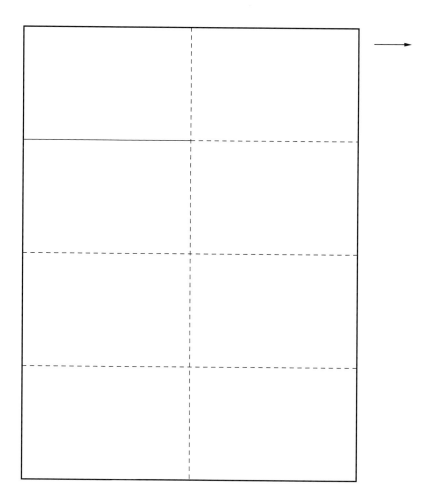

100 Map with self-cover

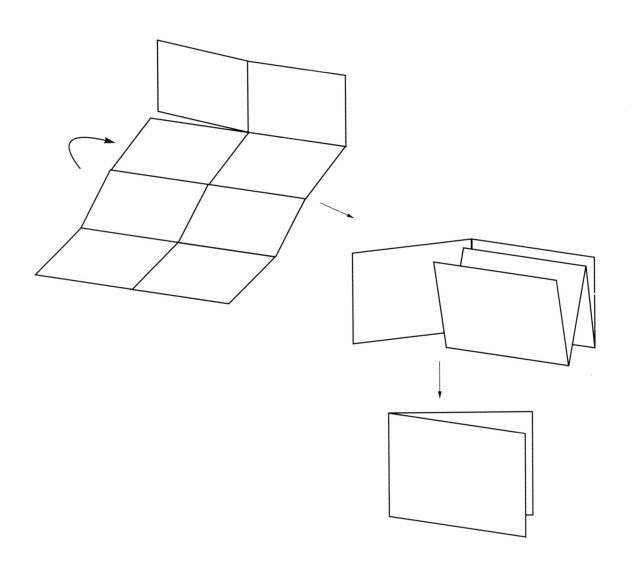

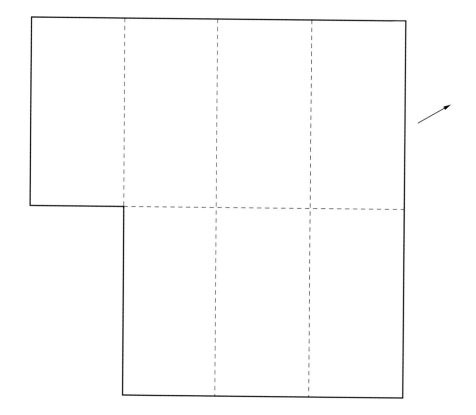

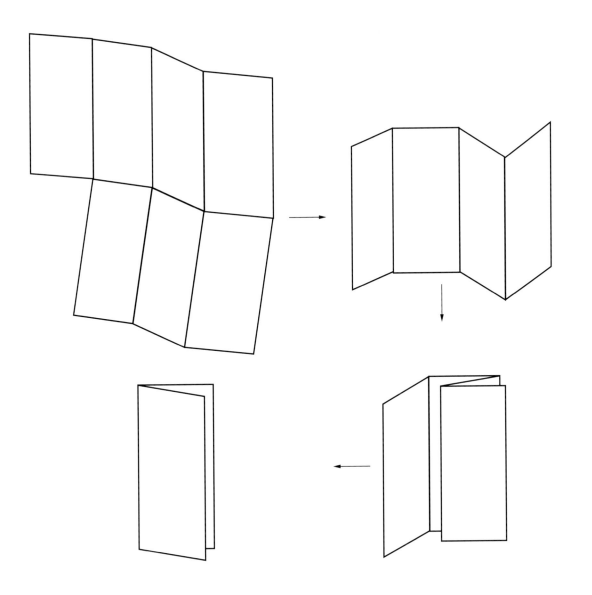

Map 103

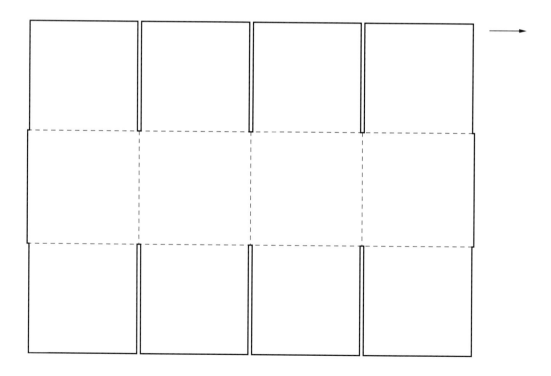

Table top fold out

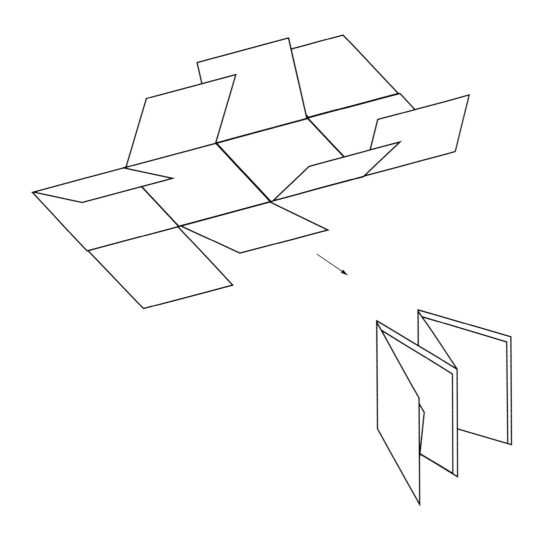

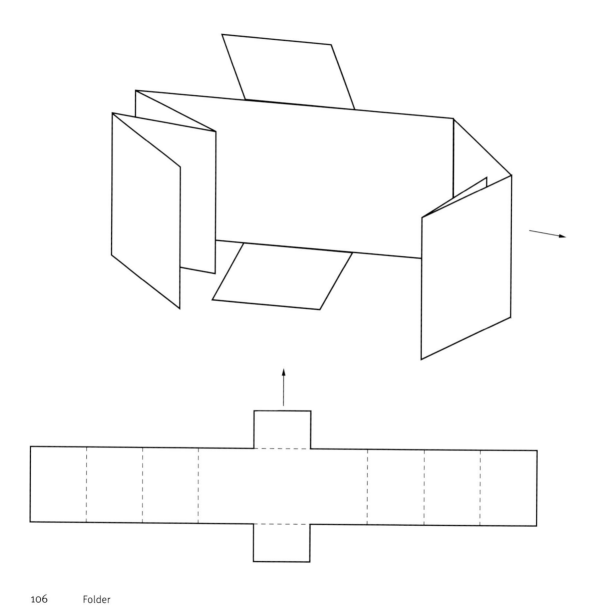

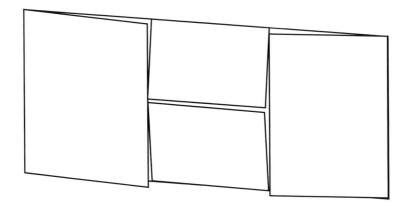

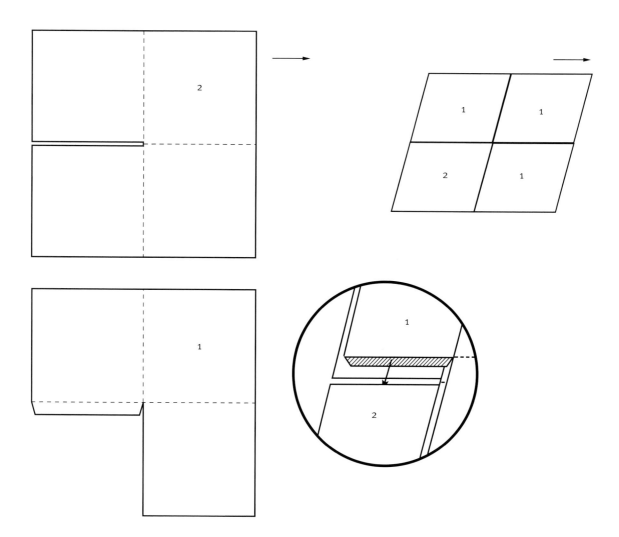

The unraveling folder

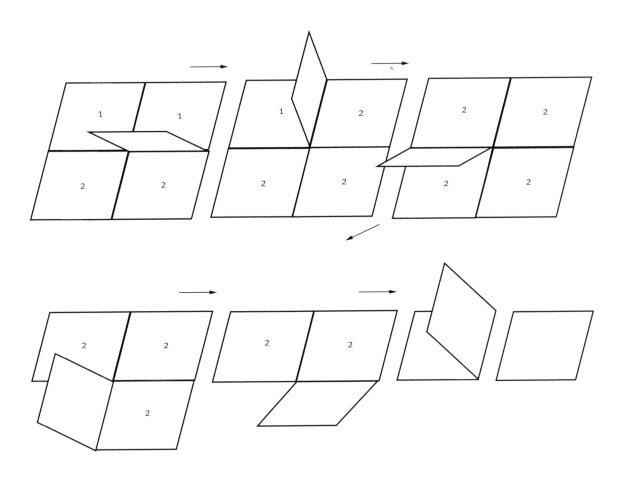

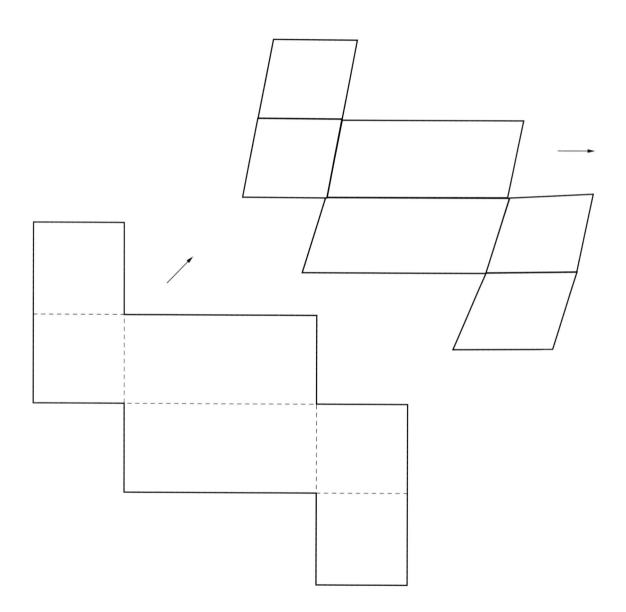

Checkbook fold-out

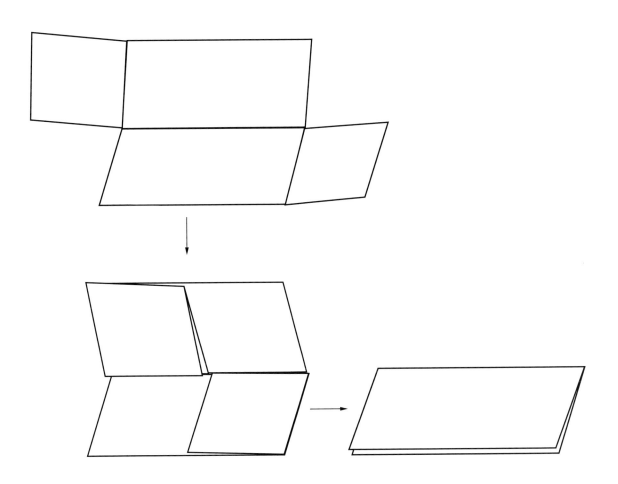

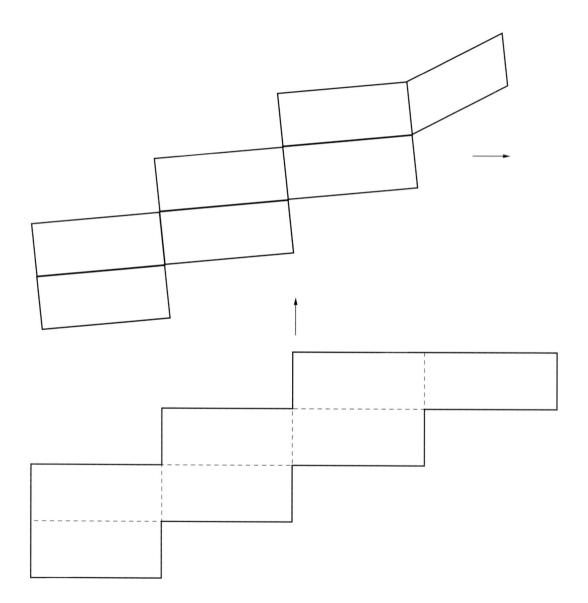

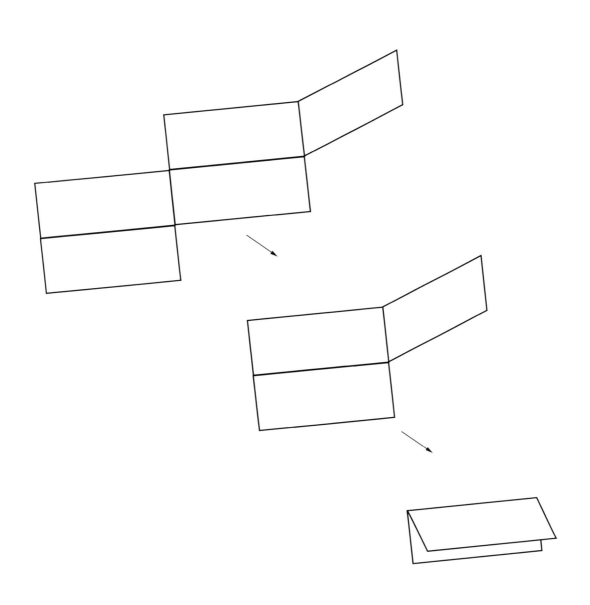

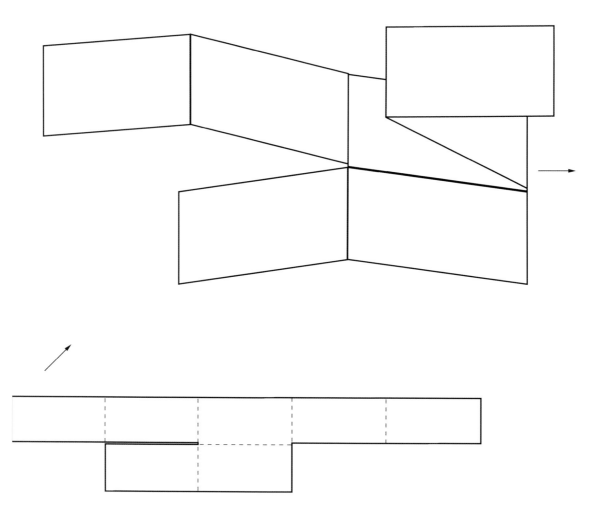

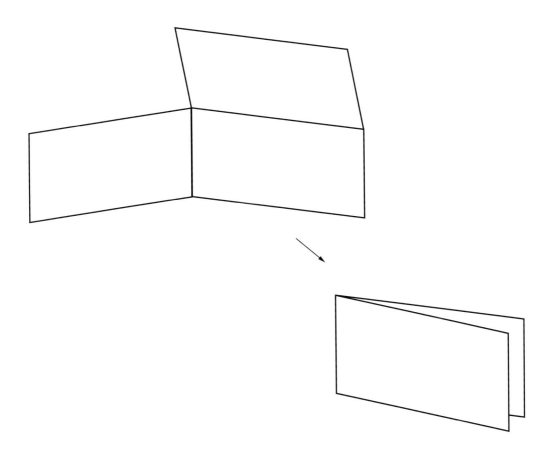

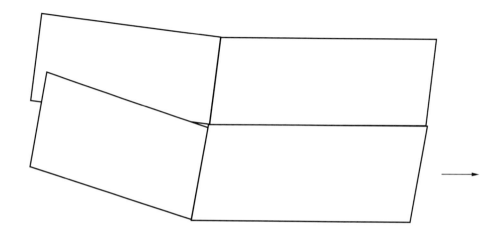

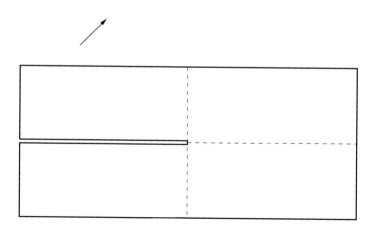

Checkbook folder

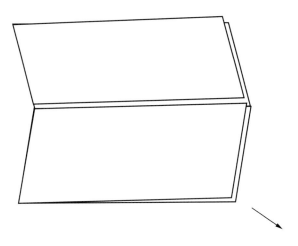

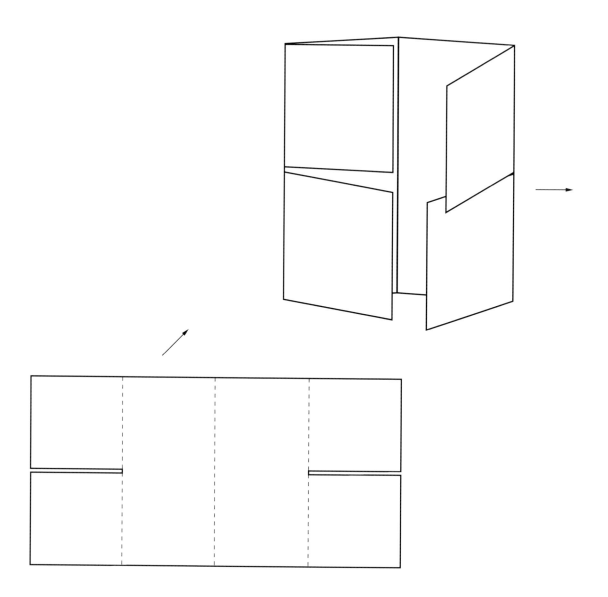

Double barn door folder

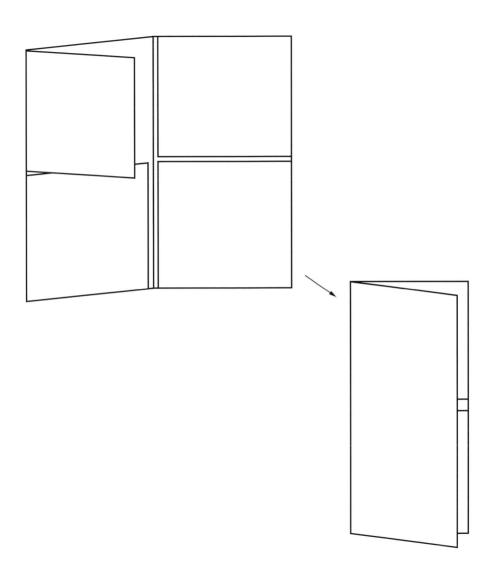

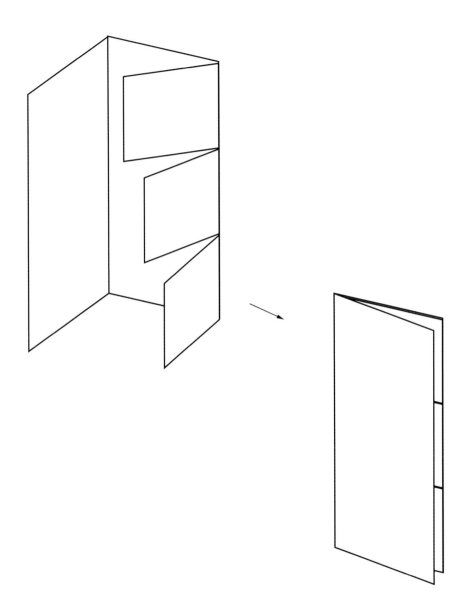

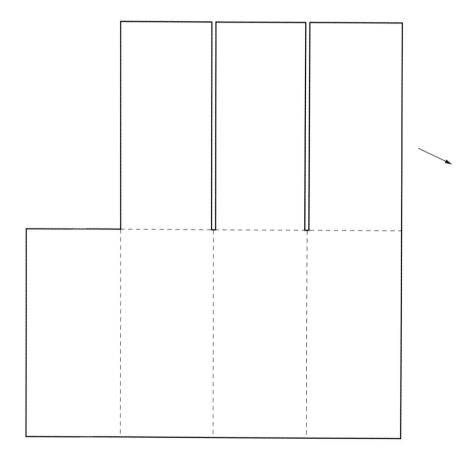

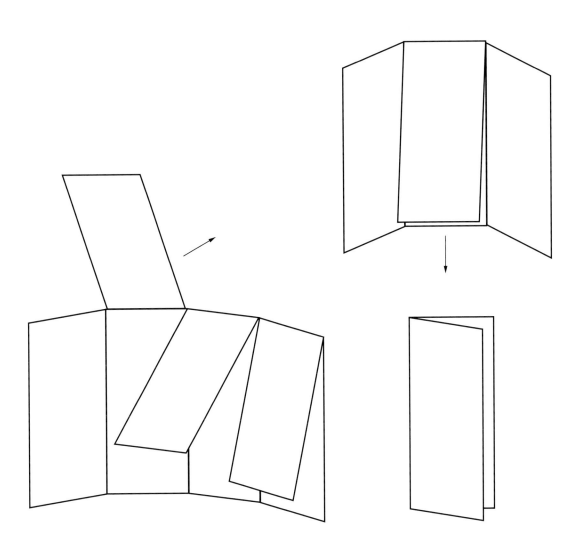

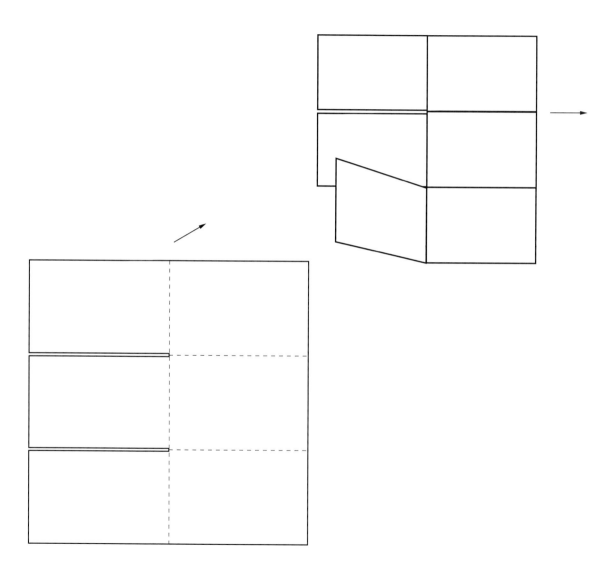

The reveal

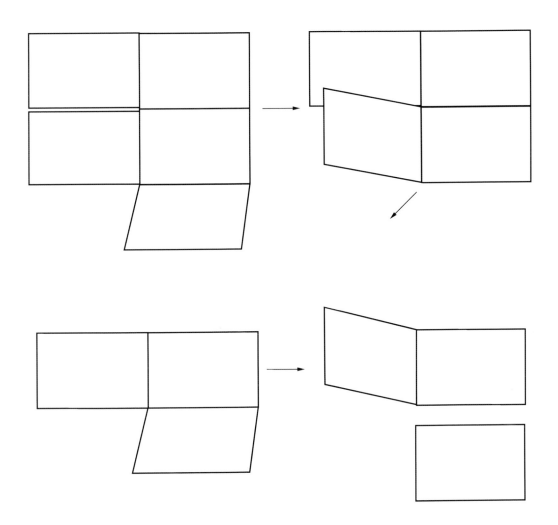

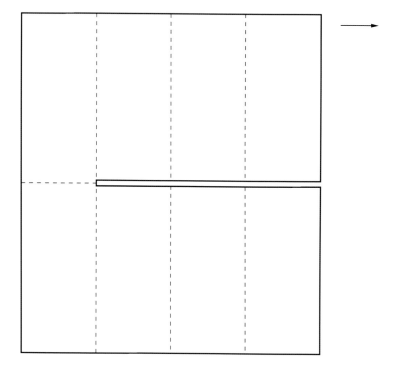

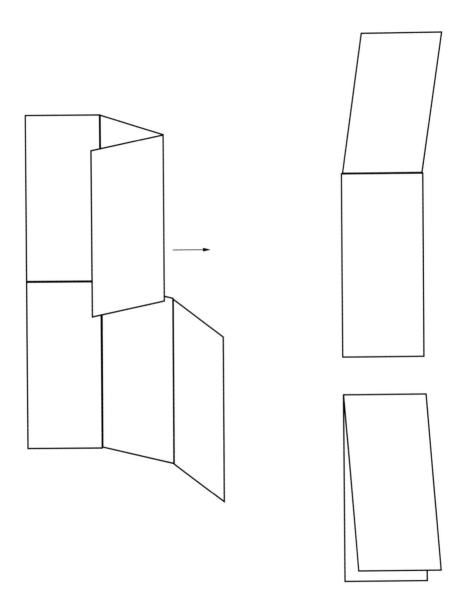

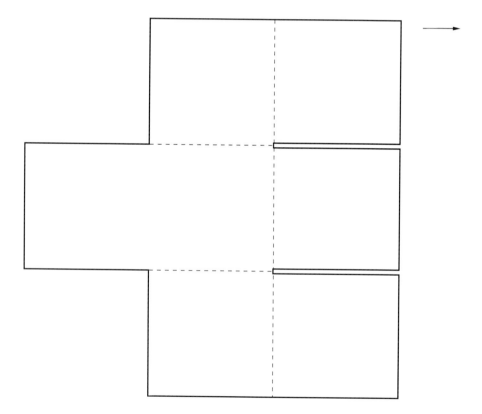

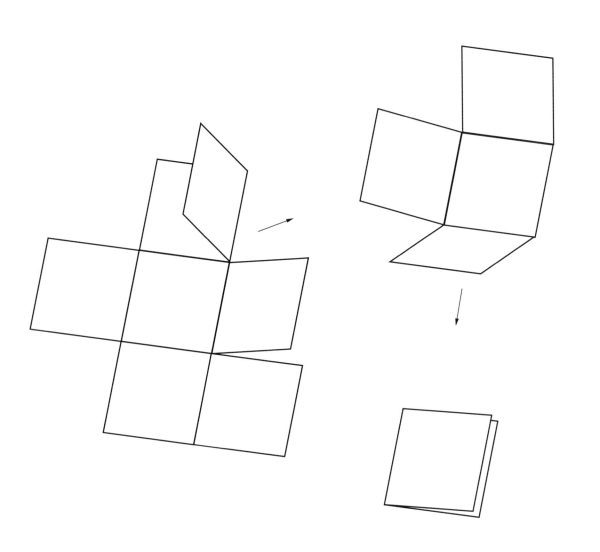

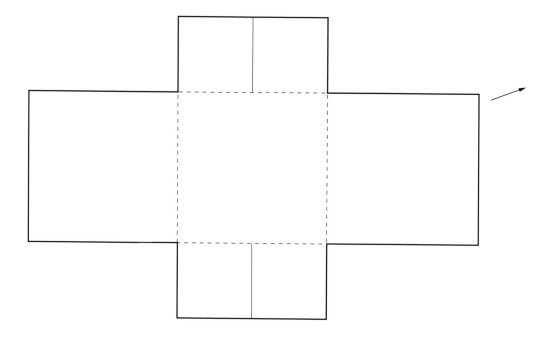

Folder

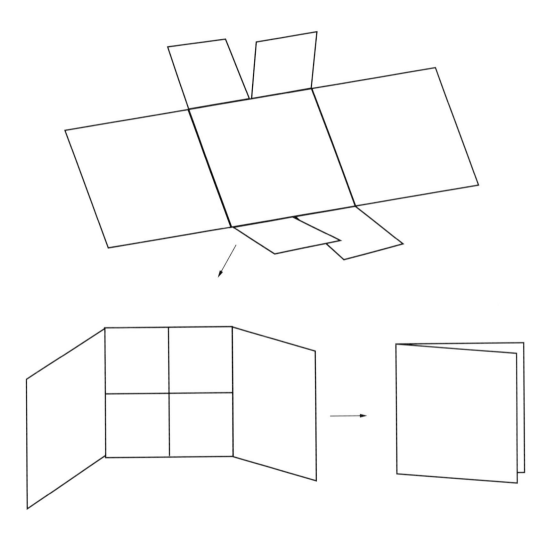

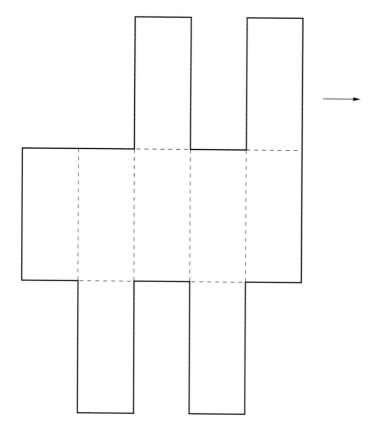

Folder

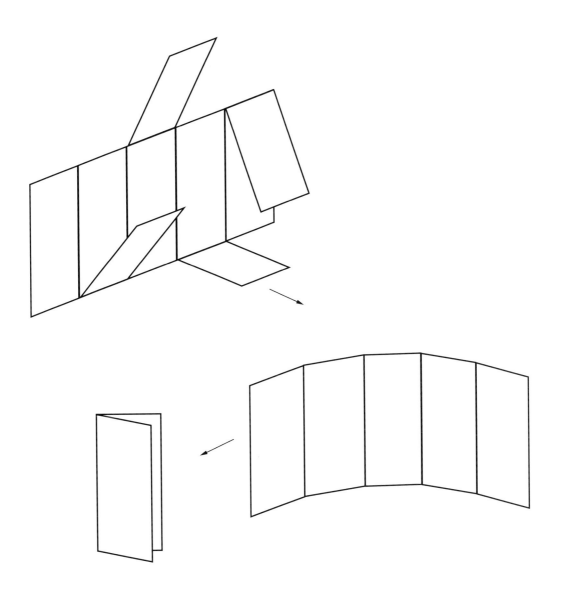

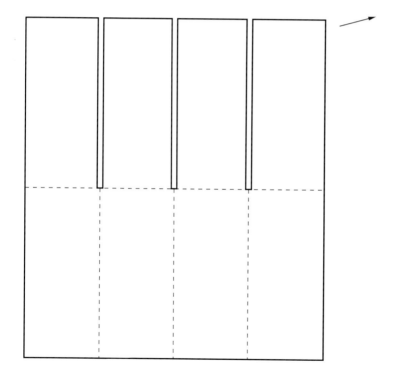

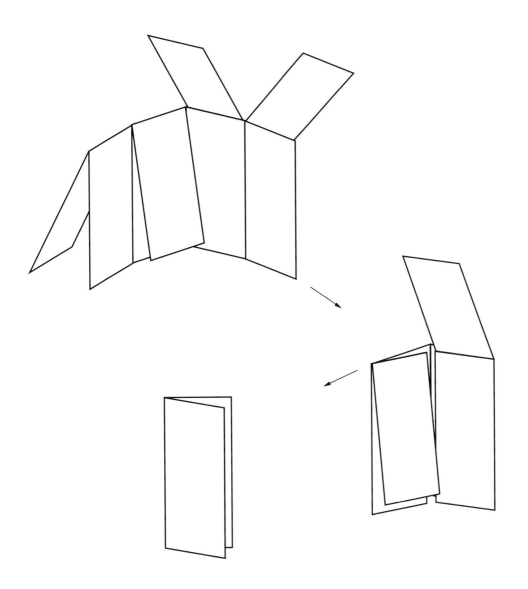

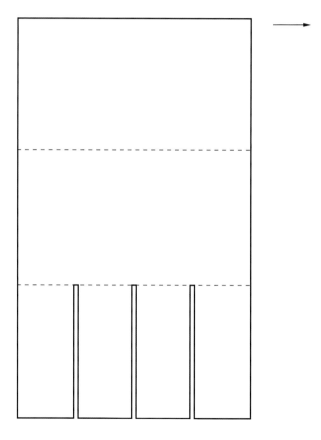

Four panel flip down

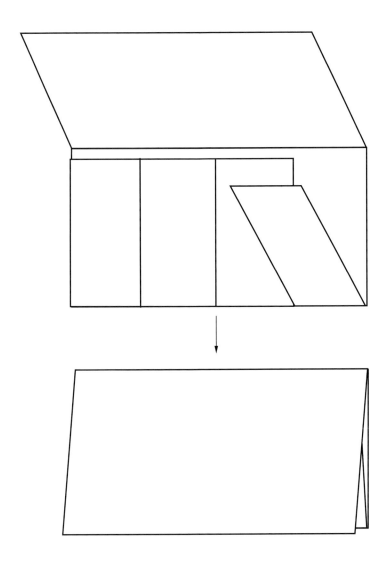

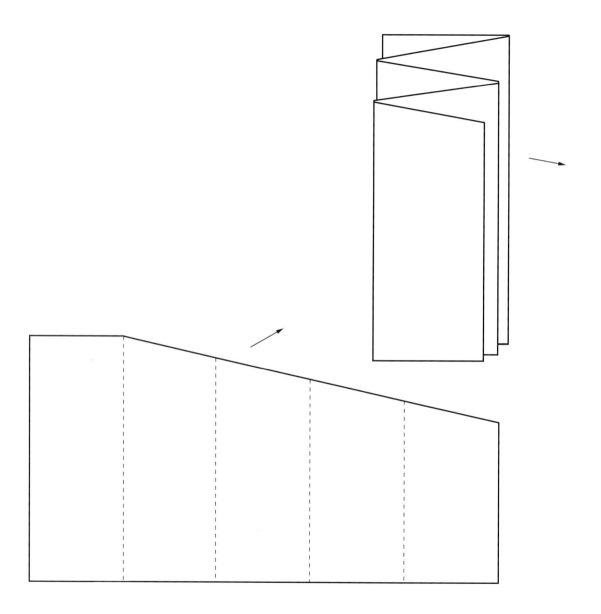

138 The incline tab

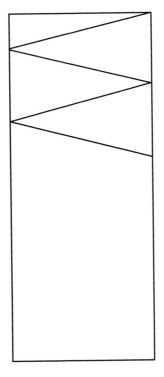

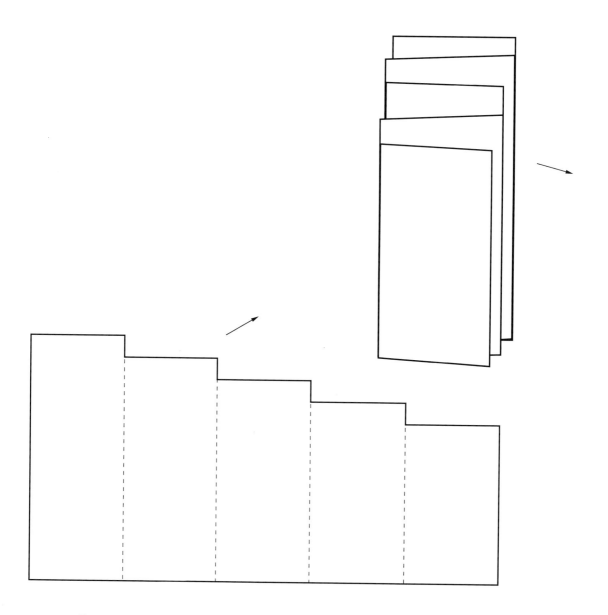

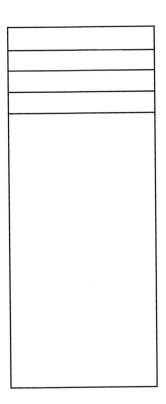

$3\frac{3}{4}$ $3\frac{1}{2}$ $3\frac{1}{4}$ 3 $2\frac{3}{4}$

Ascending tab folder

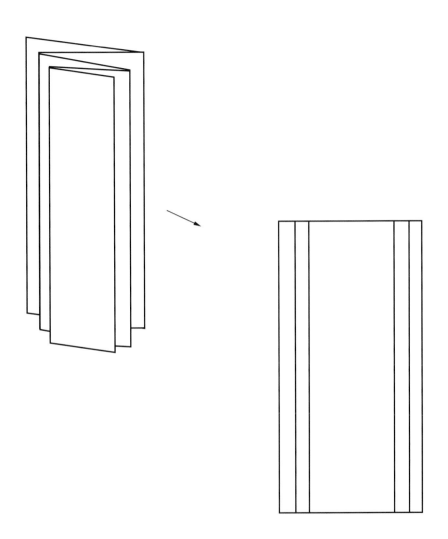

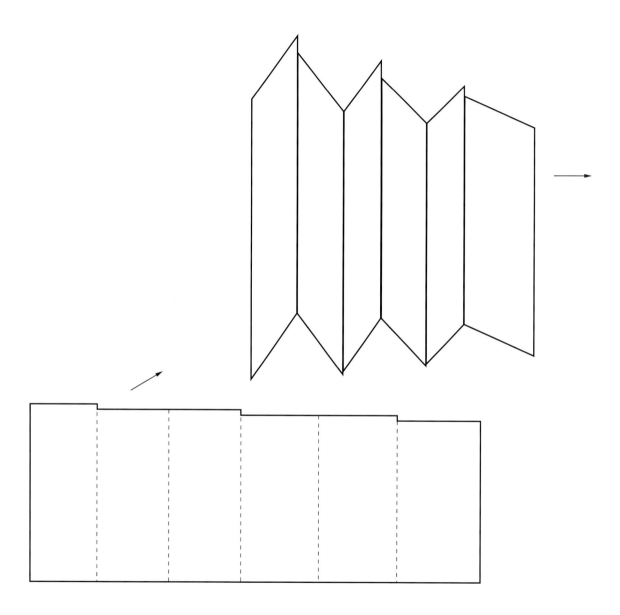

Tab folder

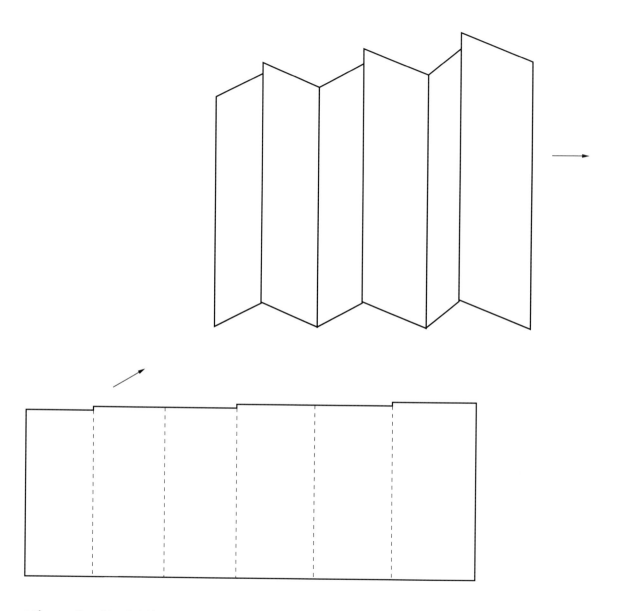

Two-side tab folder

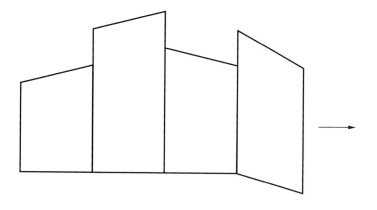

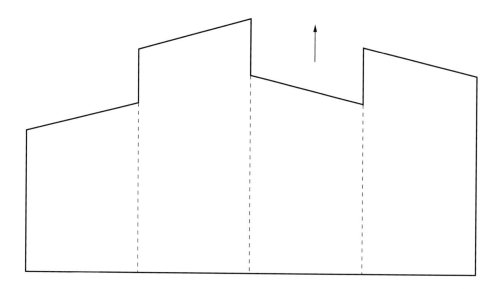

Incline tab variation

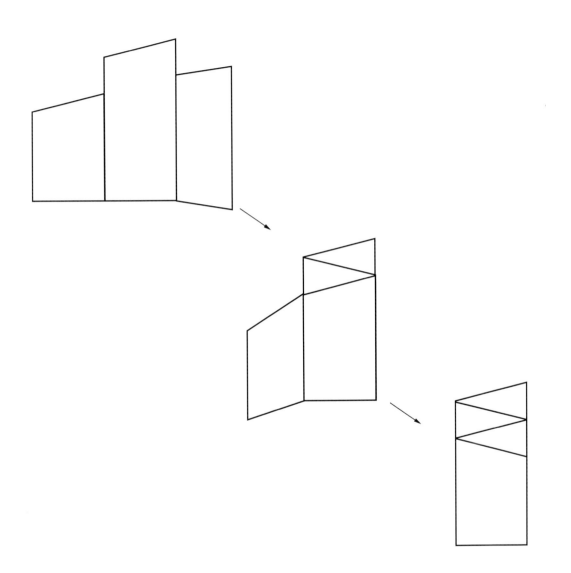

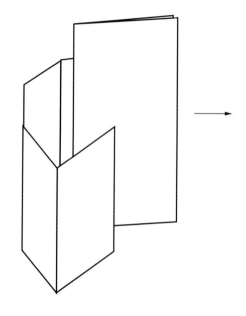

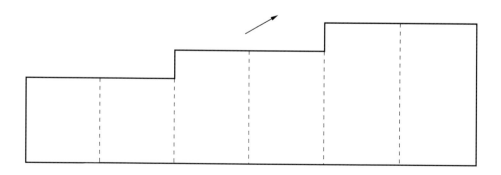

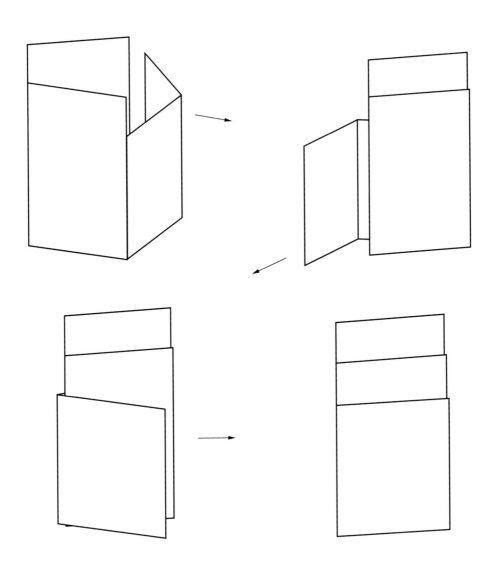

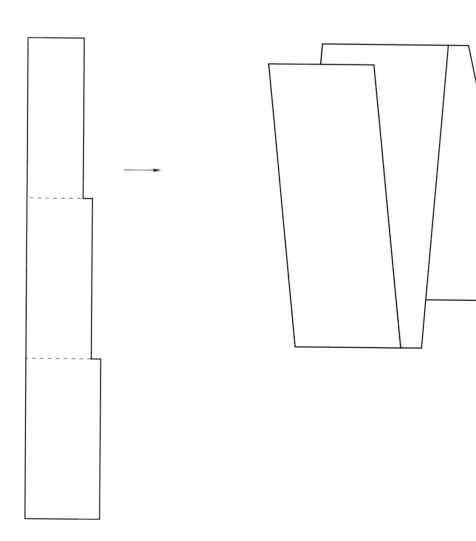

Tab folder

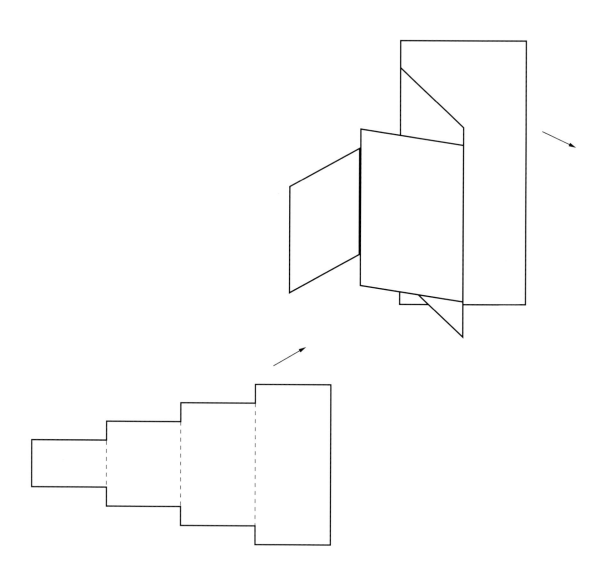

154 Staggered folder

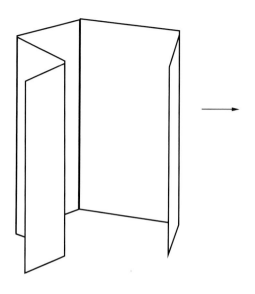

3 3/4	3 1/2	3 1/2	4	4

Front and back tab folder

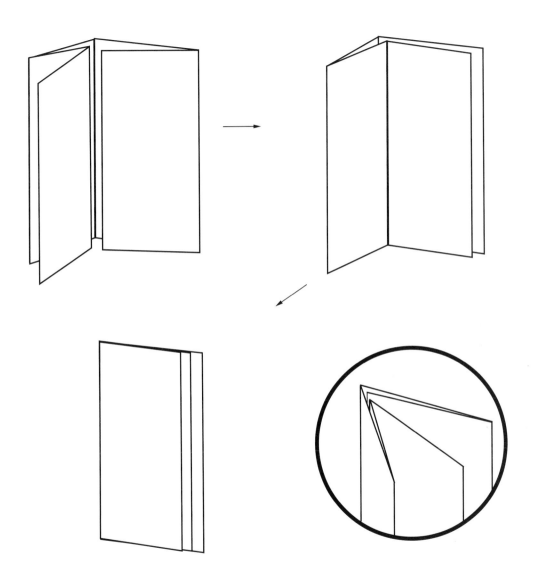

158 Inside tab folder

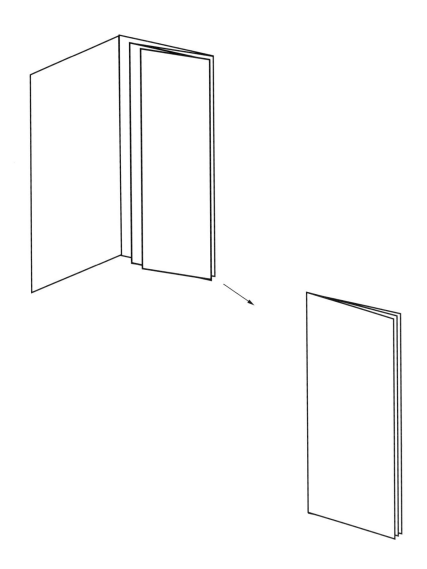

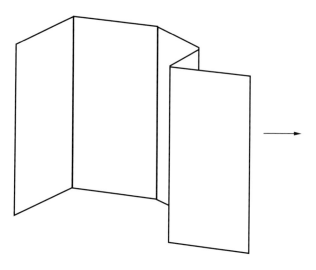

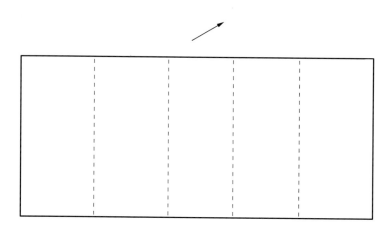

Inside tab folder variation

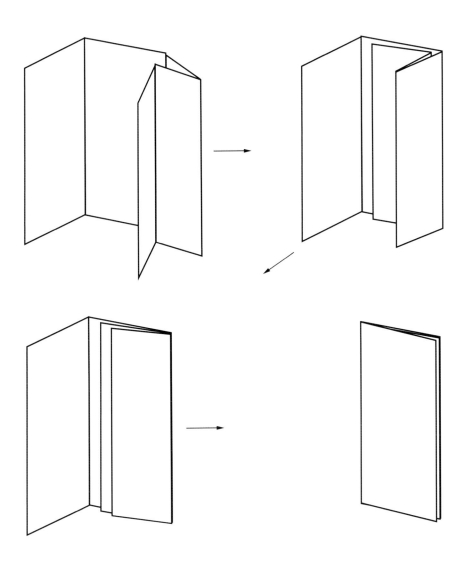

164 Double harmonica folder variation

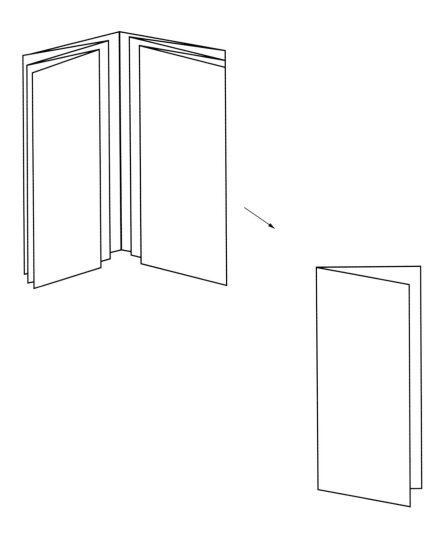

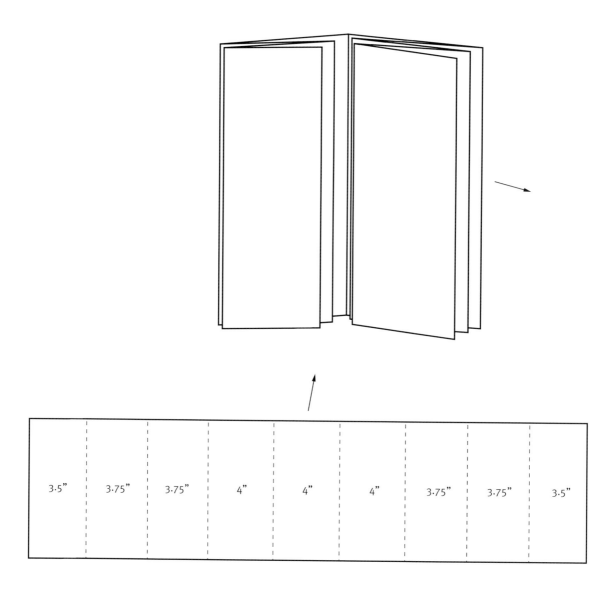

The image shows a double harmonica folder with measurements: 3.5", 3.75", 3.75", 4", 4", 4", 3.75", 3.75", 3.5"

Double harmonica folder variation

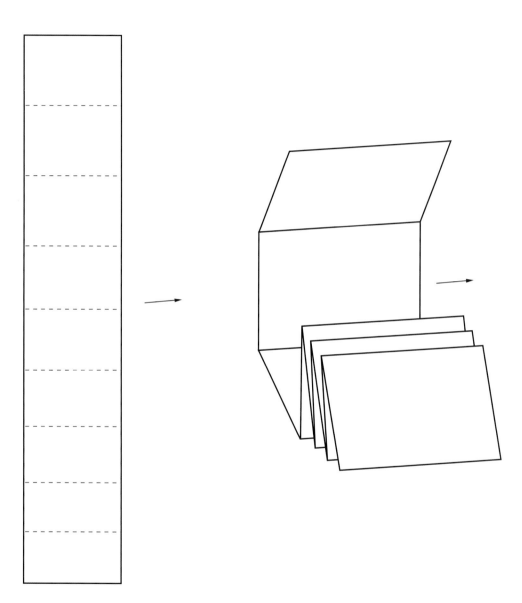

168 Tab harmonica folder with self cover

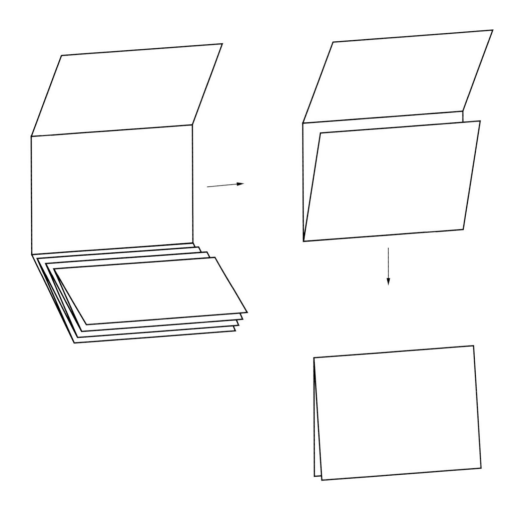

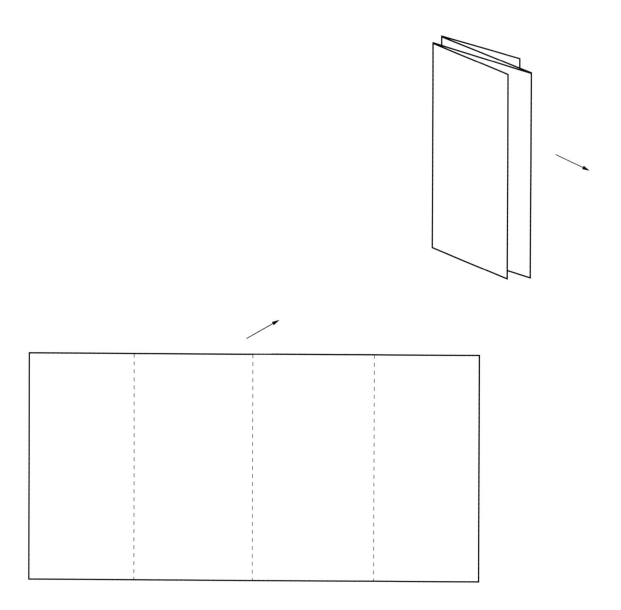

Somersault tabbed folder

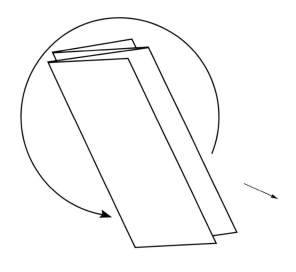
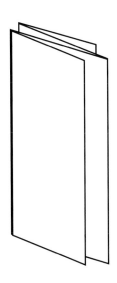

Somersault tabbed folder 171

Somersault tabbed folder variation

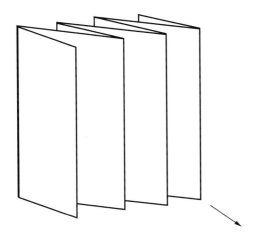

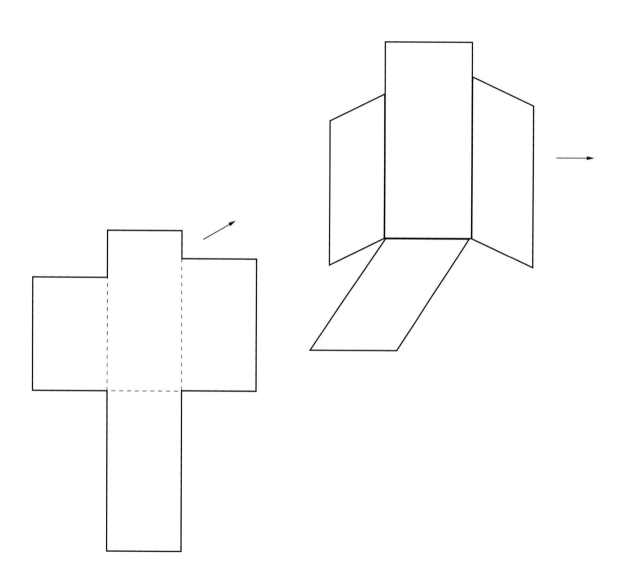

Tab variation

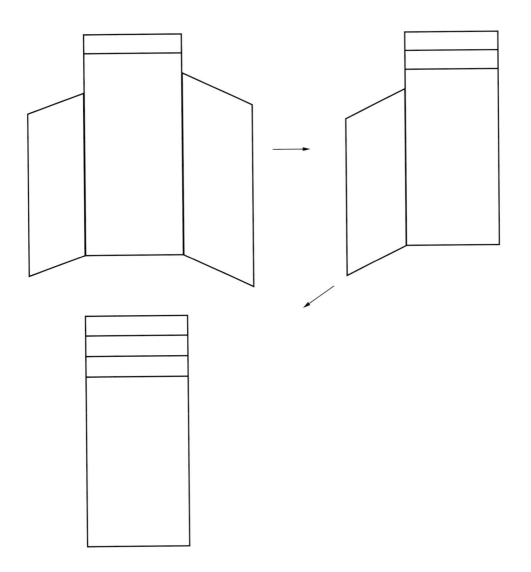

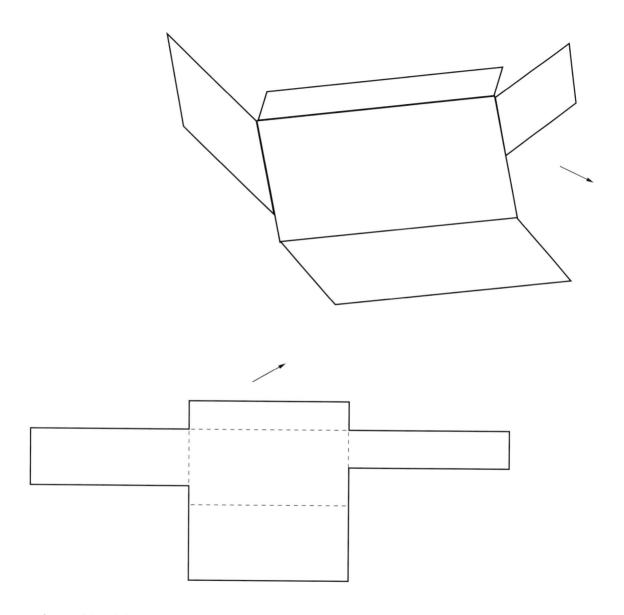

Tab variation

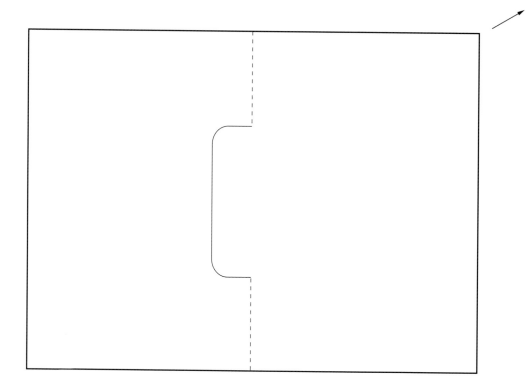

178 Pop-out tab

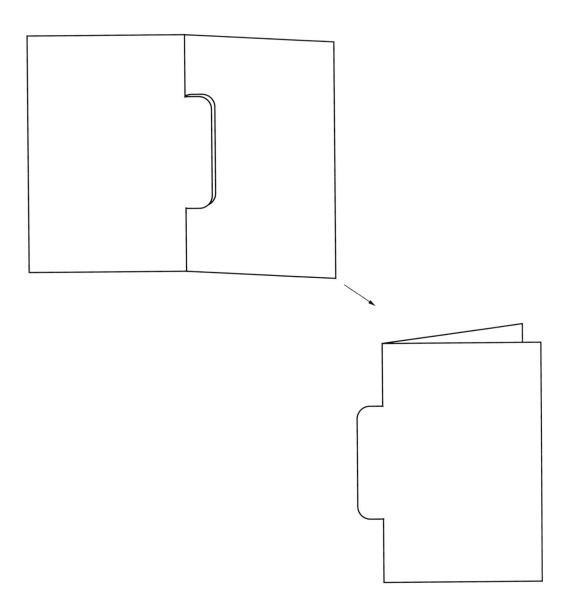

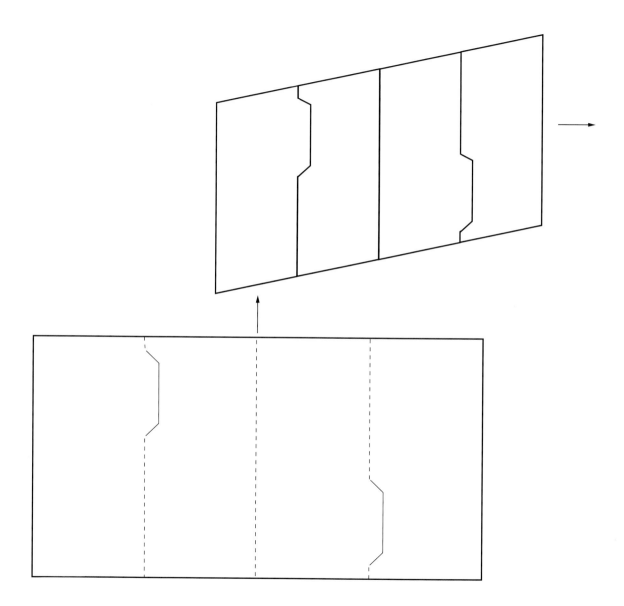

180 Pop-out tabs folder

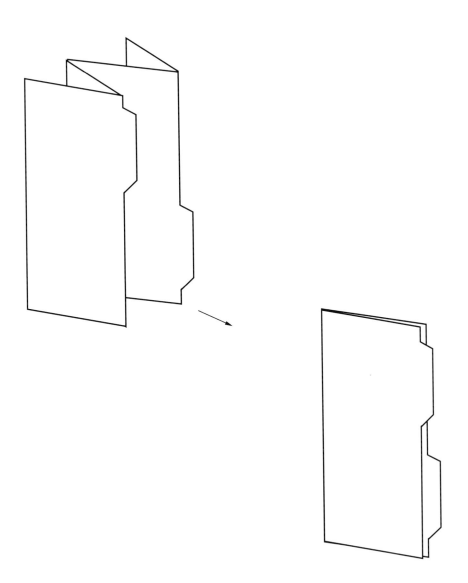

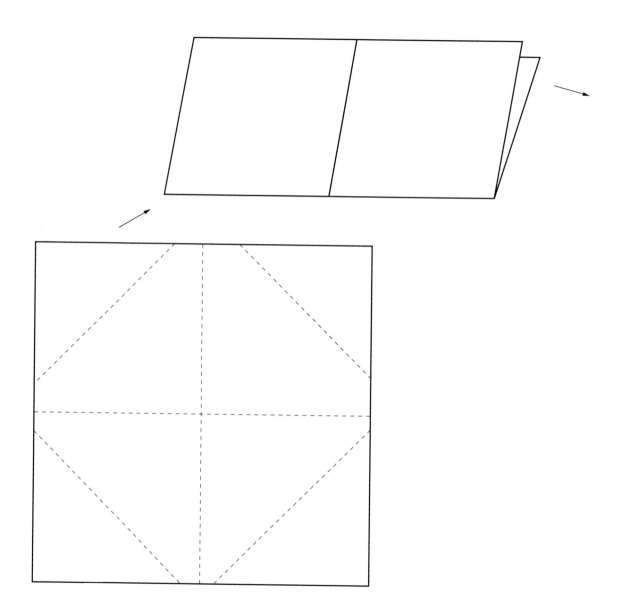

182 Napkin fold

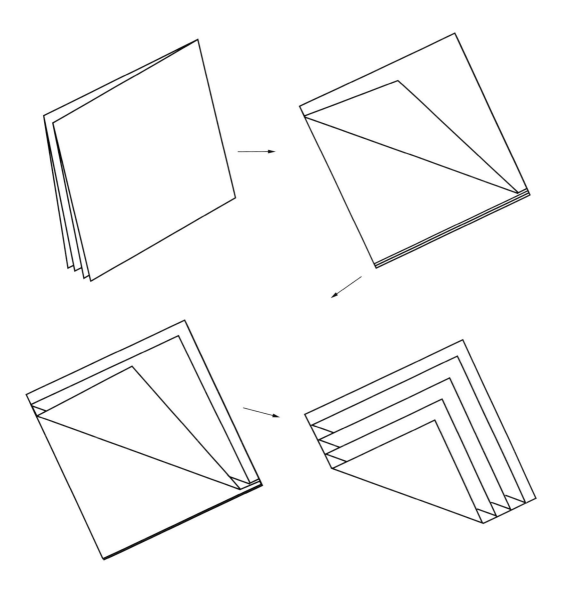

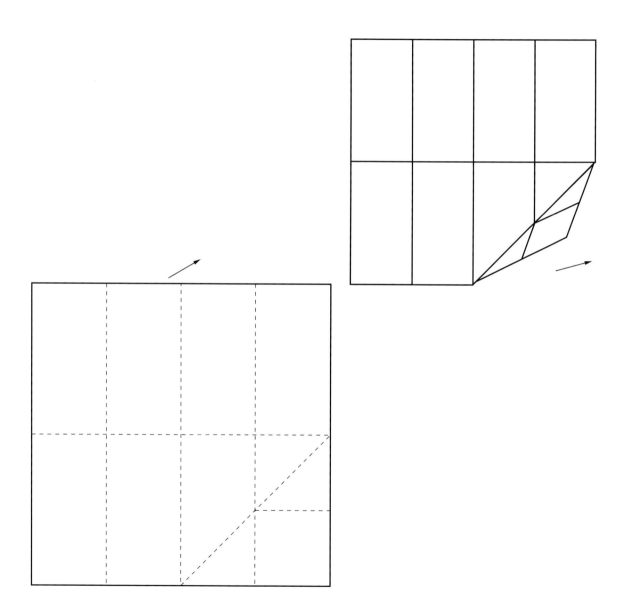

184 Napkin fold with pocket

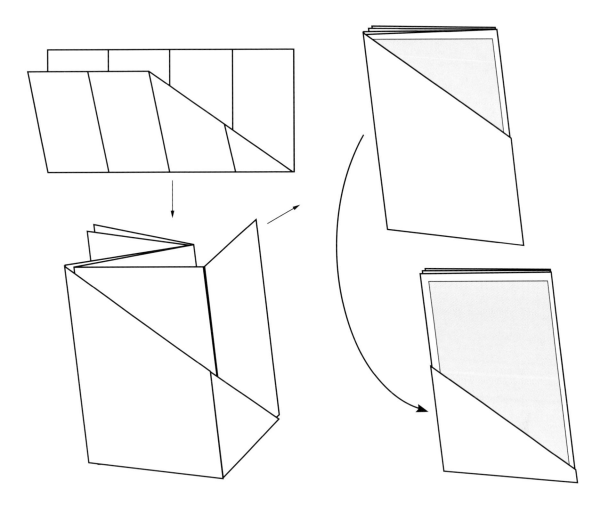

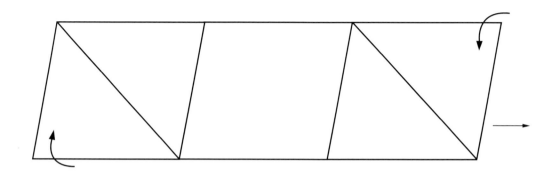

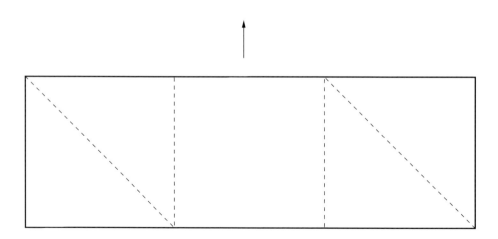

Long triangle folder

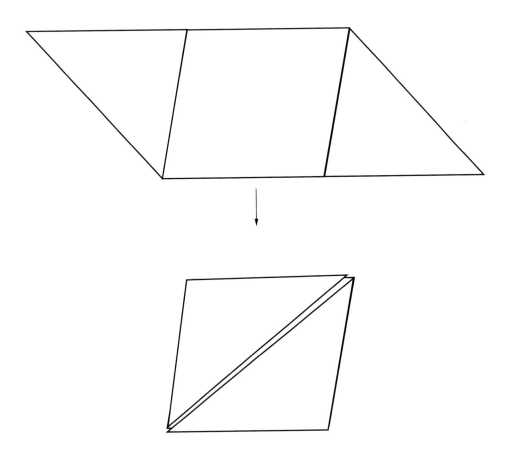

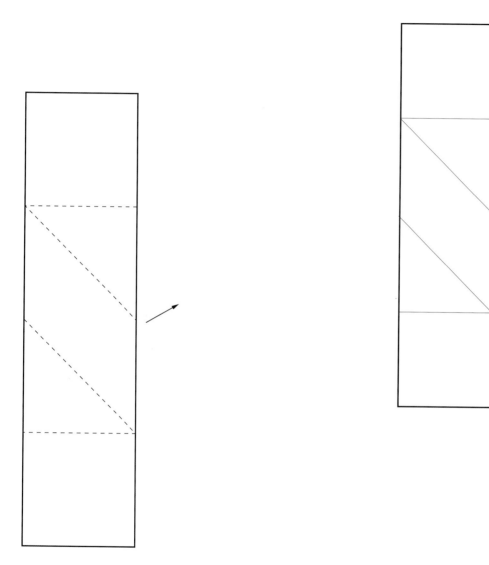

Folder

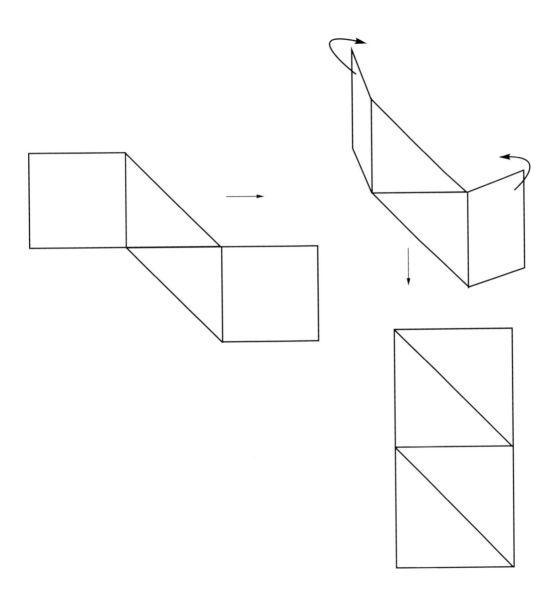

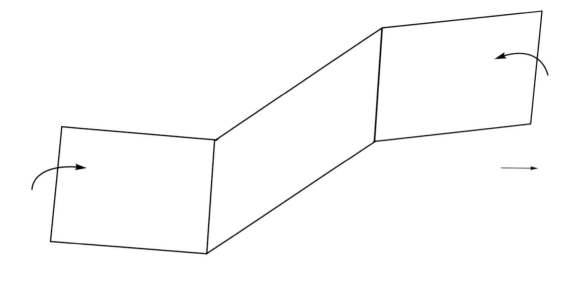

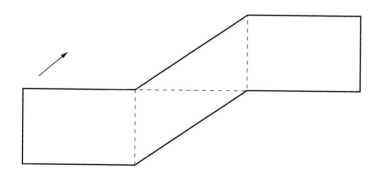

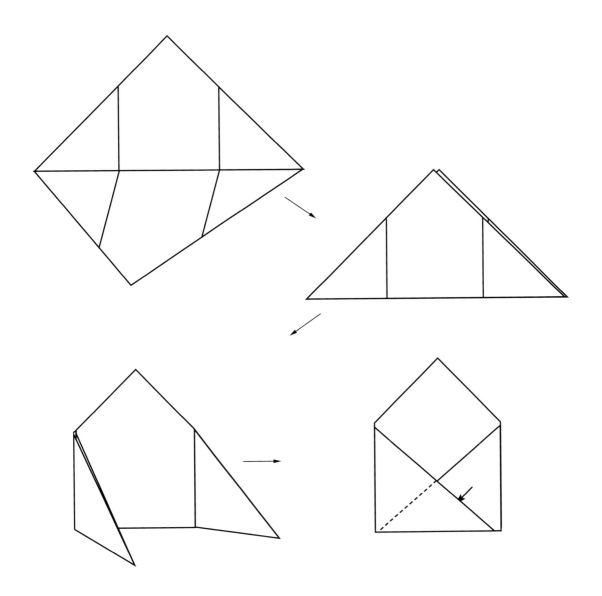

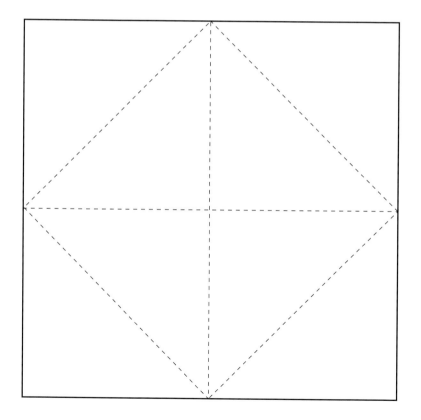

194 Triangle fold

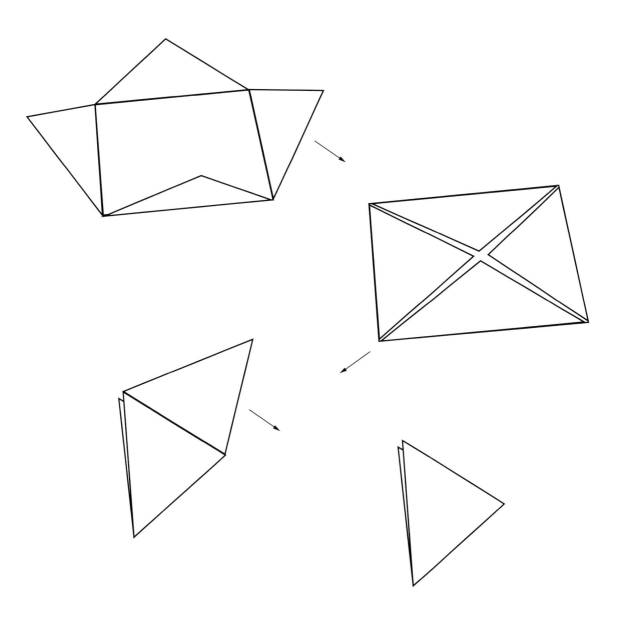

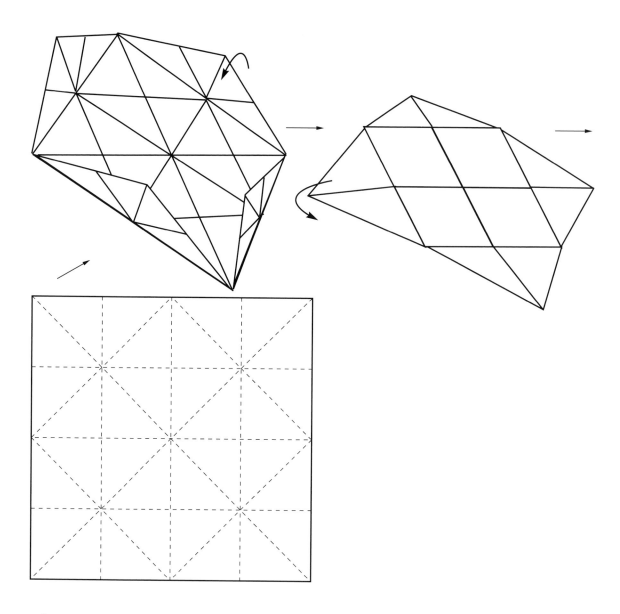

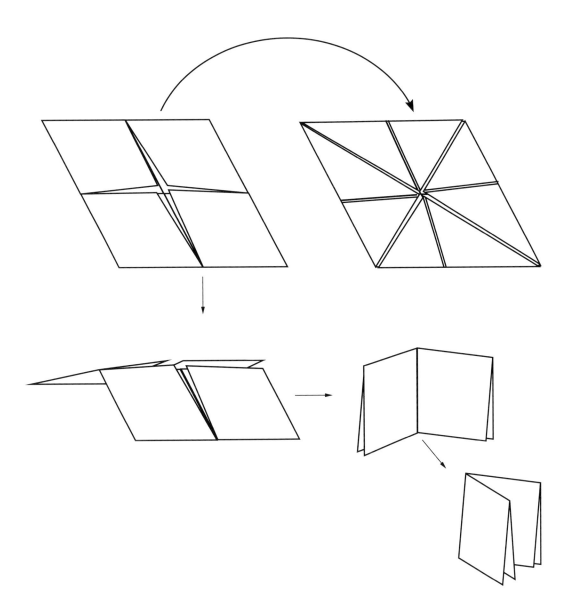

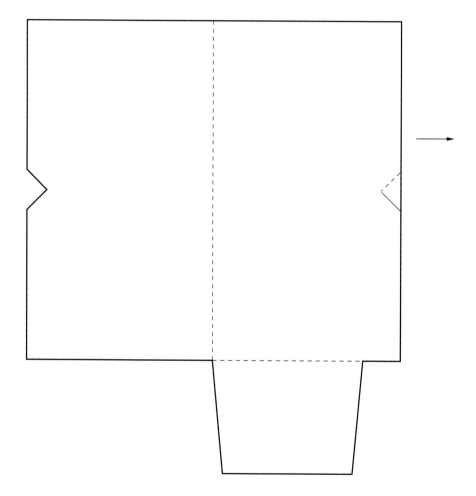

198 Folder with lock

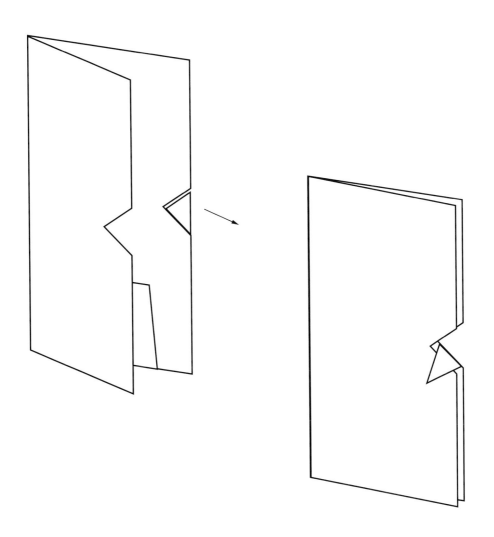

200 Folder with lock

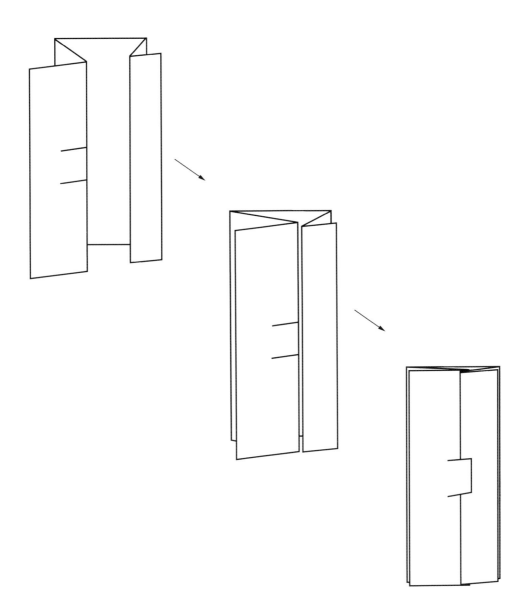

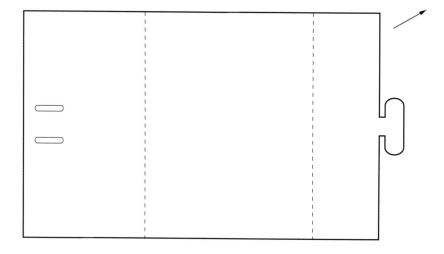

202 Folder with lock

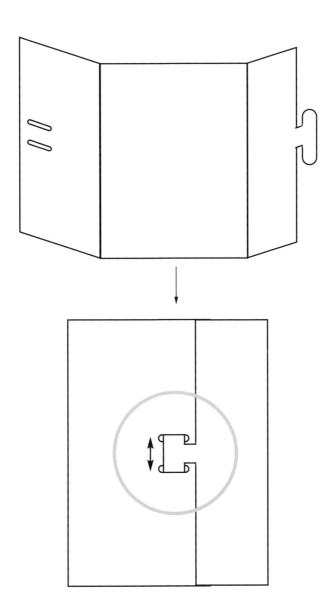

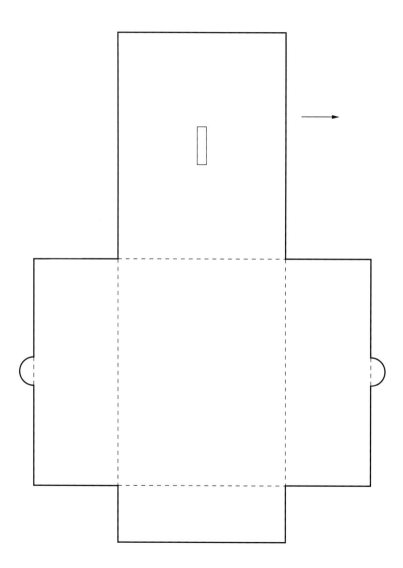

Folder with lock

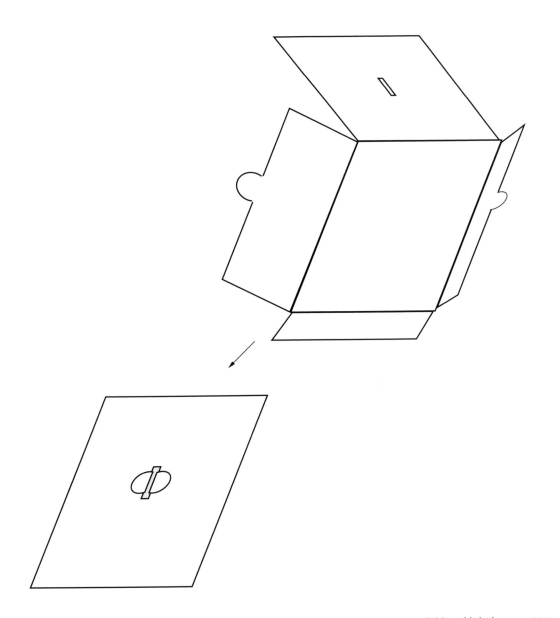

206 Folder with lock

208 Locking cover folder

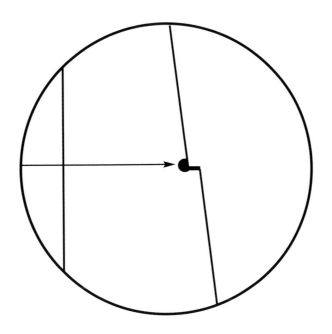

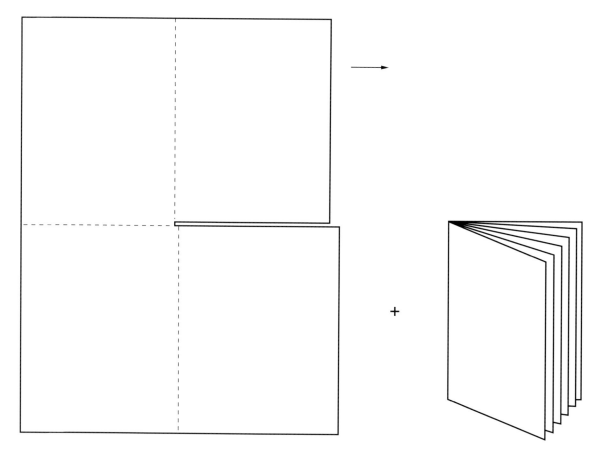

Fold-out cover

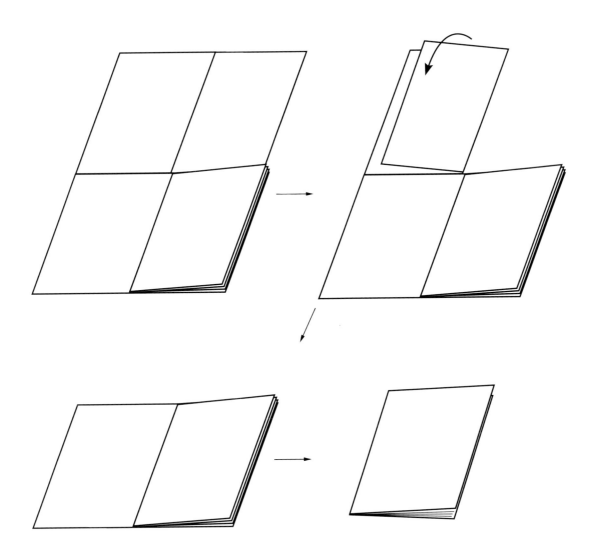

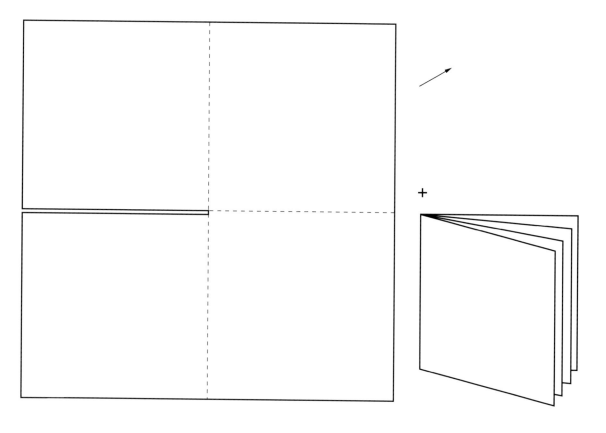

Fold-out booklet

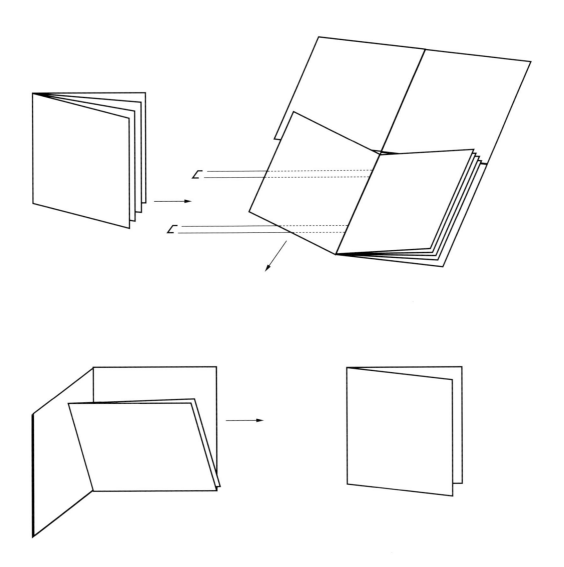

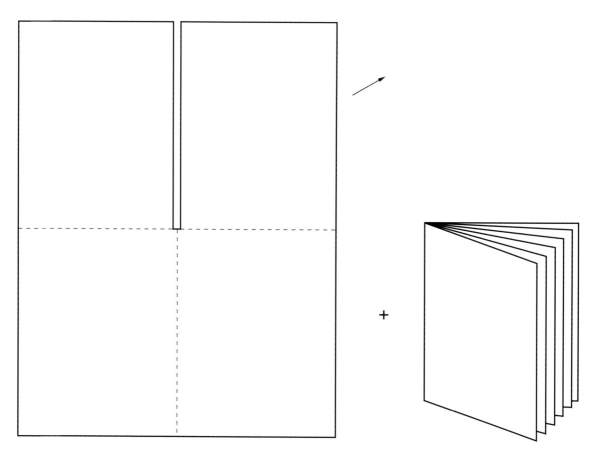

214 Booklet with fold-out display panels

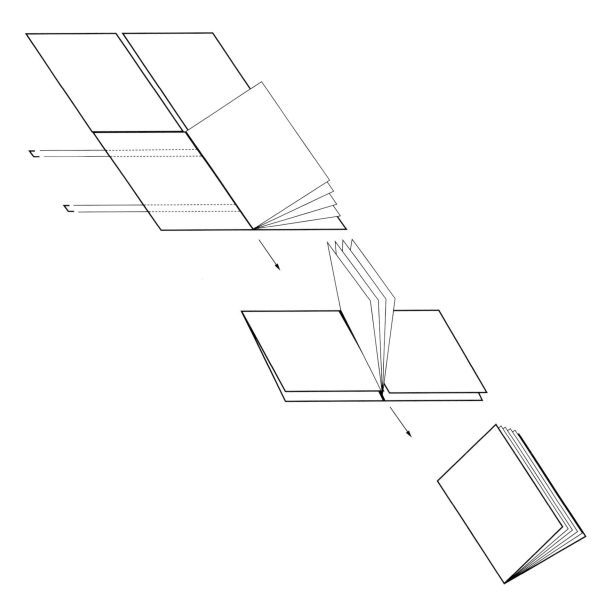

Booklet with fold-out display panels 215

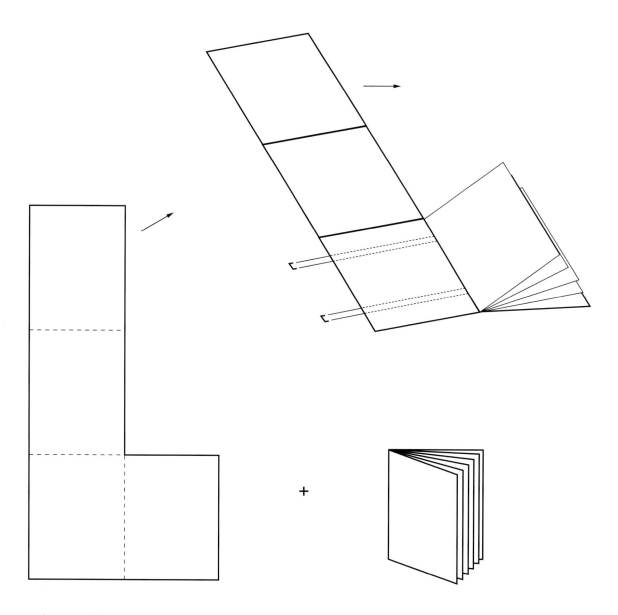

+

Folder cover on booklet

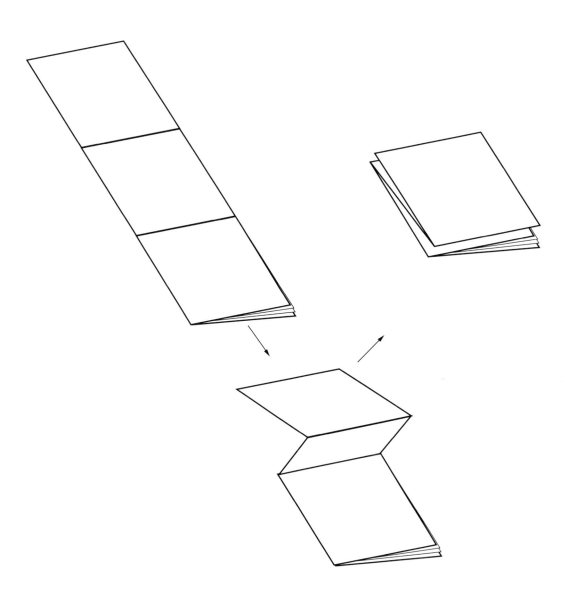

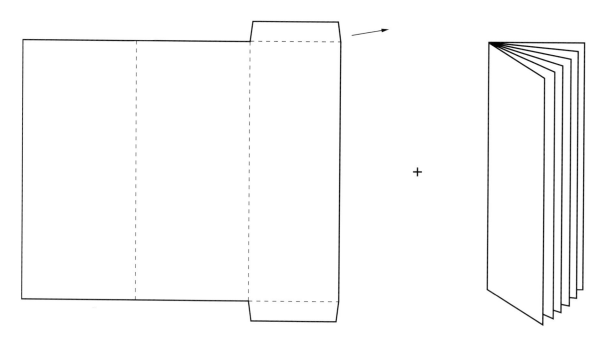

Booklet pocket

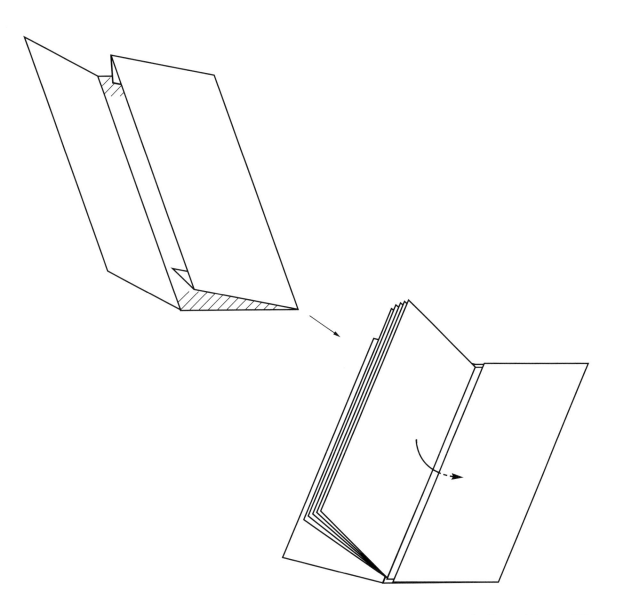

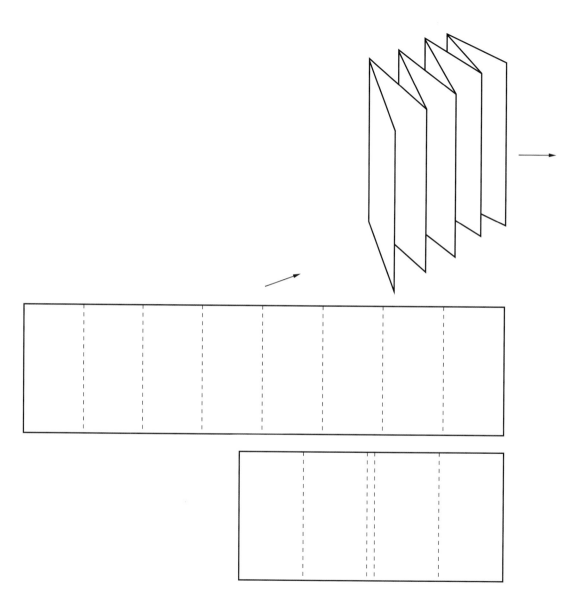

Harmonica booklet

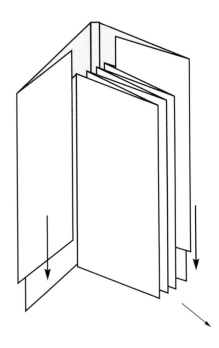

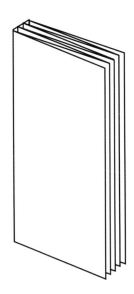

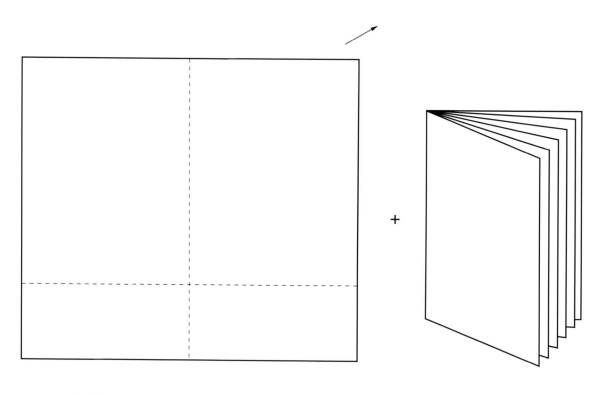

Booklet with cover pockets

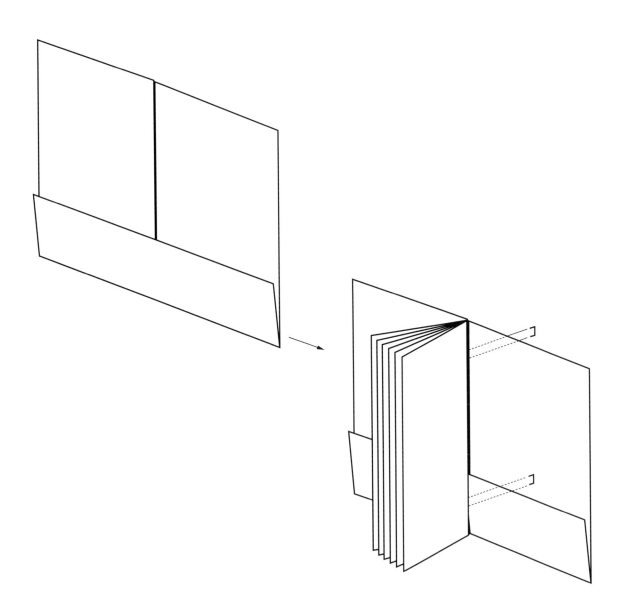

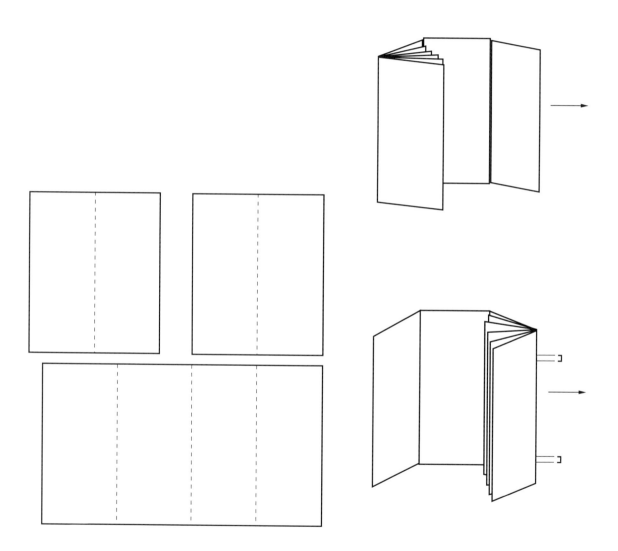

Booklet folder

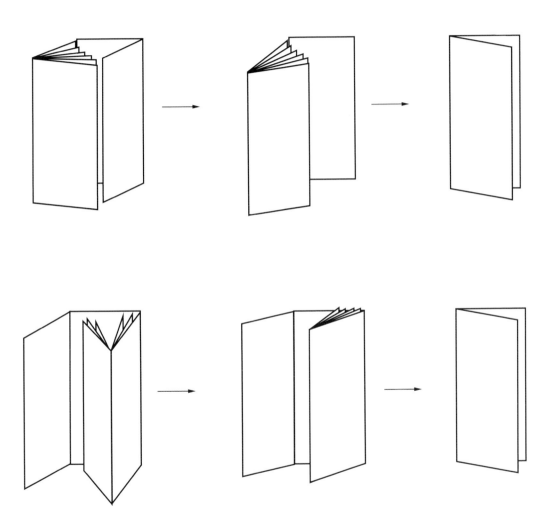

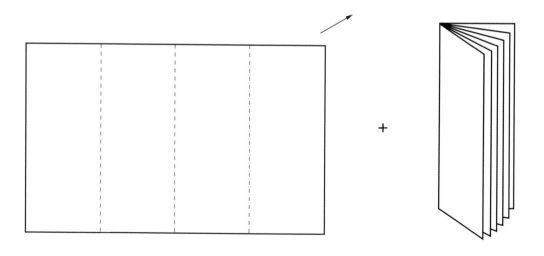

Booklet with hidden binding

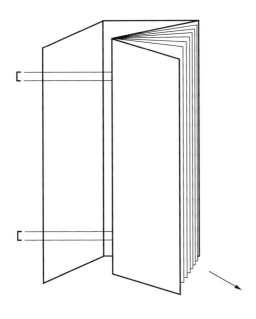

Booklet with hidden binding 227

Tabbed booklet

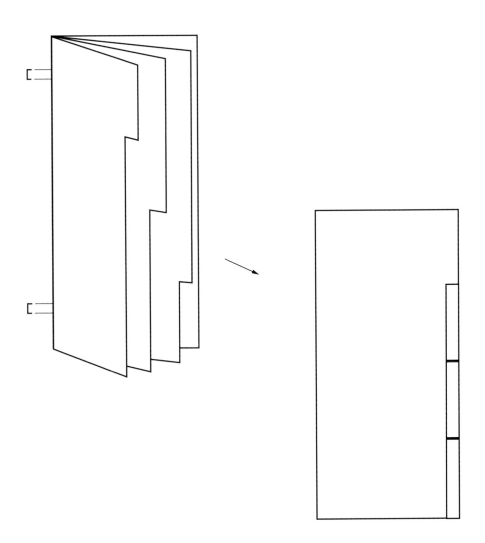

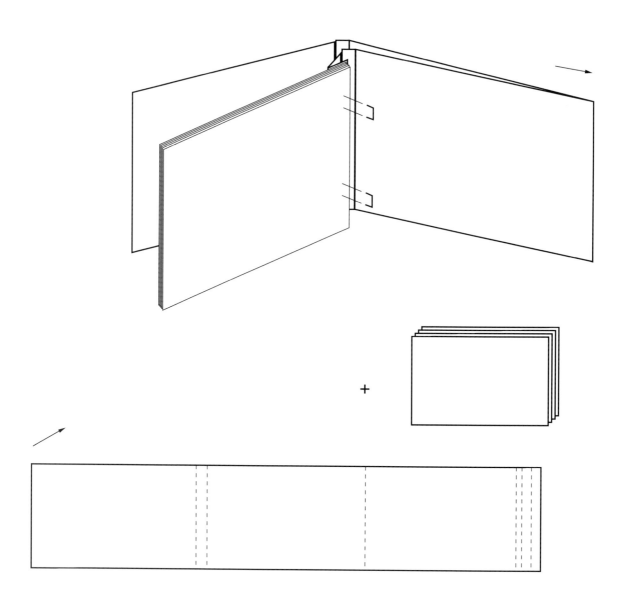

234 Booklet with concealed binding

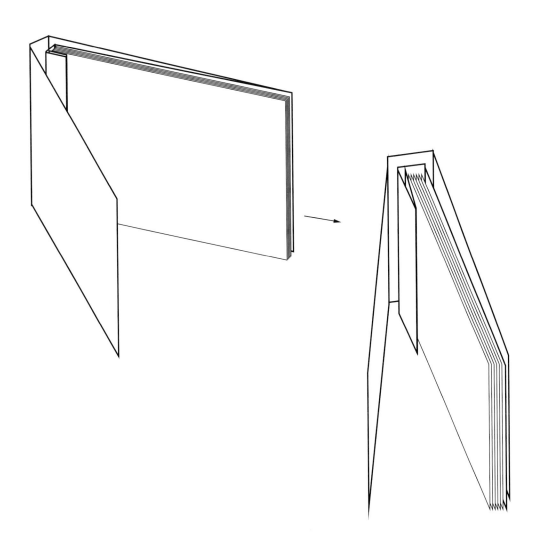

Booklet with concealed binding 235

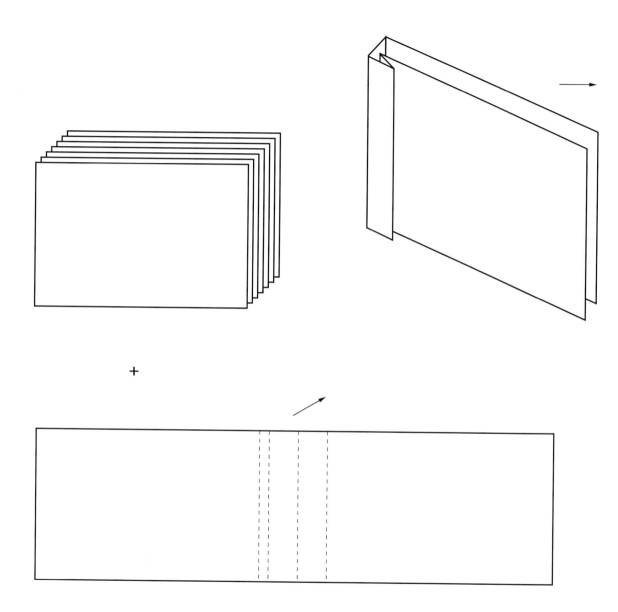

236 Booklet with concealed binding

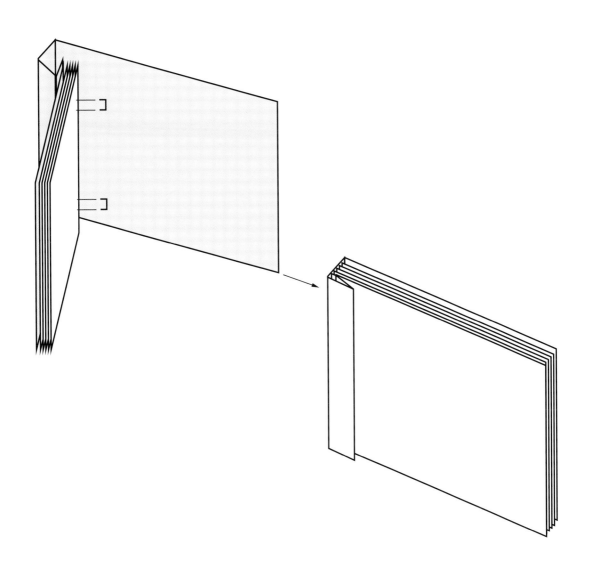

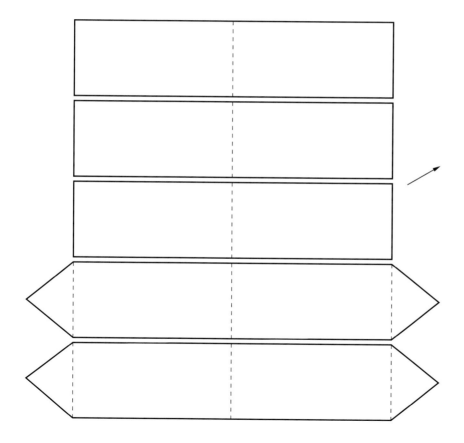

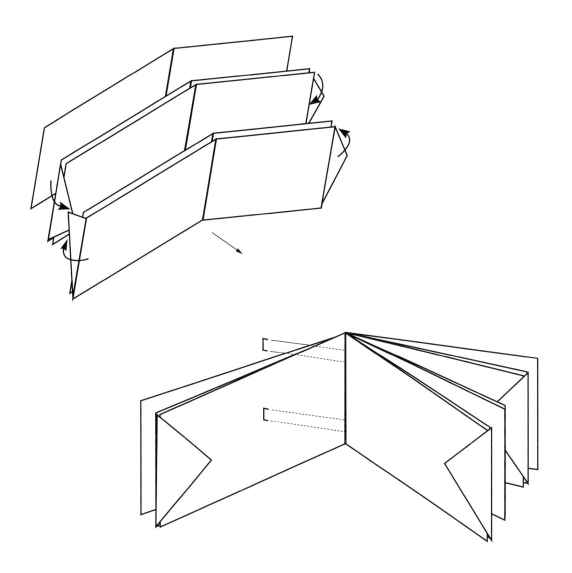

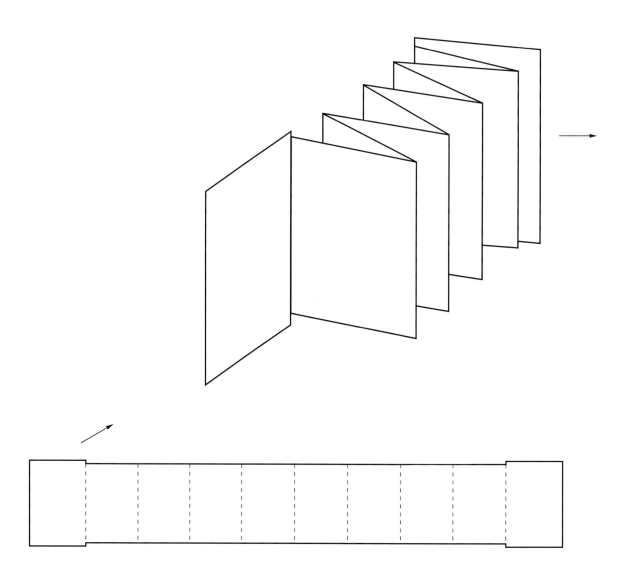

240　　　Self-cover harmonica booklet

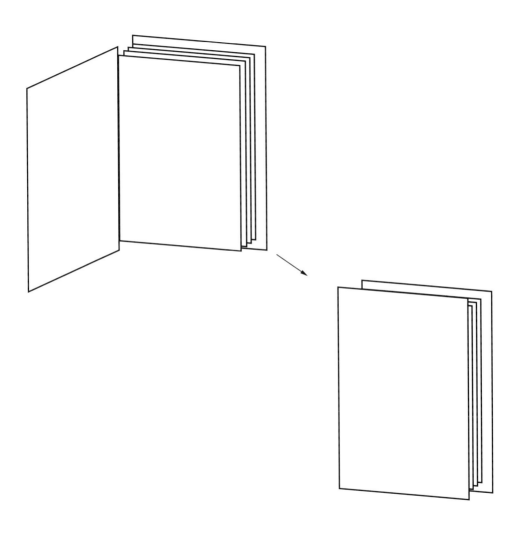

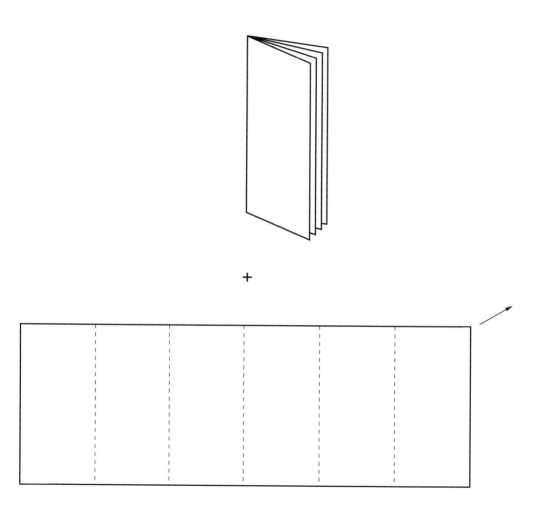

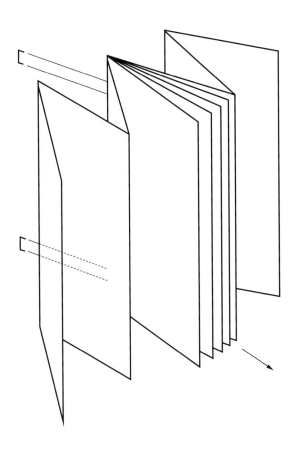

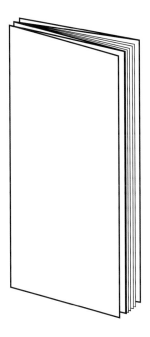

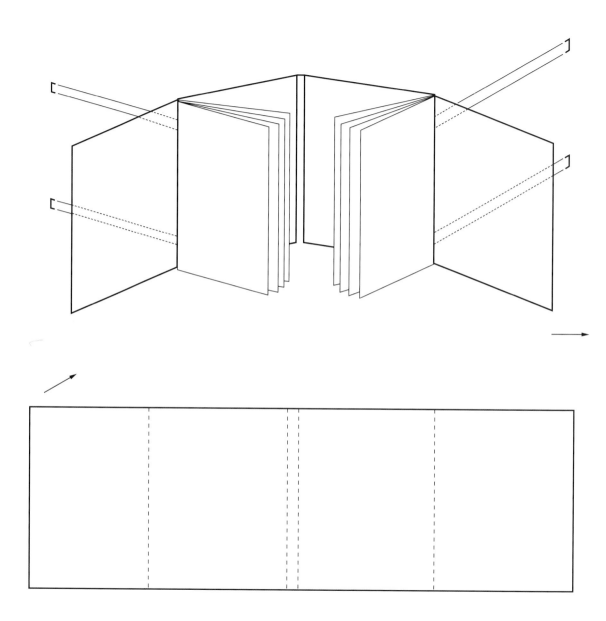

244 Double booklet folder

Double booklet folder 245

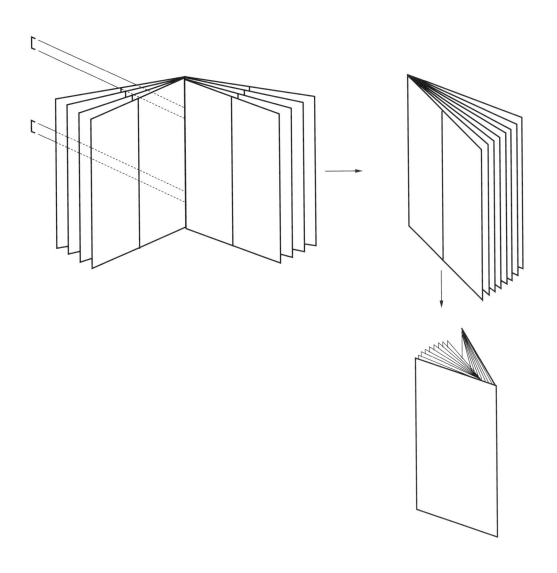

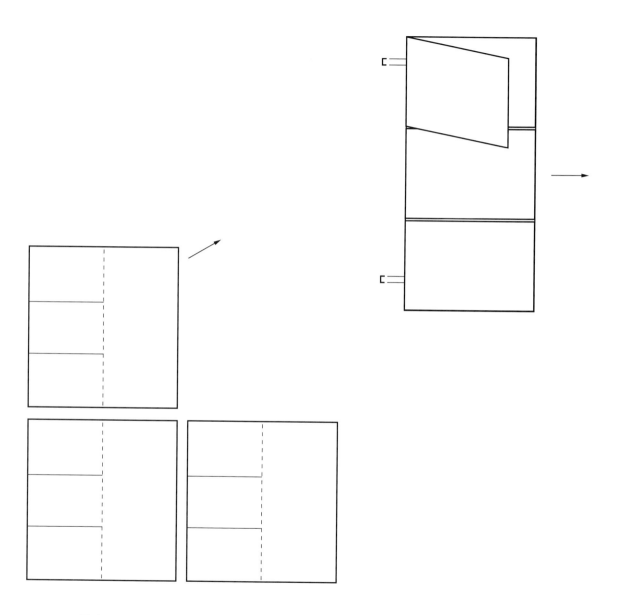

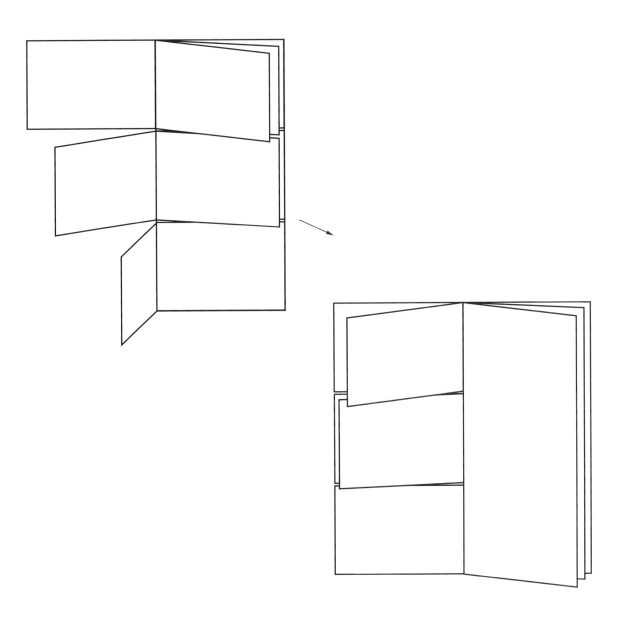

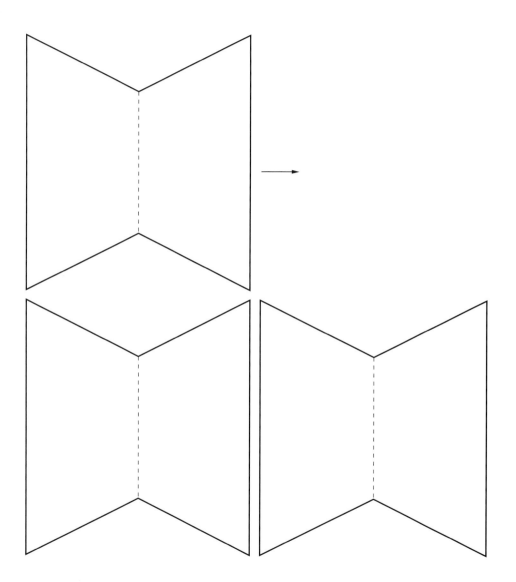

Rhomboid booklet

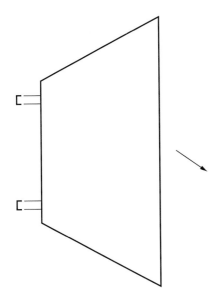

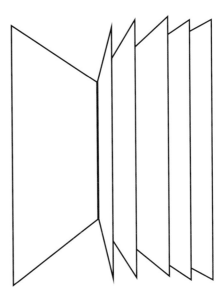

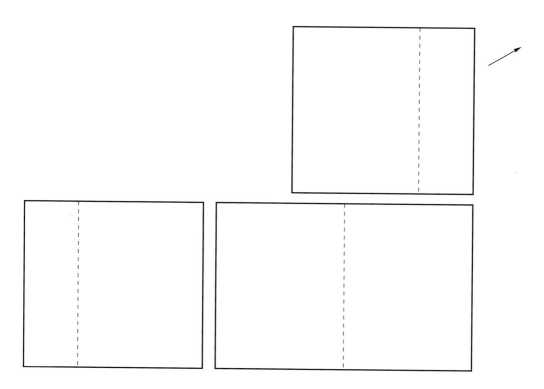

Long/short booklet

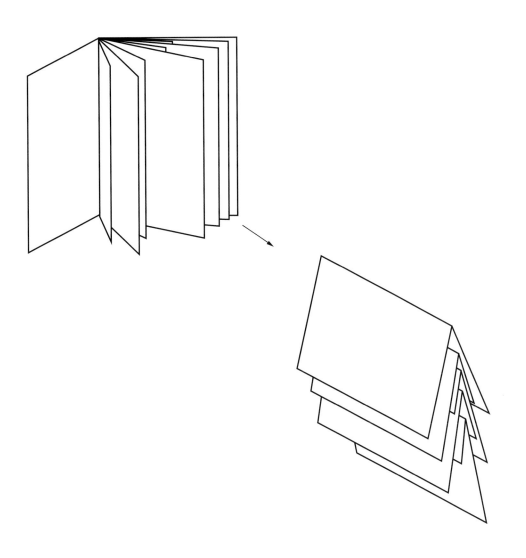

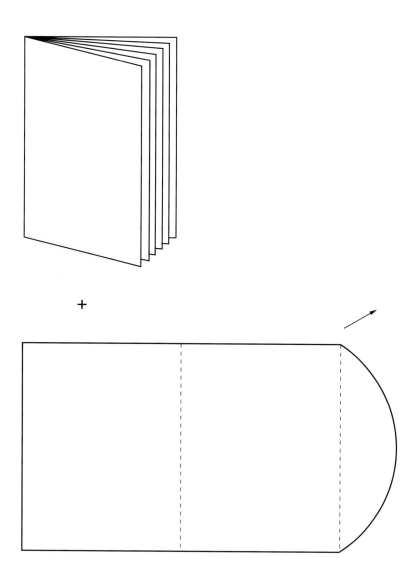

Booklet with lock

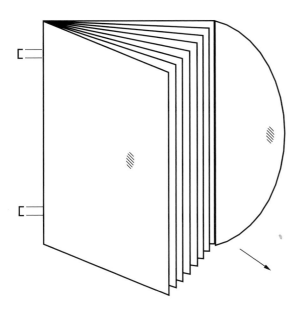

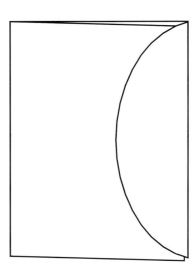

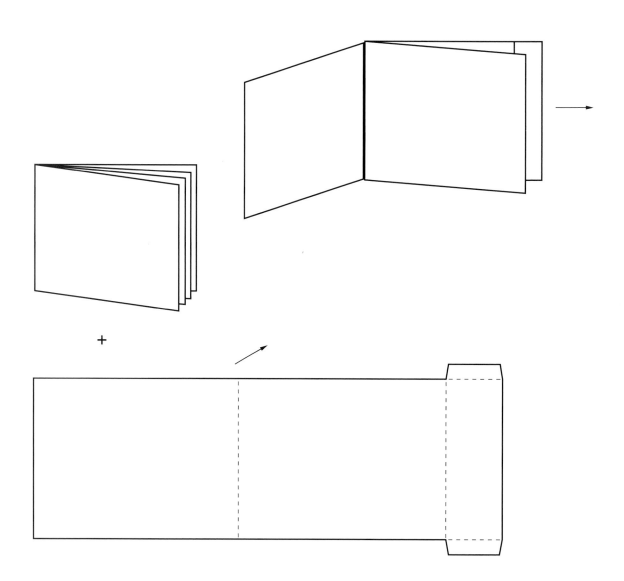

Booklet with page pocket

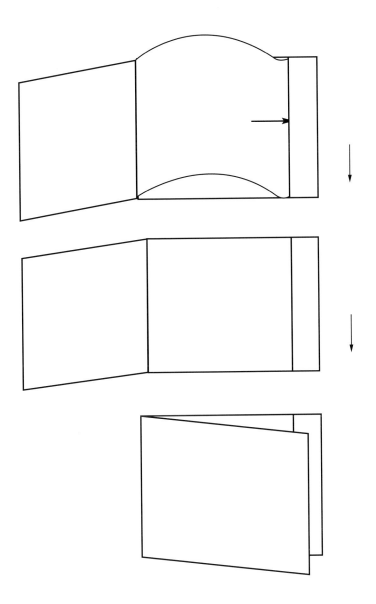

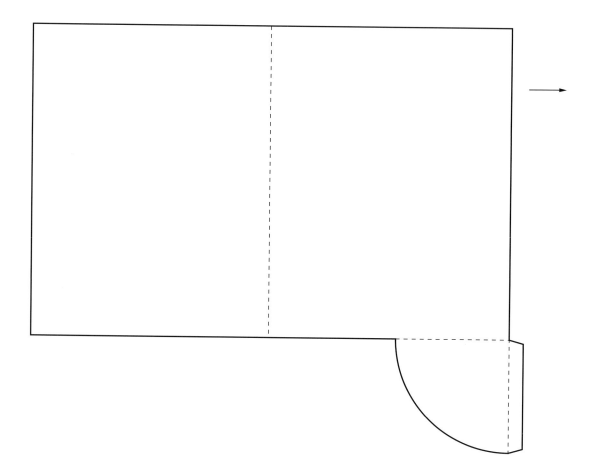

260 Booklet with corner pocket

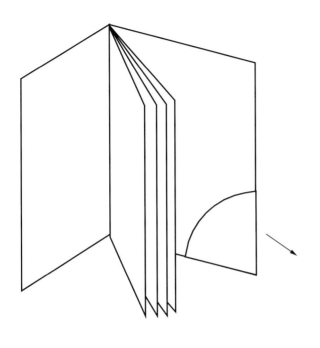

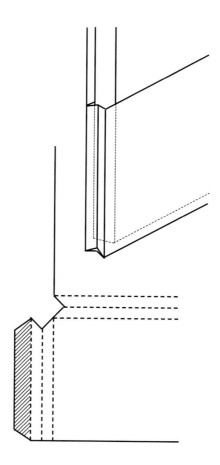

Pocket systems

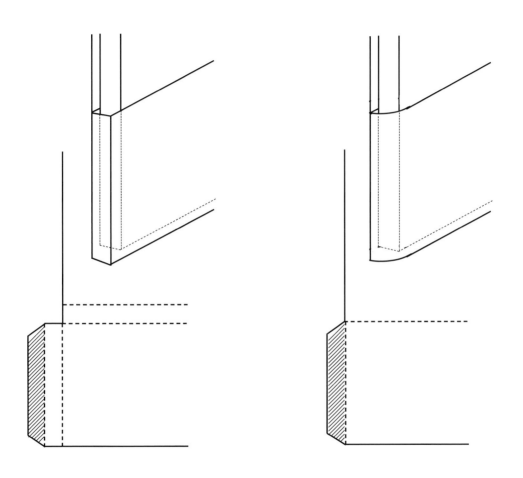

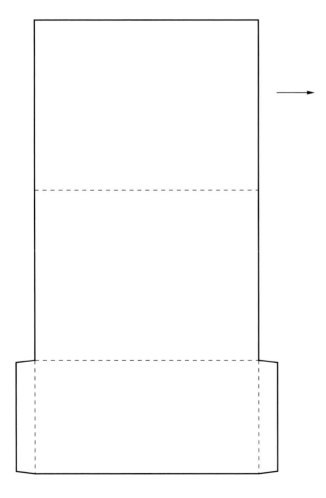

Horizontal pocket folder

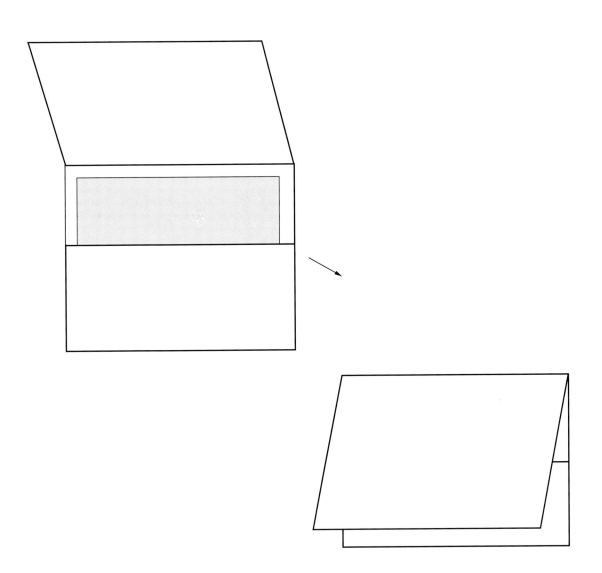

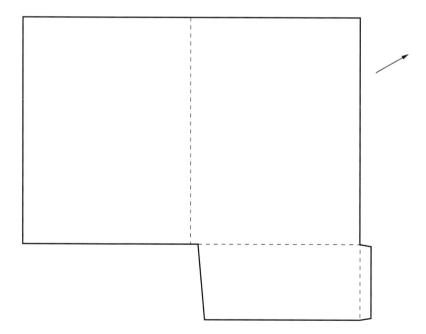

266 Standard pocket folder

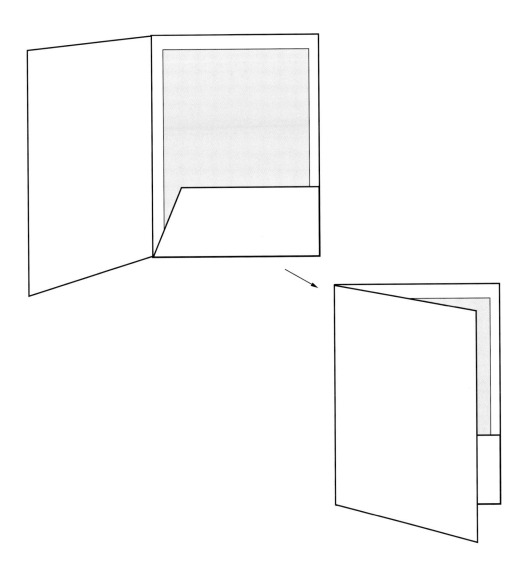

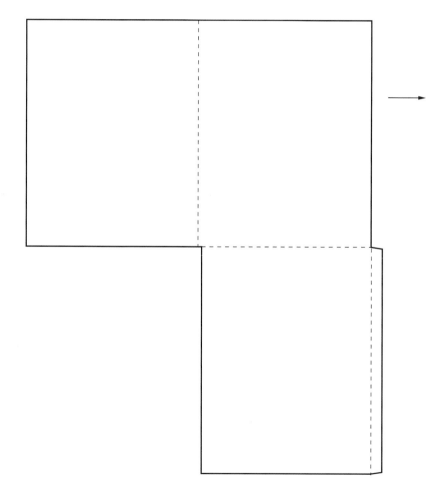

268 Full-panel pocket

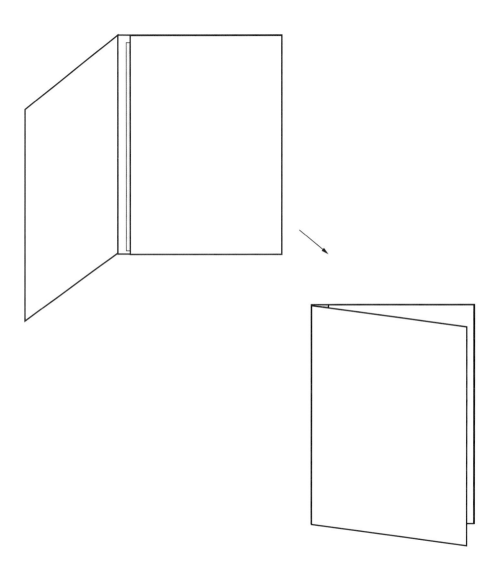

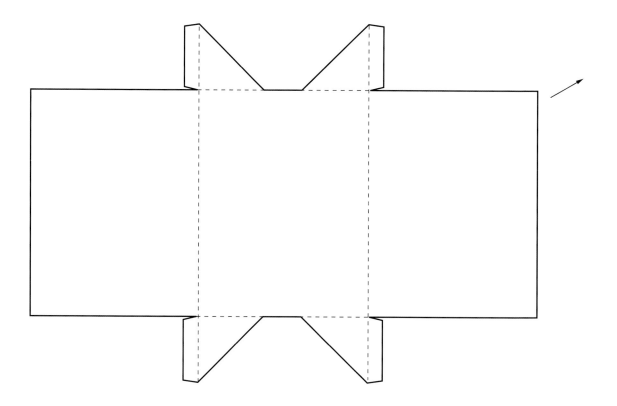

Corner pocket folder

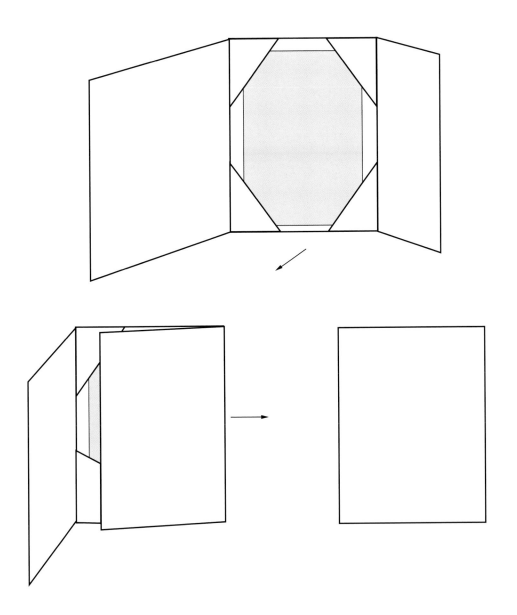

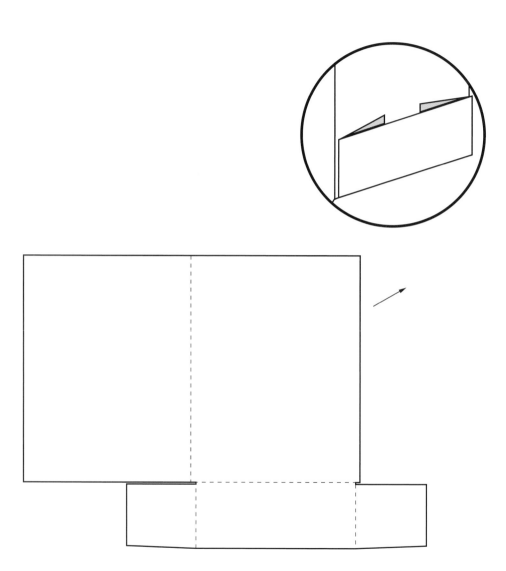

Embracing pocket folder

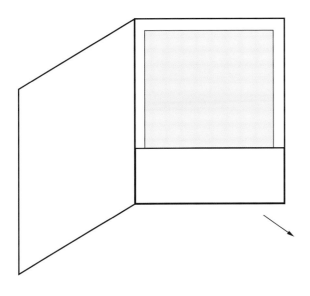

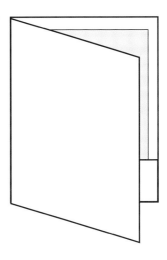

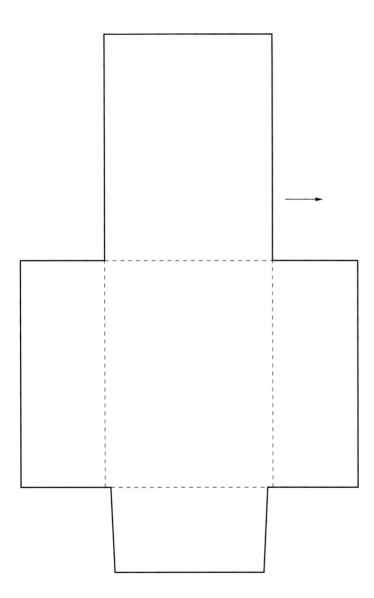

274 Flip top pocket folder

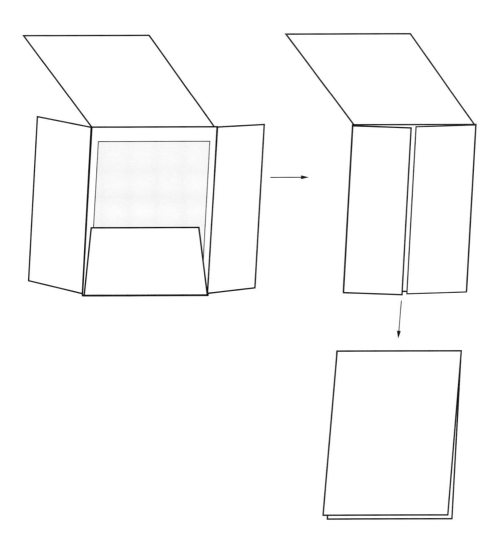

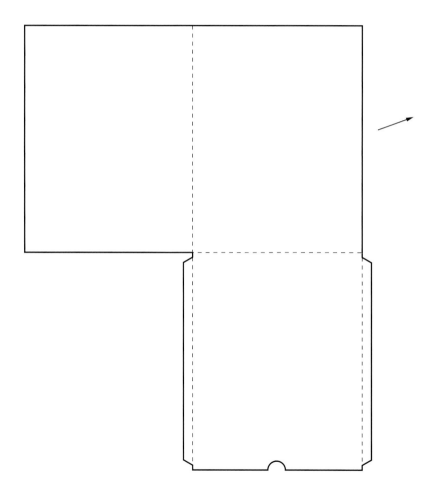

276　　Back pocket folder

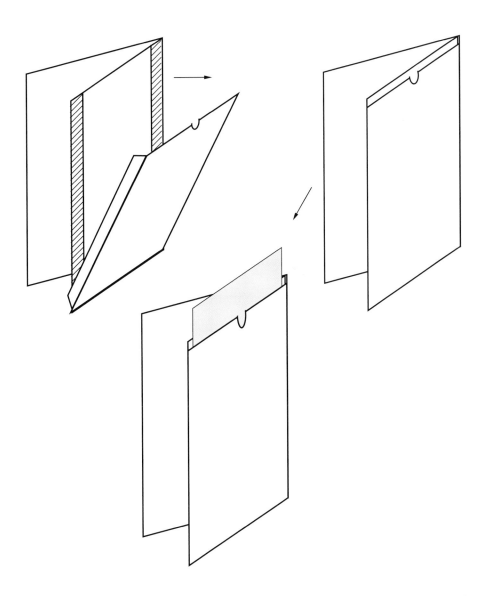

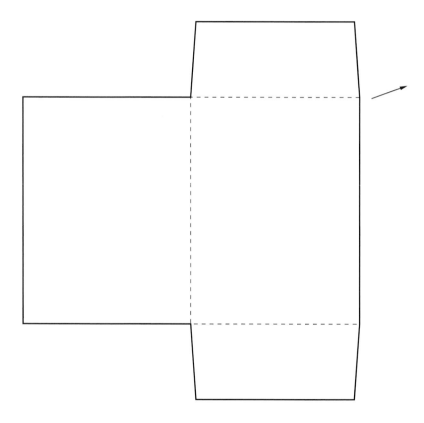

Top and bottom pocket

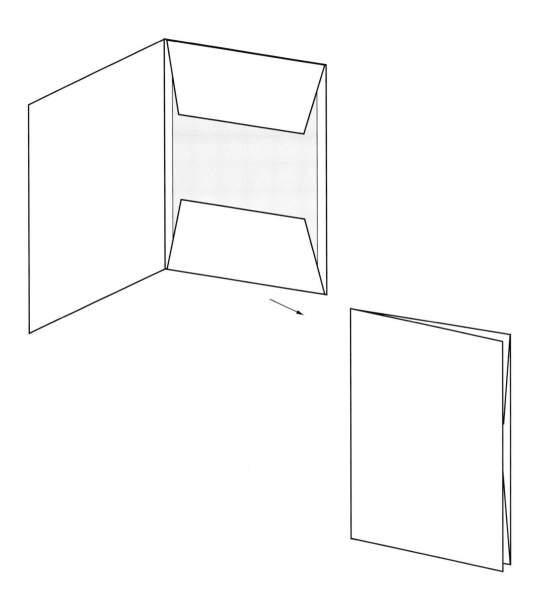

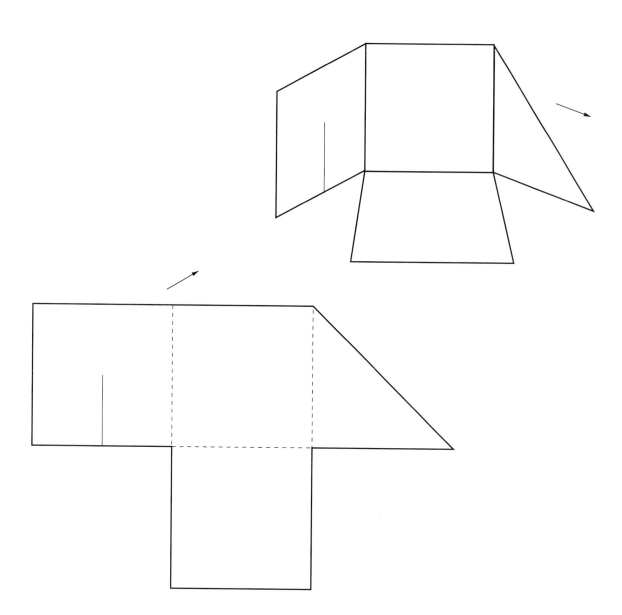

Slotted-tab pocket folder

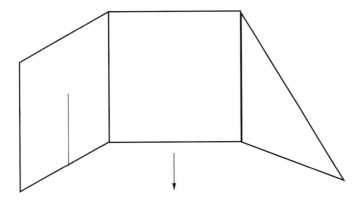

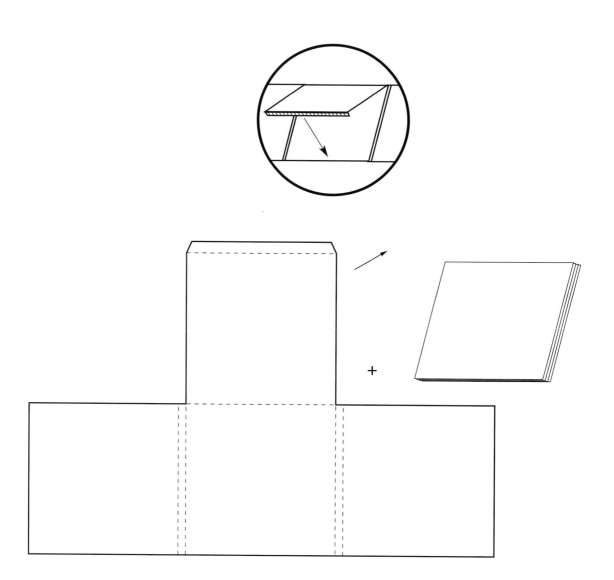

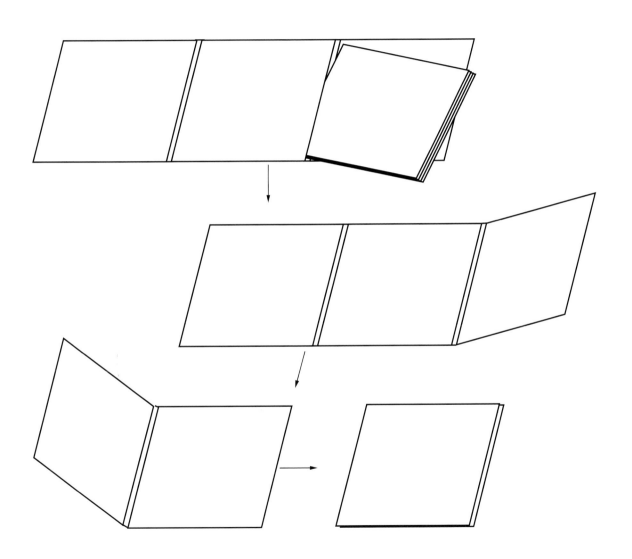

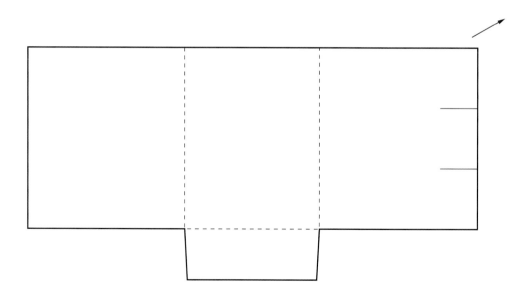

284 Folder with locking device

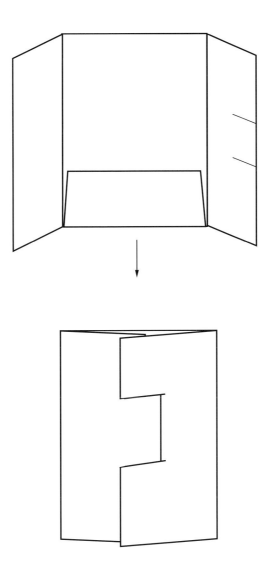

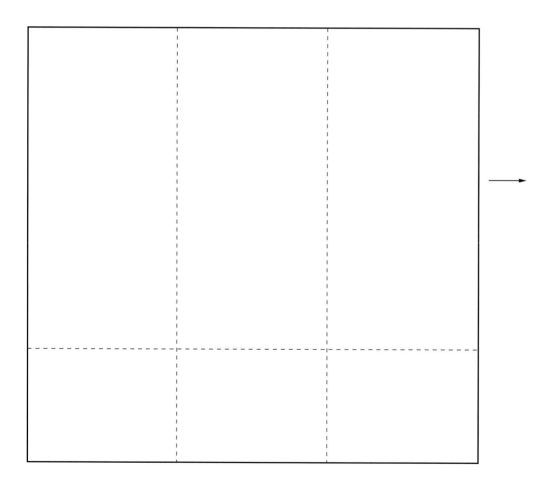

286　　Folder holder

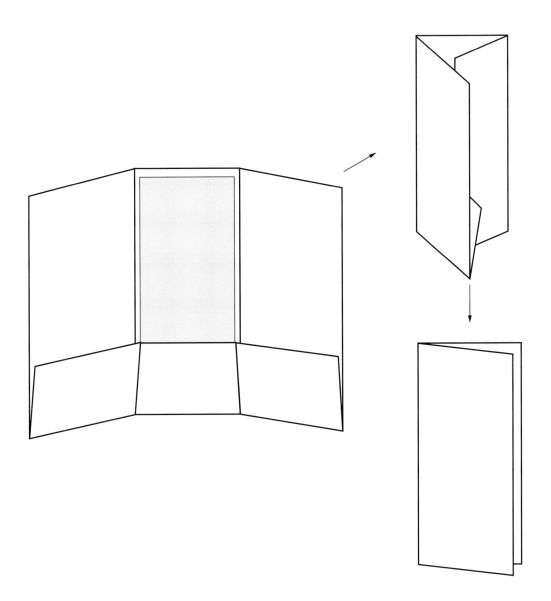

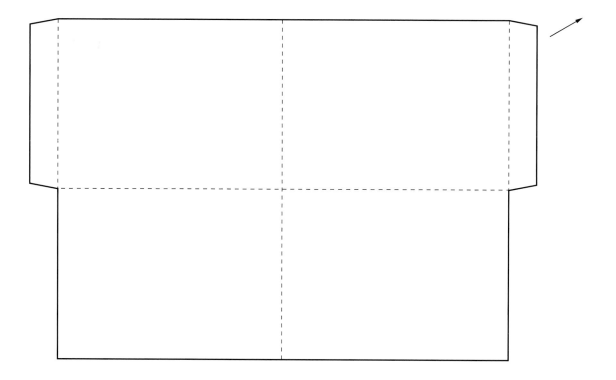

288 Bill fold

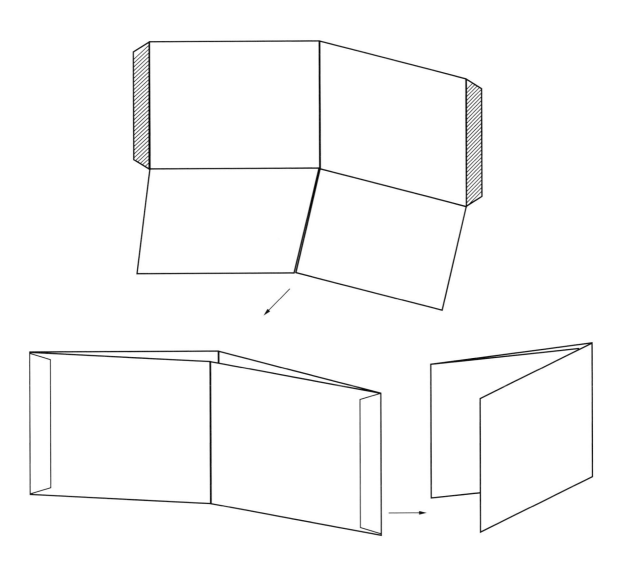

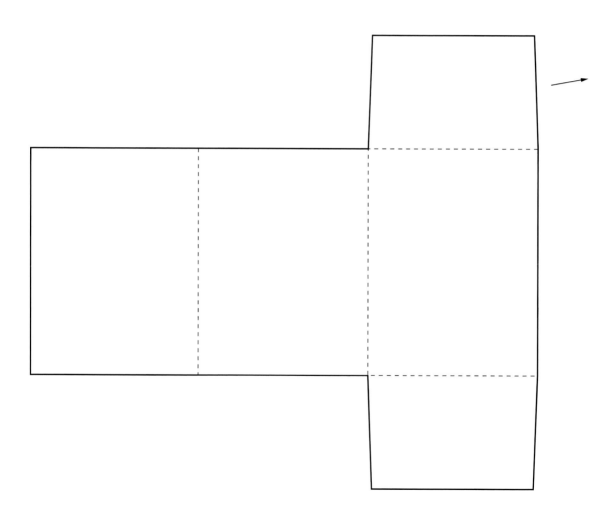

Pocket folder

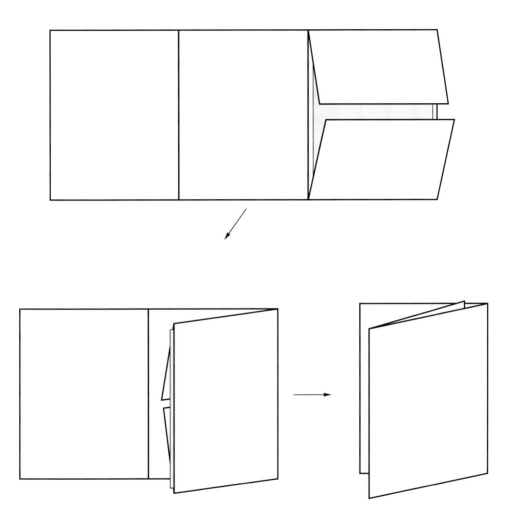

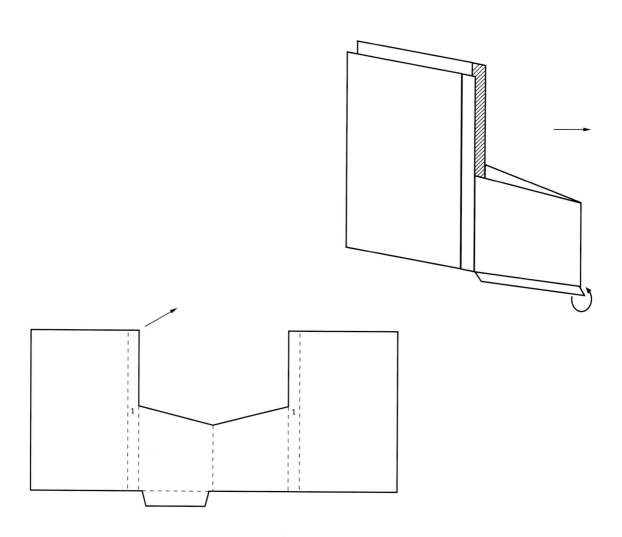

Free standing pocket

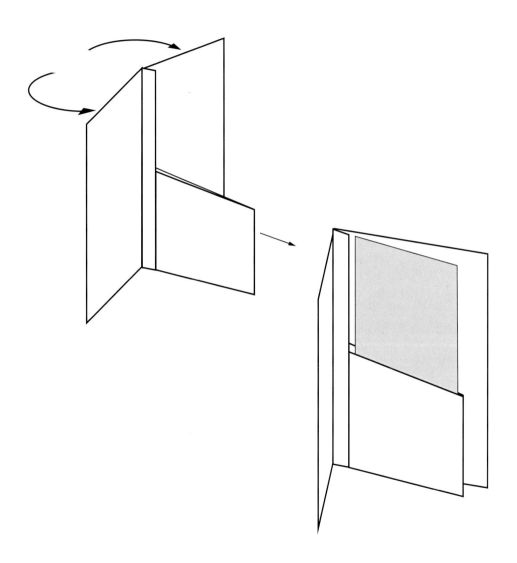

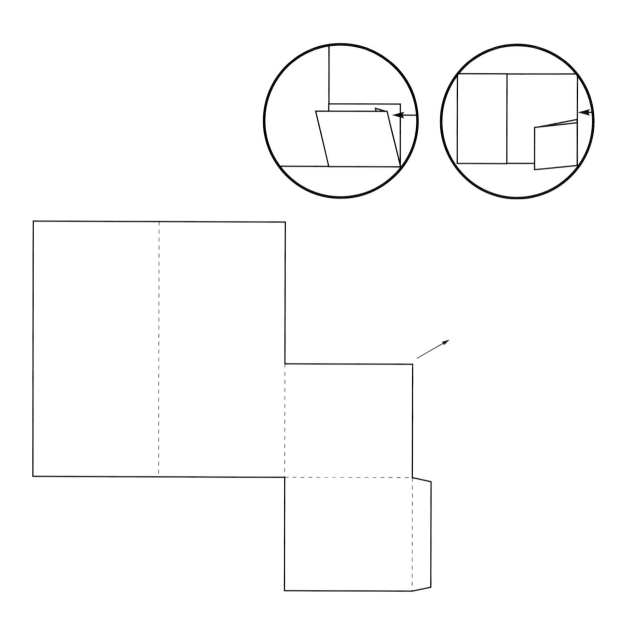

Swing-out pocket

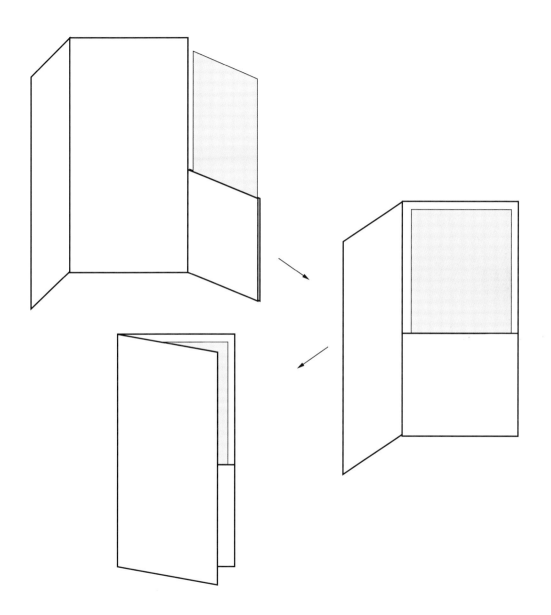

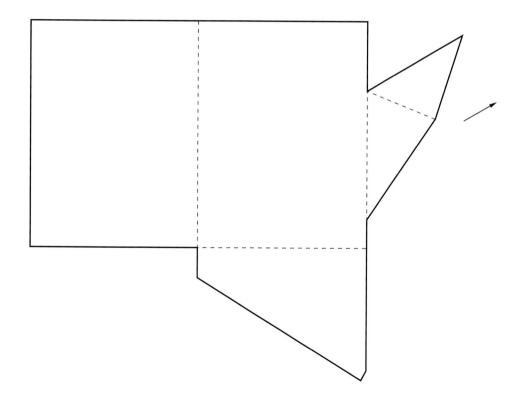

296　　Pocket folder

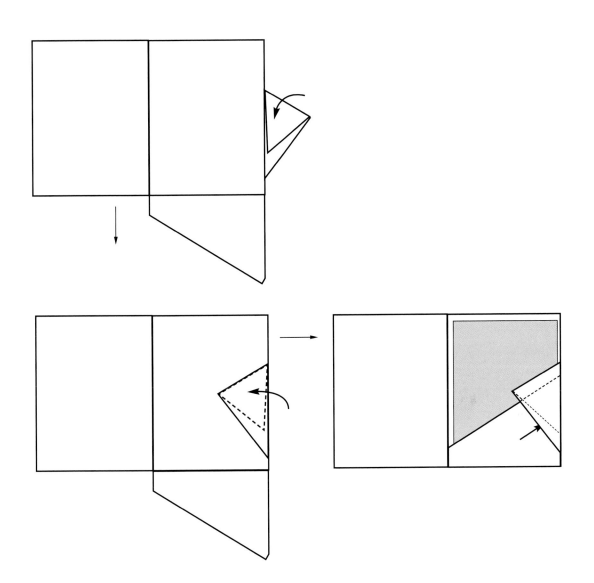

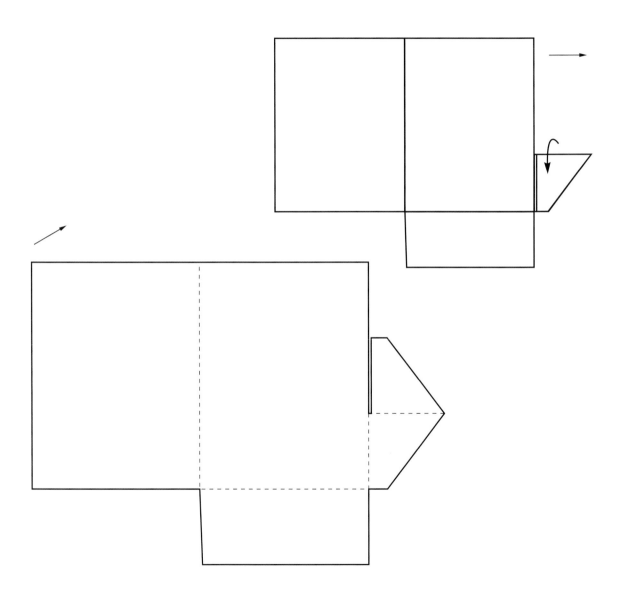

Pocket folder

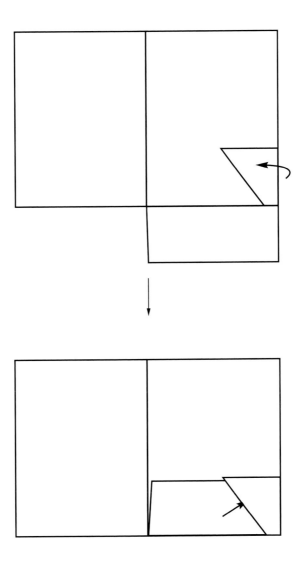

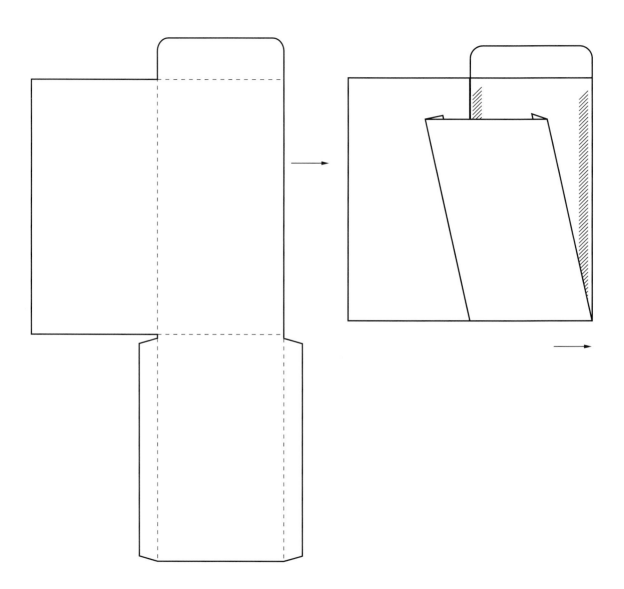

Pocket folder

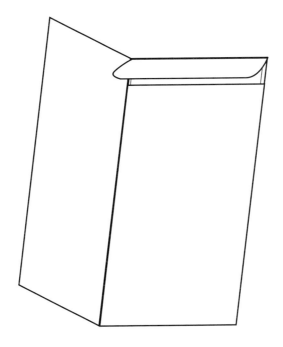

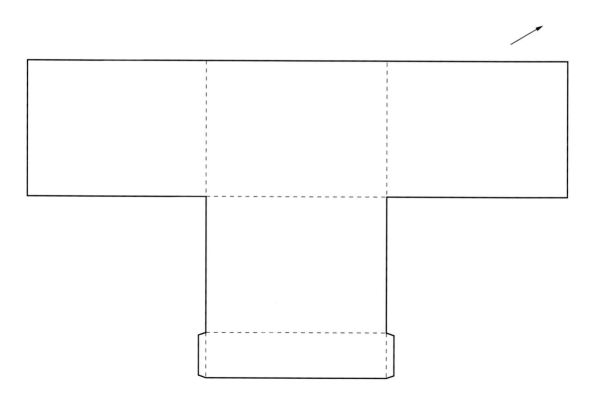

Pocket folder

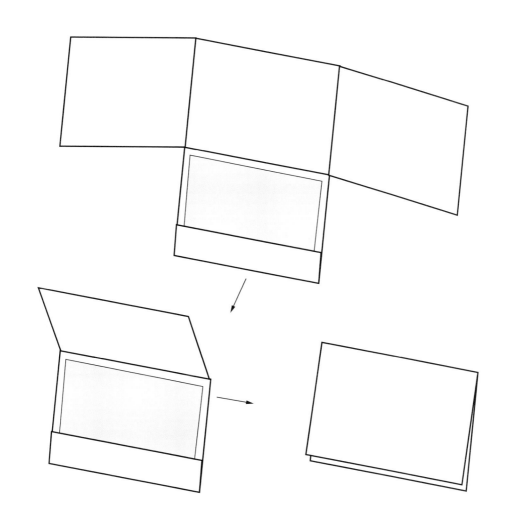

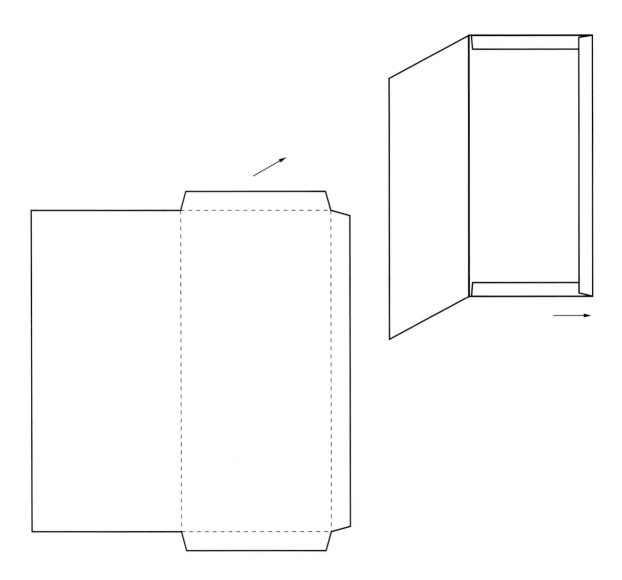

Pocket folder

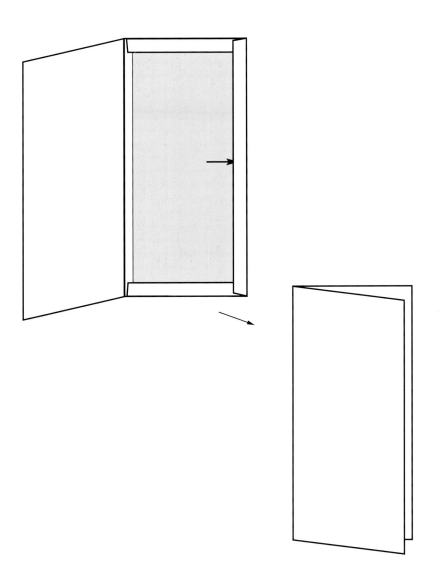

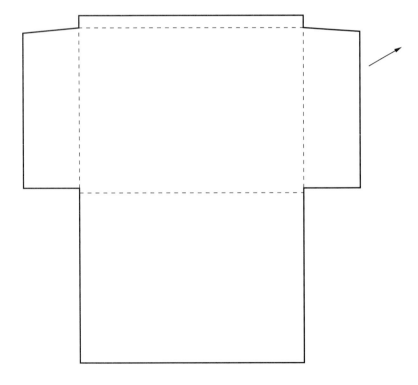

306 Pocket folder

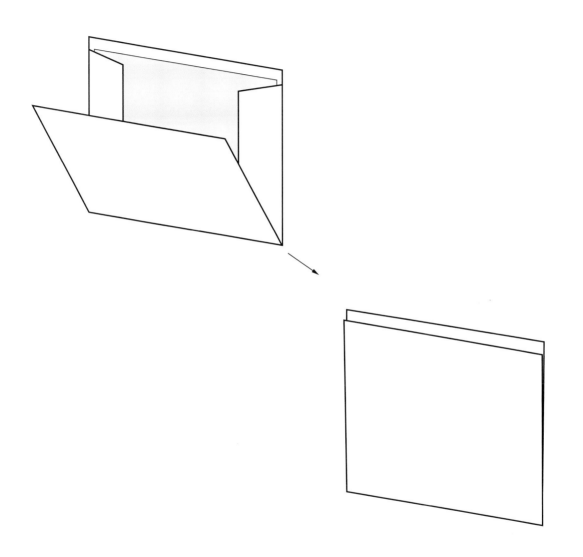

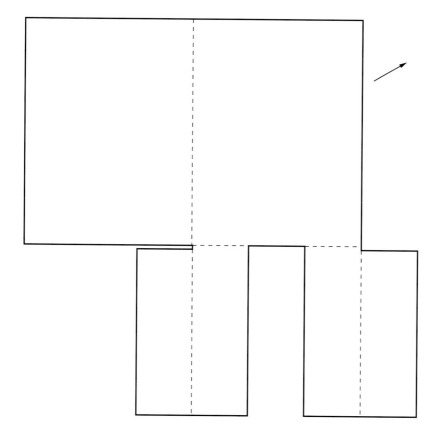

308 Pocket folder

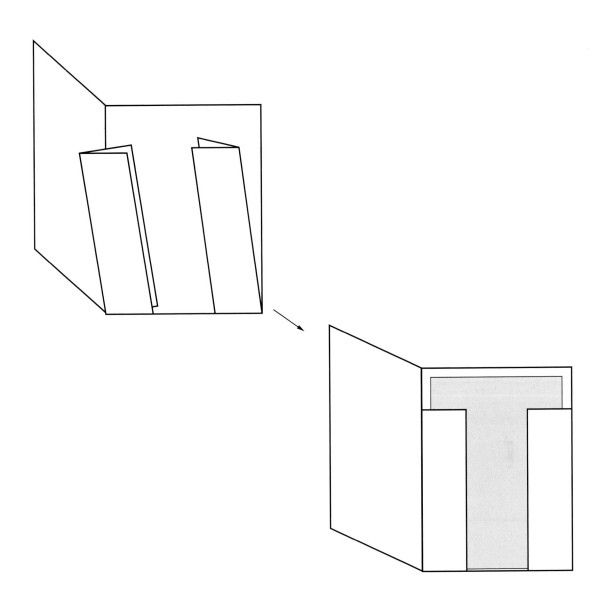

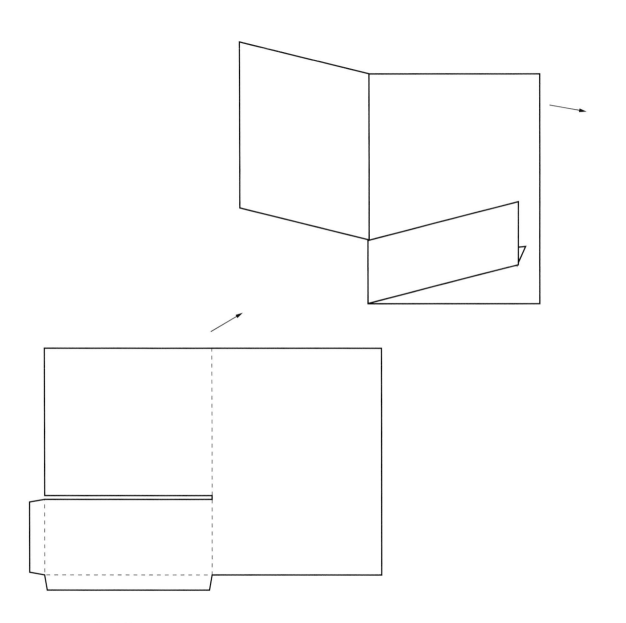

Pocket folder

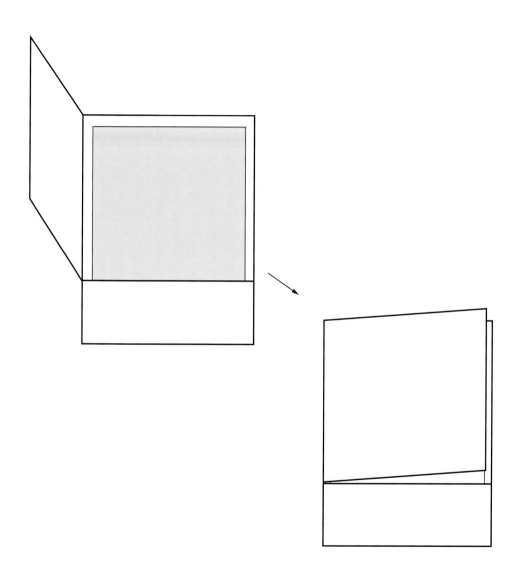

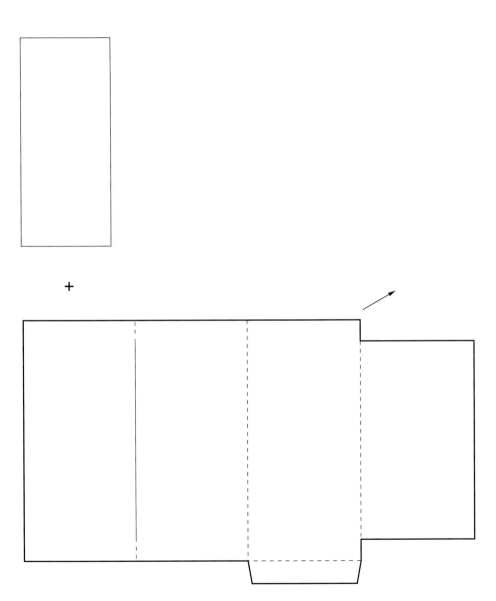

Pocket folder

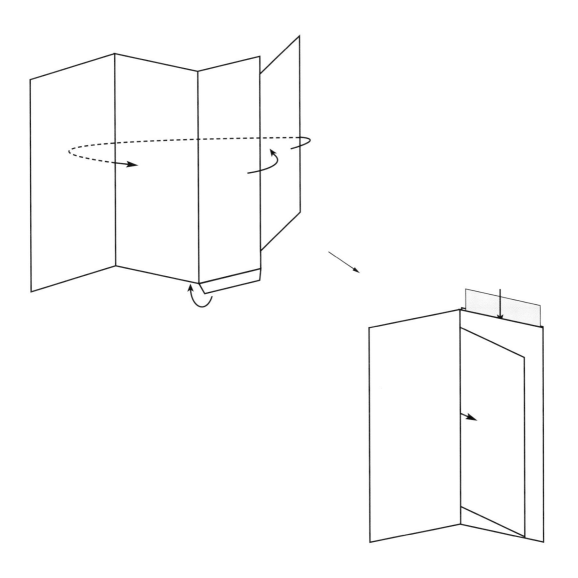

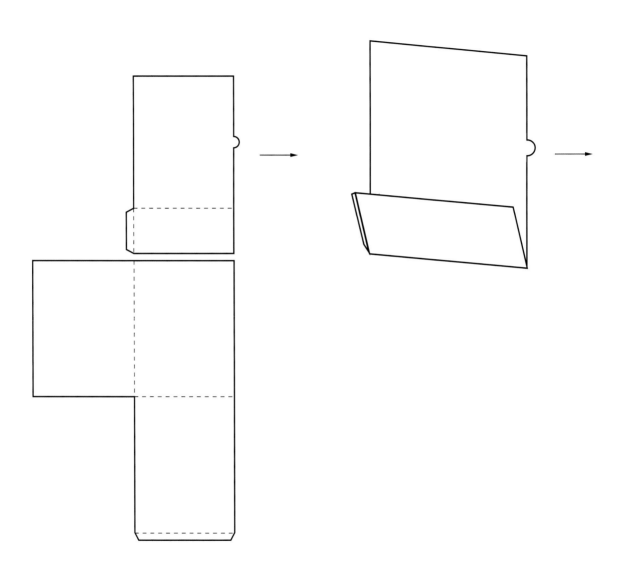

314 Pull-out pocket folder

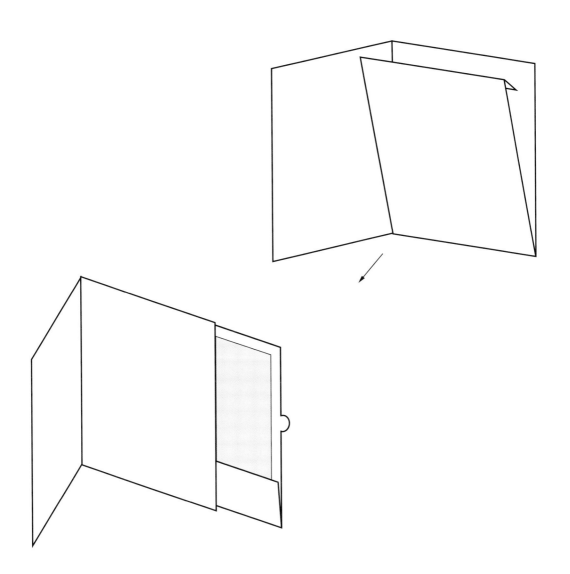

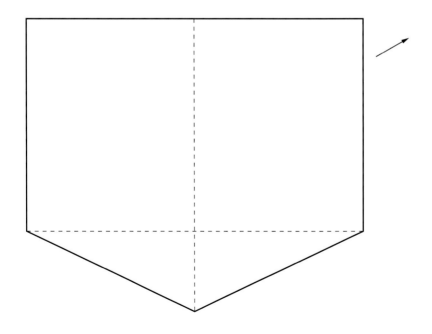

The pinch pocket

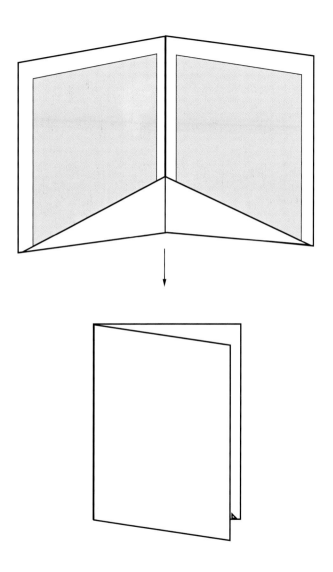

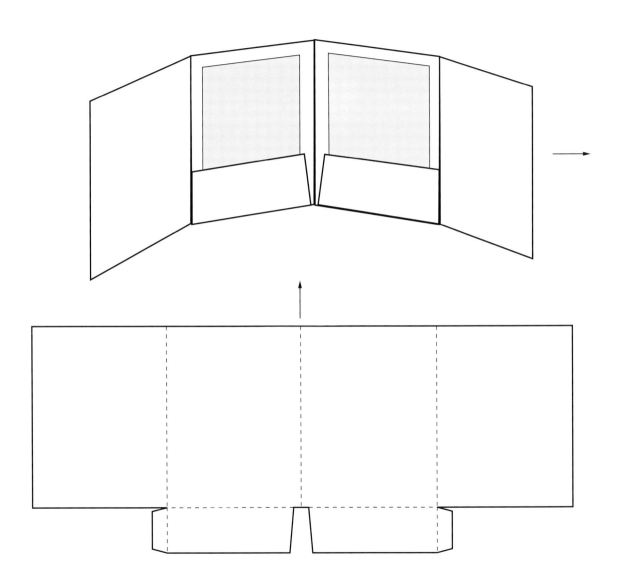

318 Double pockets with end panels

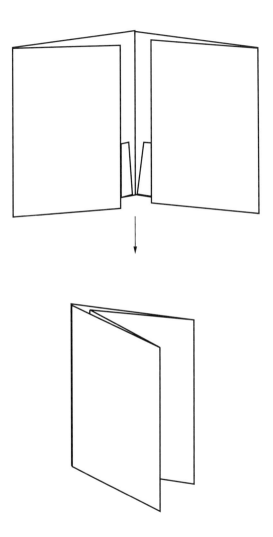

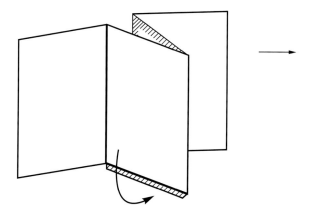

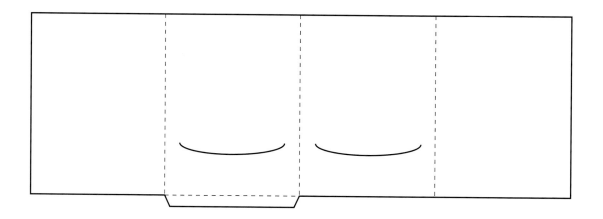

320 Back-to-back pocket folder

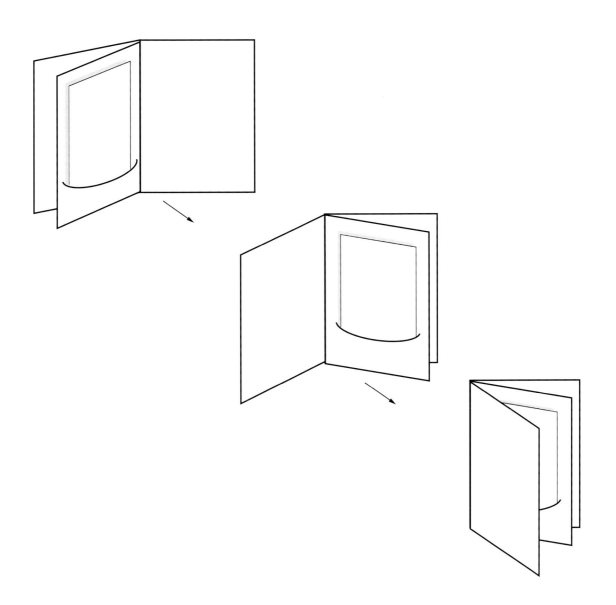

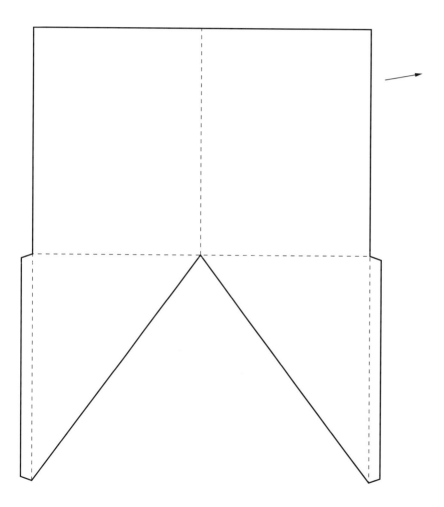

322 Diagonal pocket folder

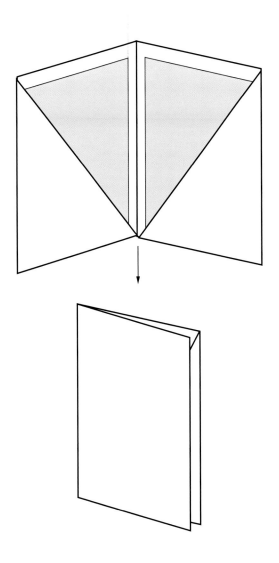

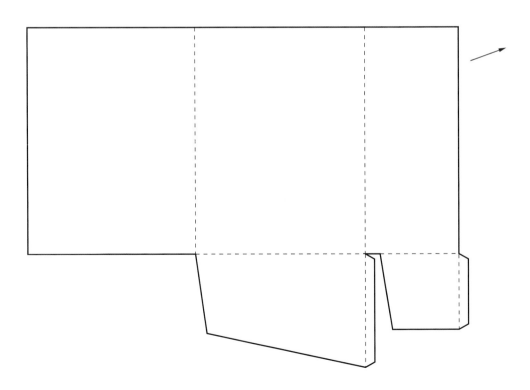

324 Full pocket with half pocket

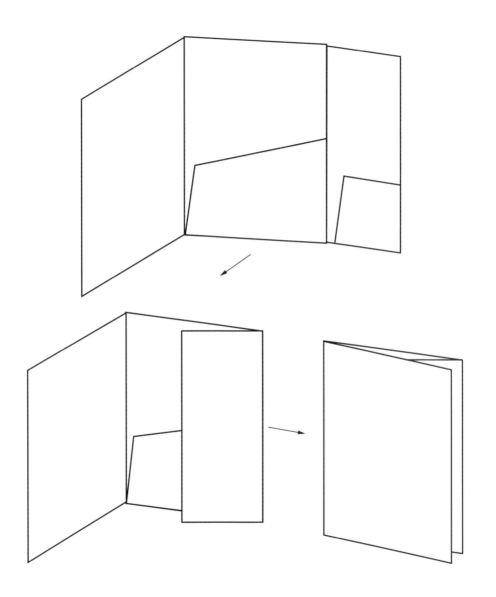

Full pocket with half pocket 325

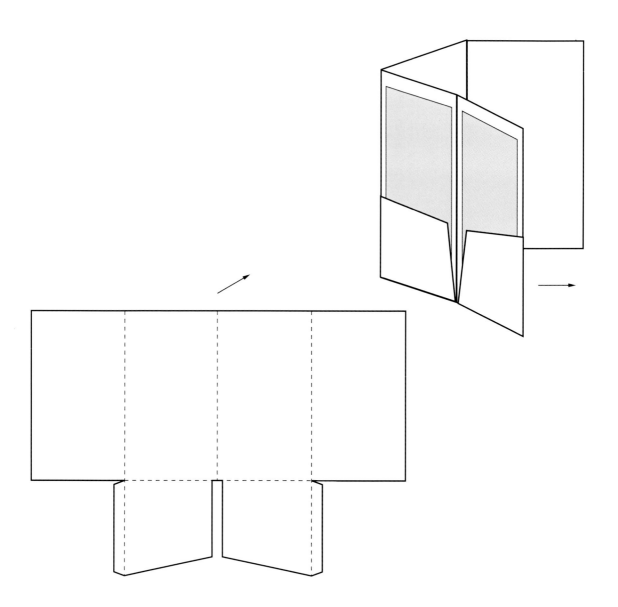

326 Double pocket folder

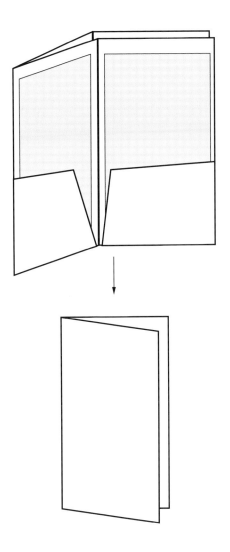

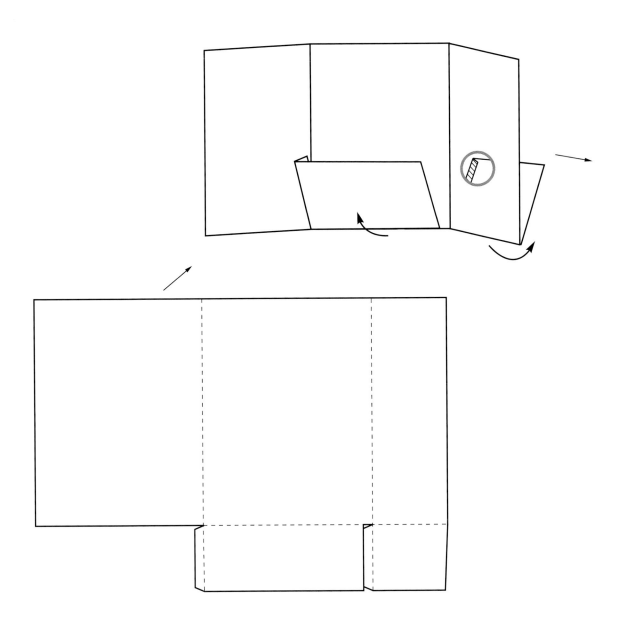

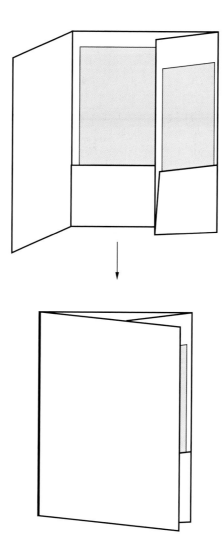

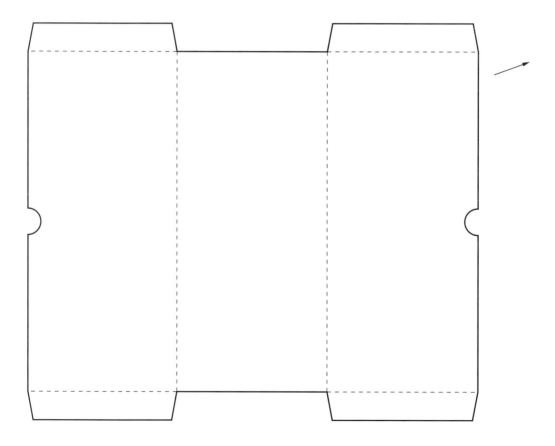

330 Double-sided folder holder

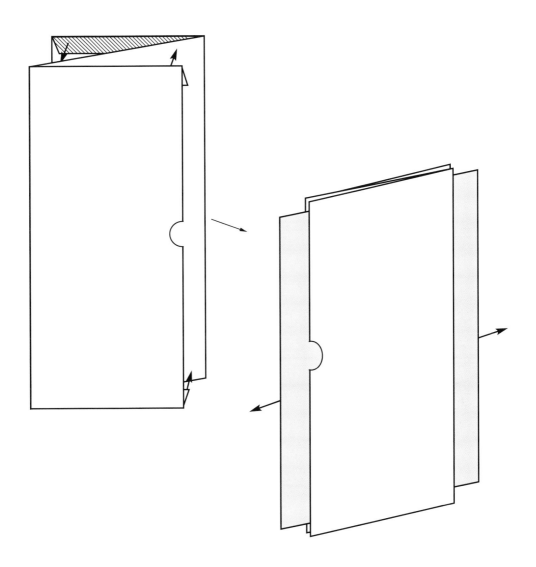

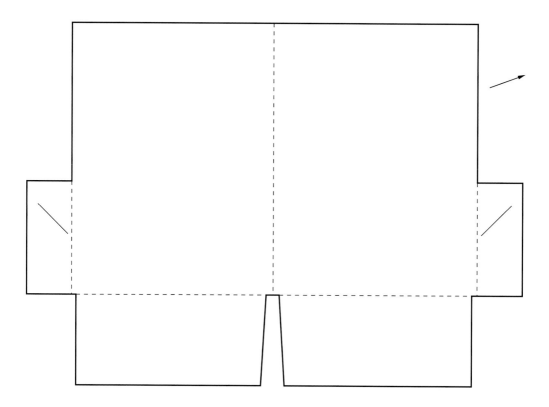

332 Double pocket folder

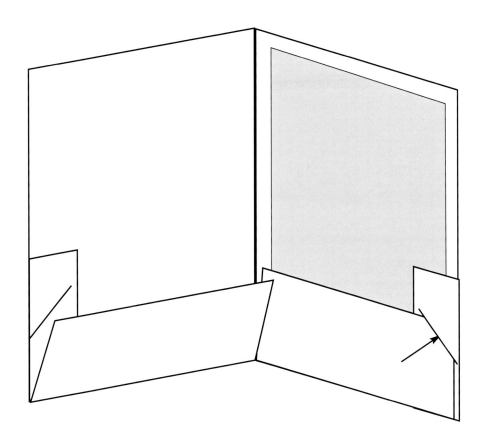

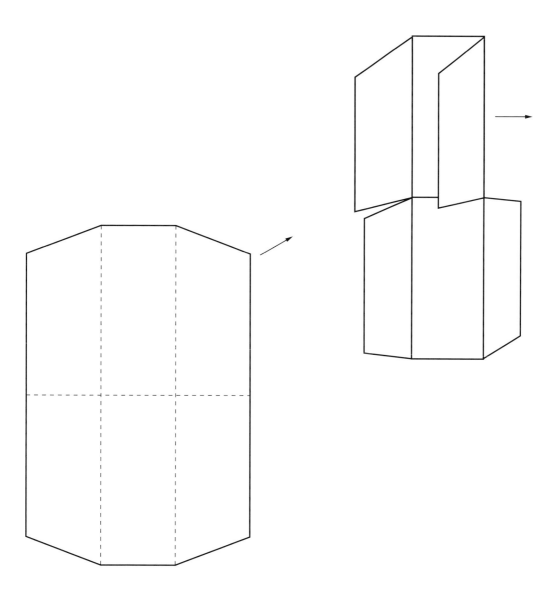

334 Double pocket folder

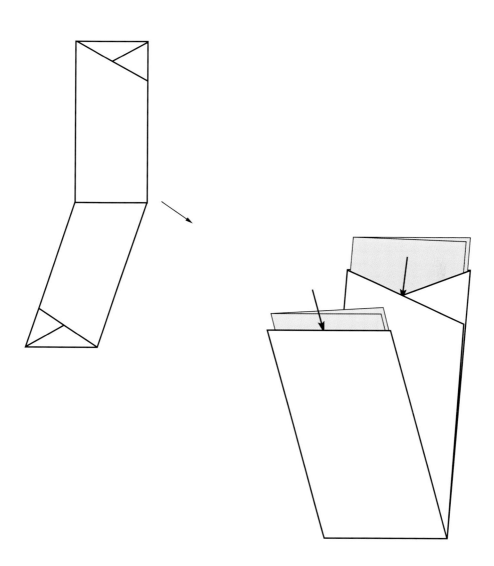

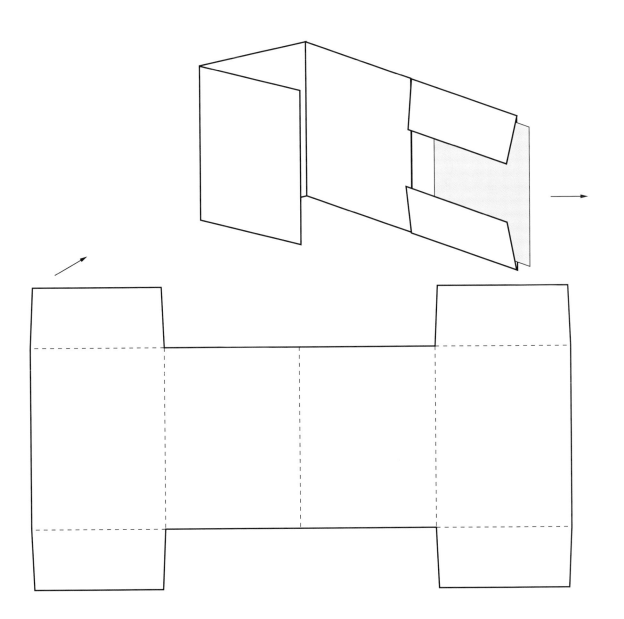

336 Double pocket folder

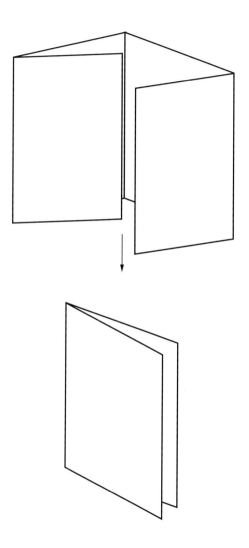

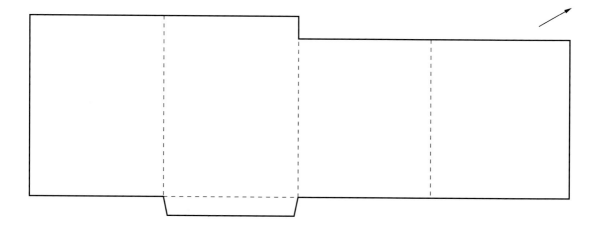

338 Pocket folder

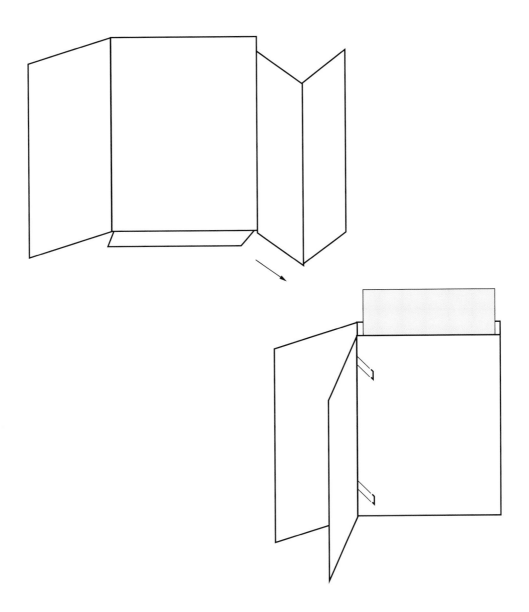

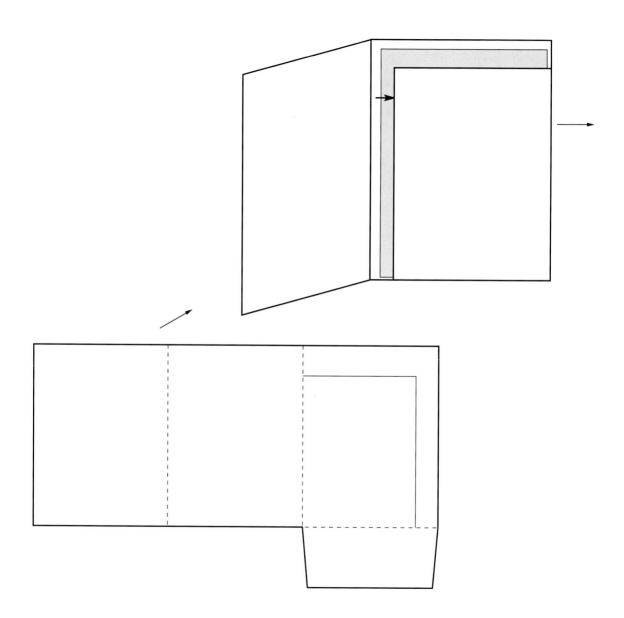

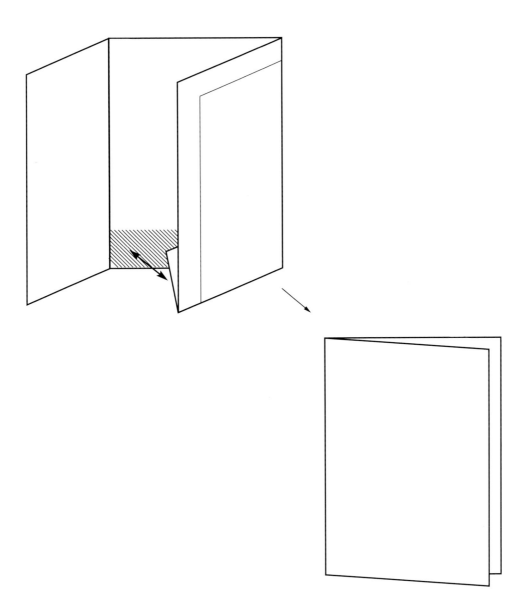

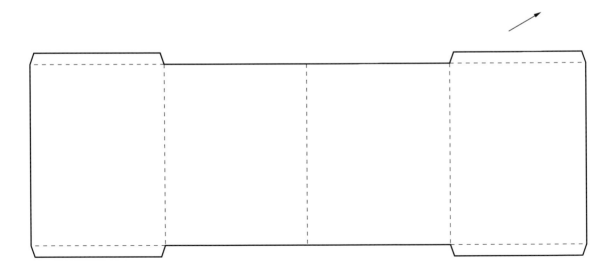

342 Double pocket folder

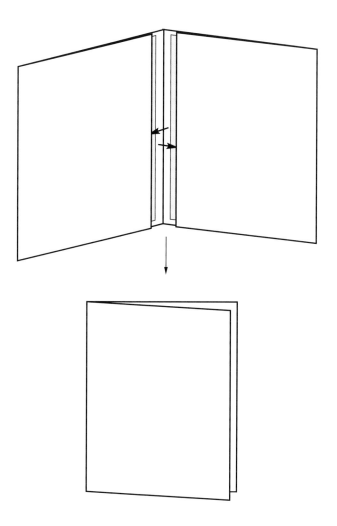

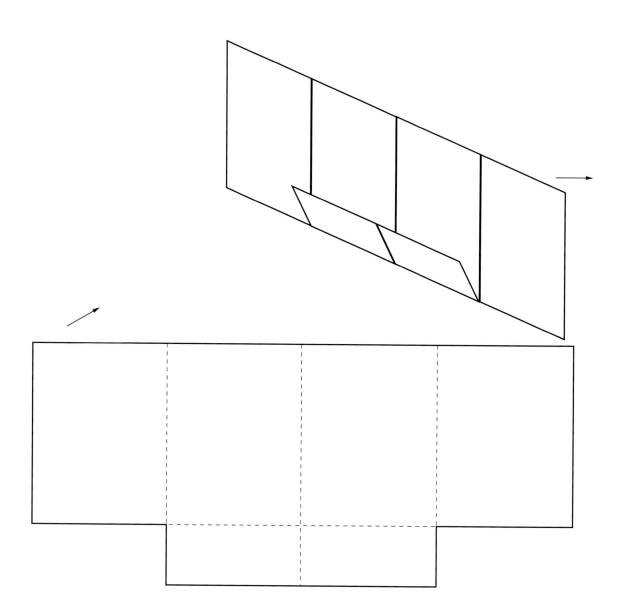

Double pocket folder

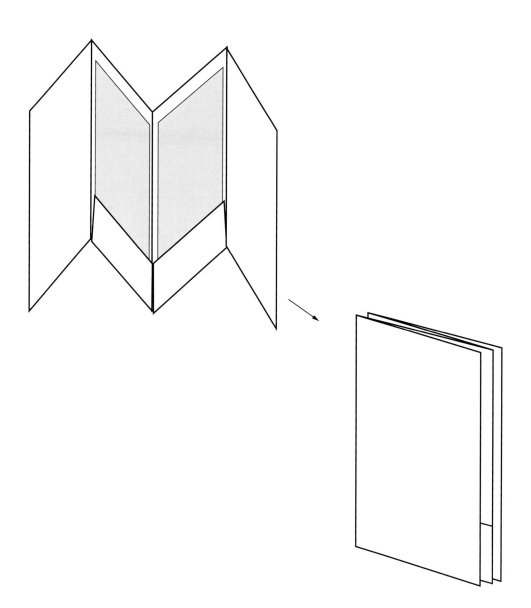

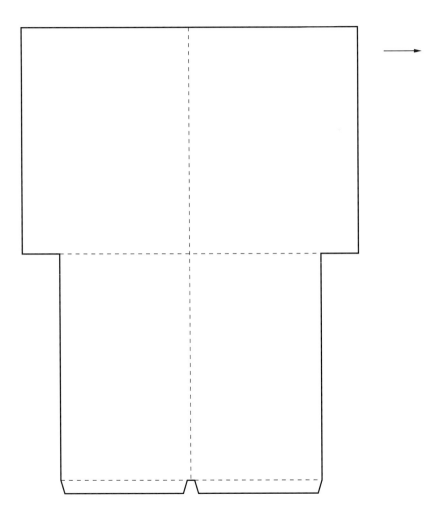

346 Double pocket folder

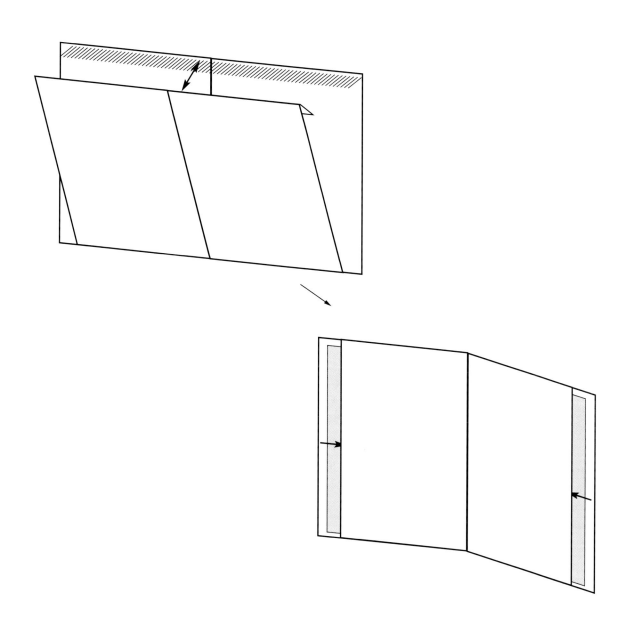

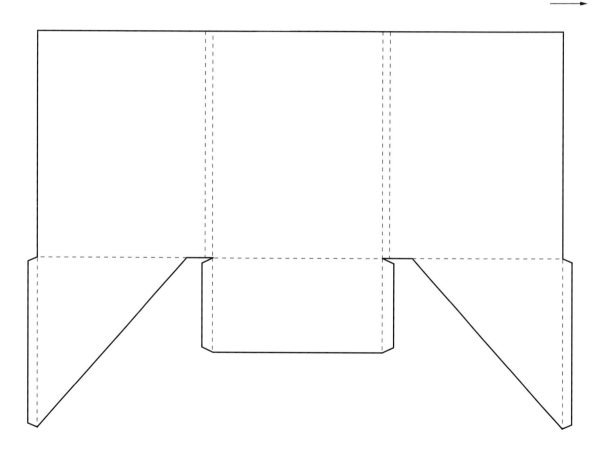

348 Triple pocket folder

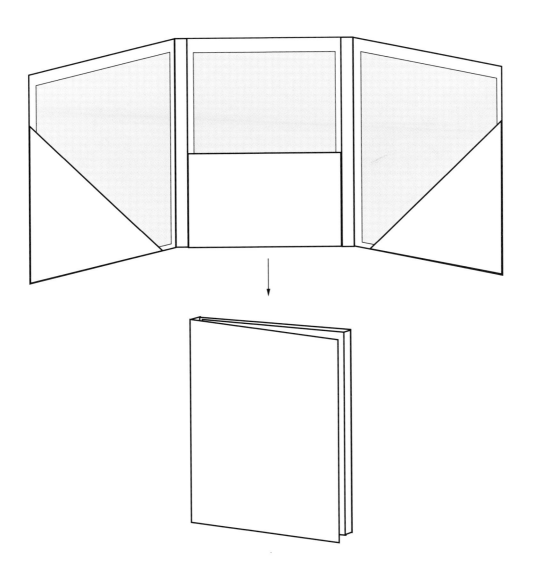

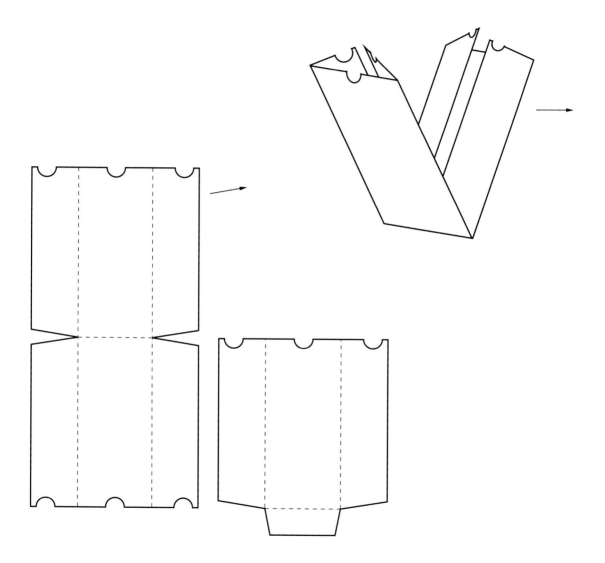

350 Three pocket folder holder

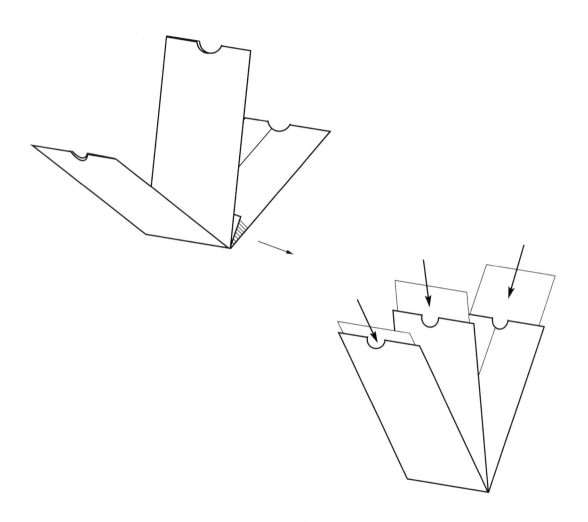

Three pocket folder holder

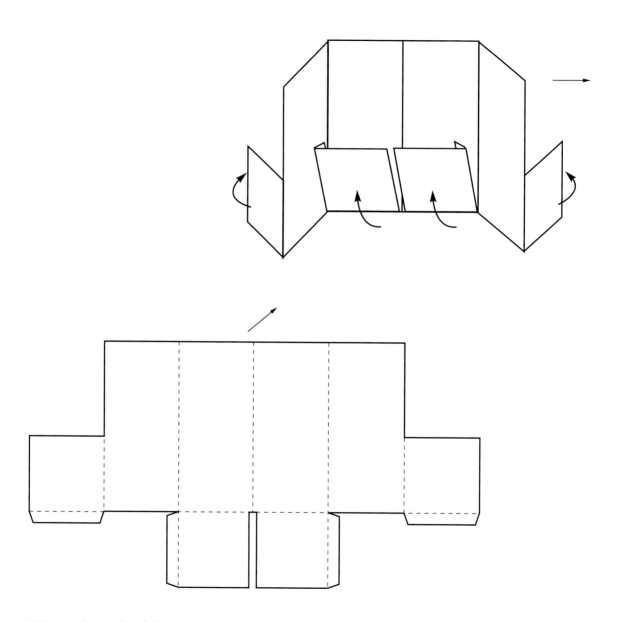

Four pockets folder

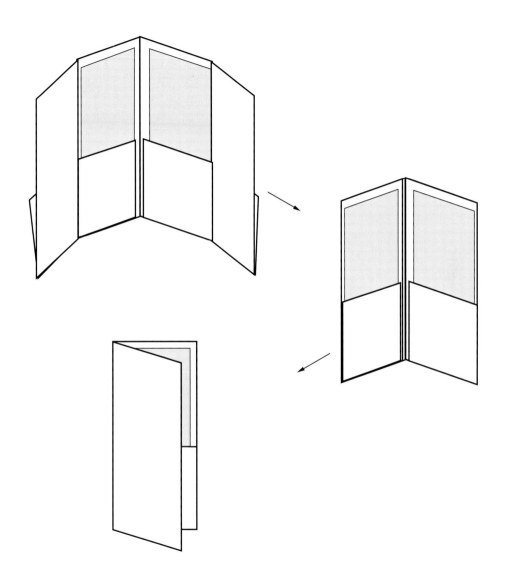

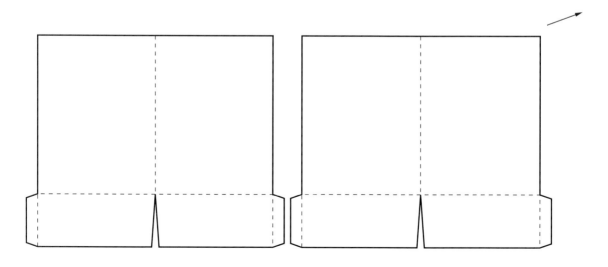

354 Pocket folder with four pockets

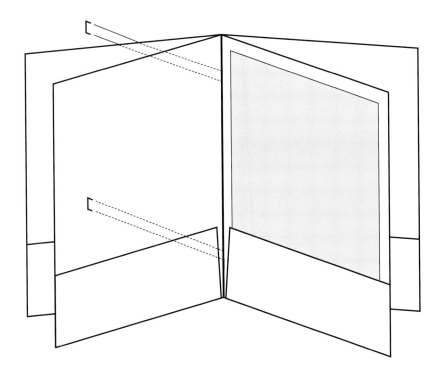

Pocket folder with four pockets 355

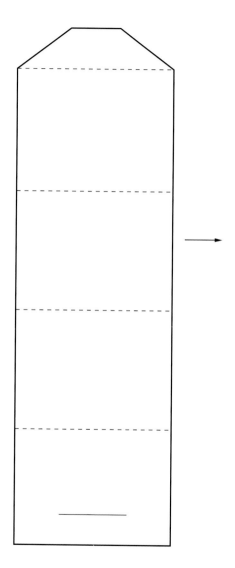

356 Dossier-type folder

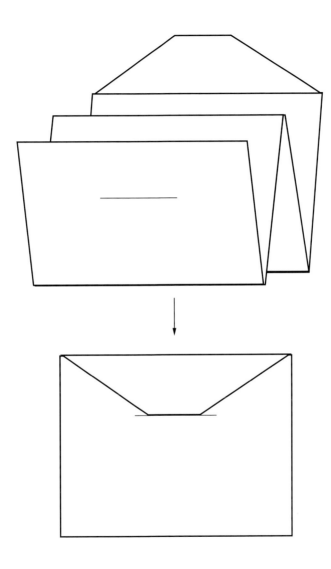

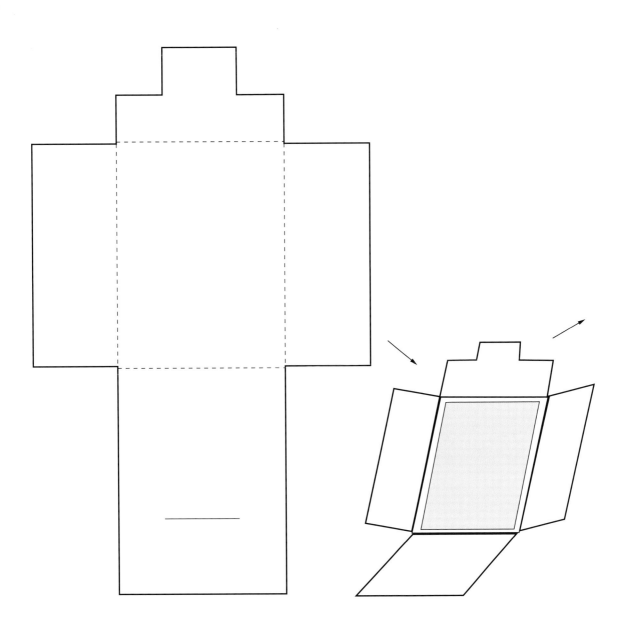

Folder with envelop slot

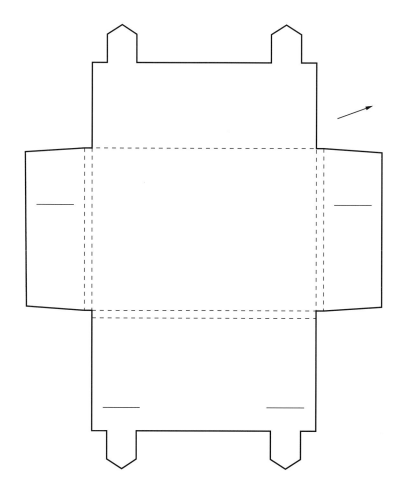

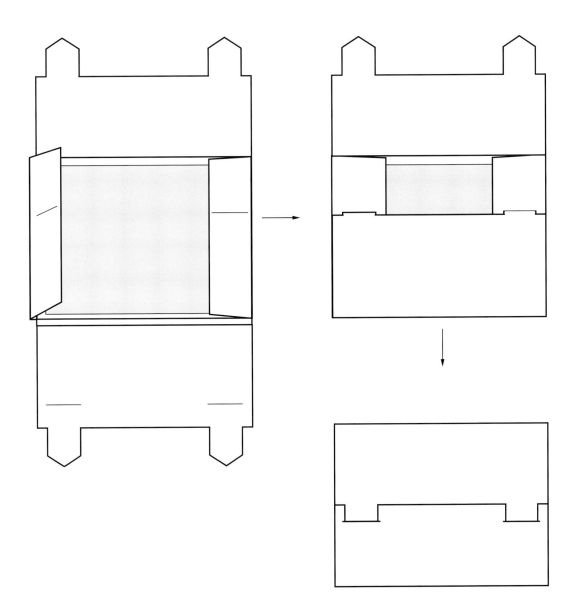

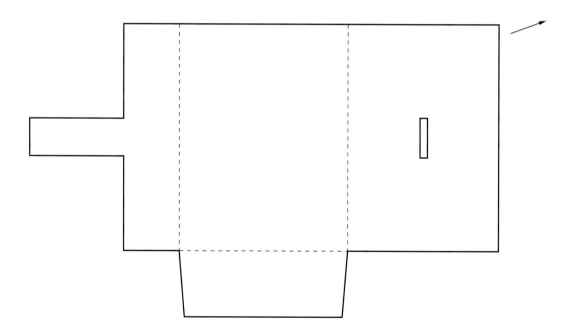

362 Tab-lock pocket folder

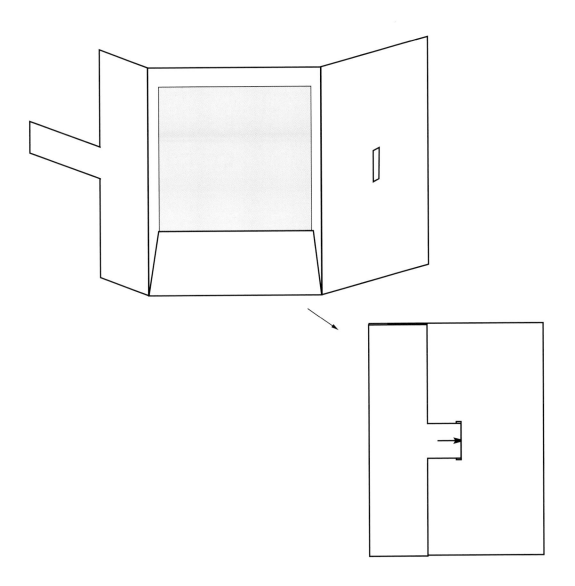

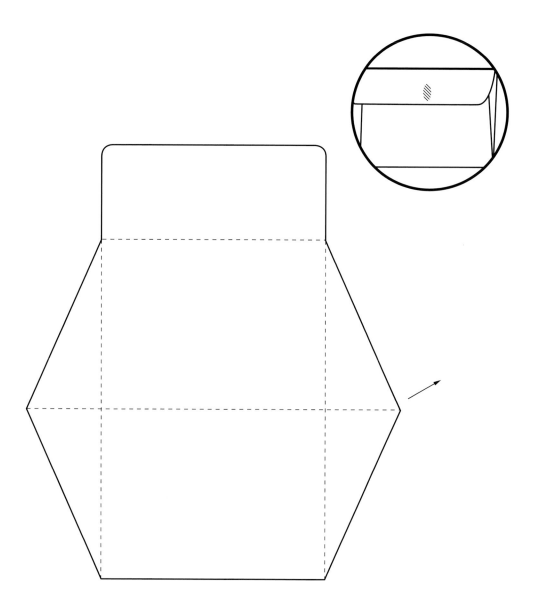

Pocket folder

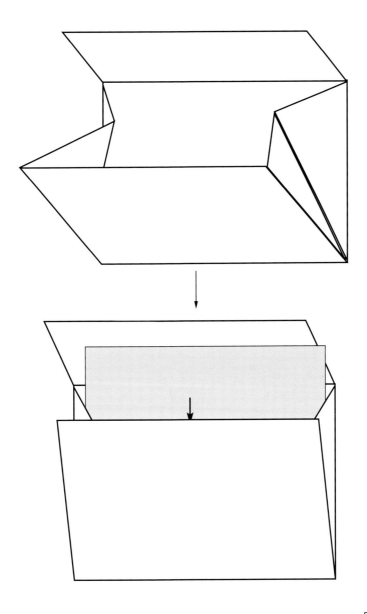

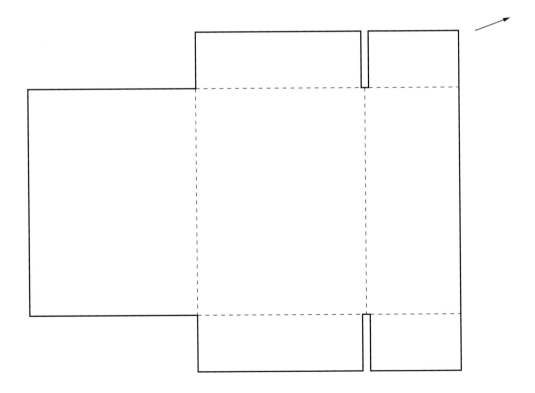

366 Self-locking pocket folder

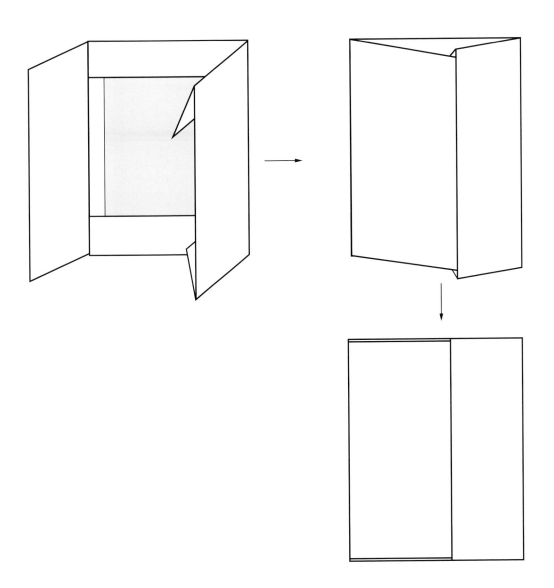

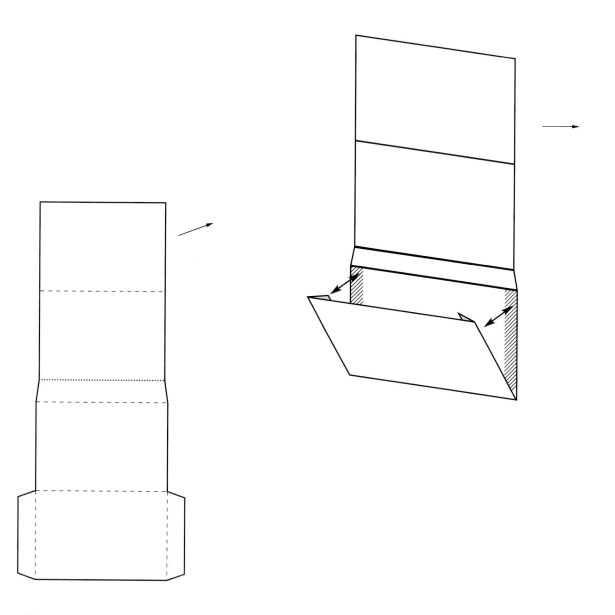

Card and envelope combination

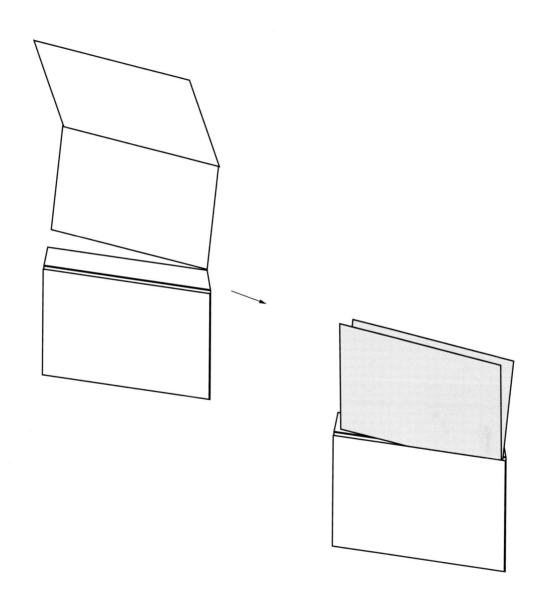

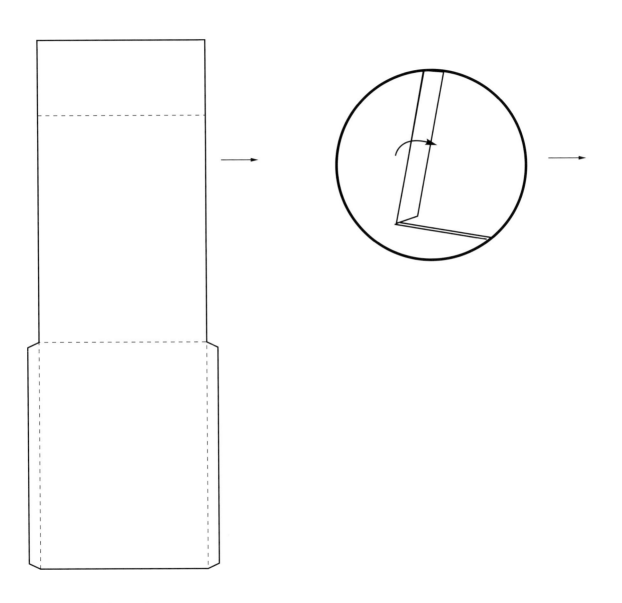

Calendar envelope

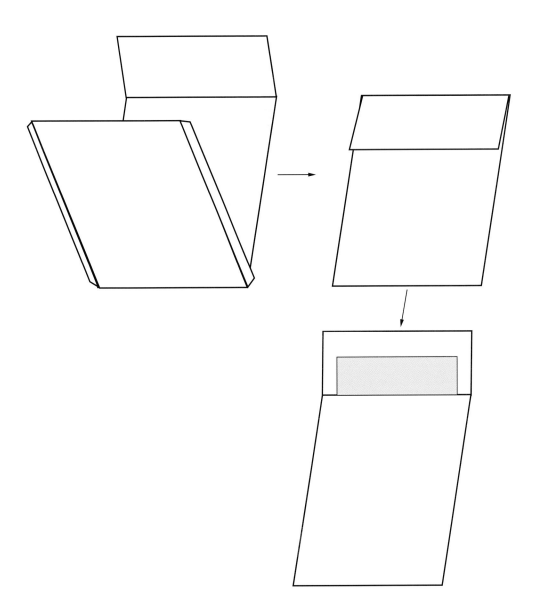

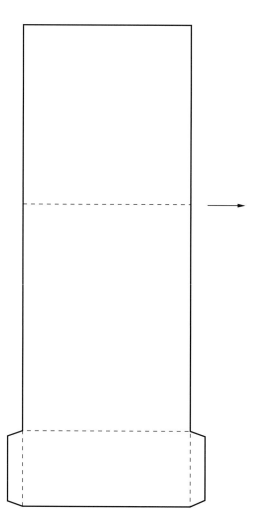

372 Pocket folder

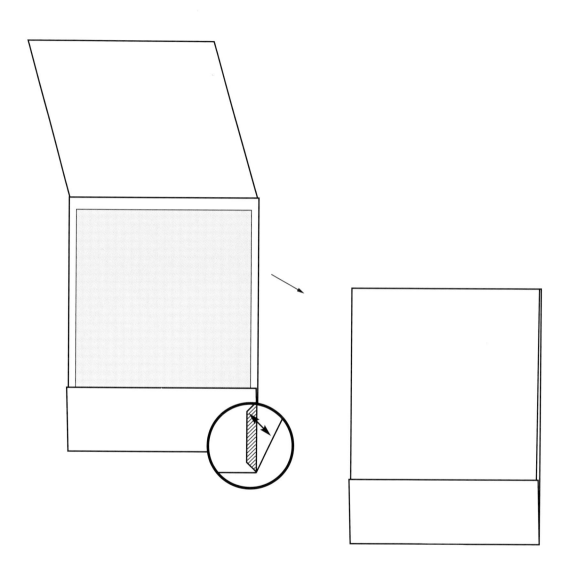

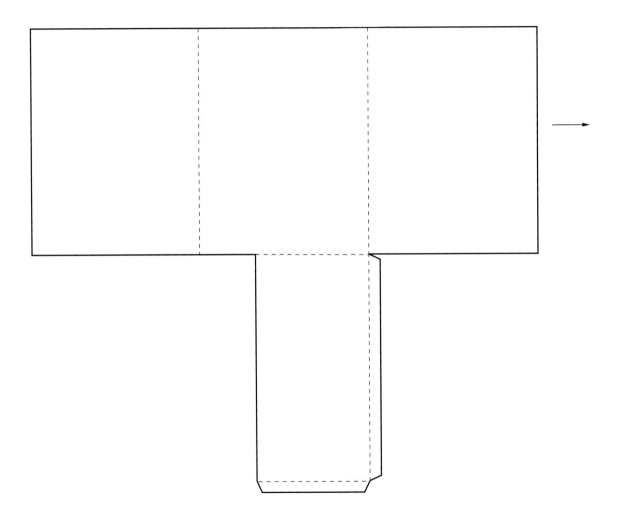

Centre pocket folder

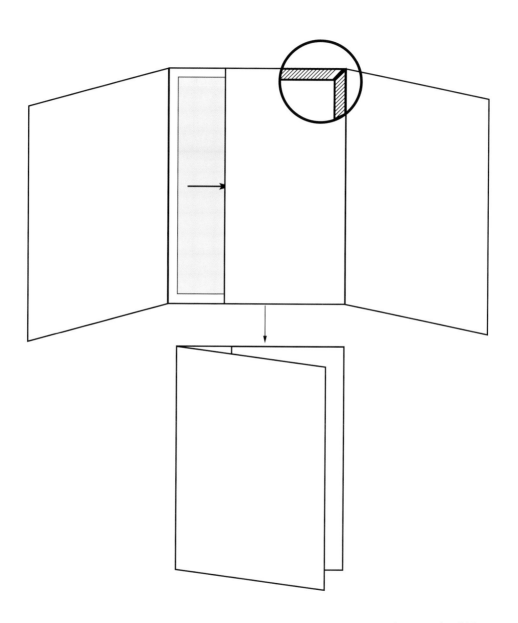

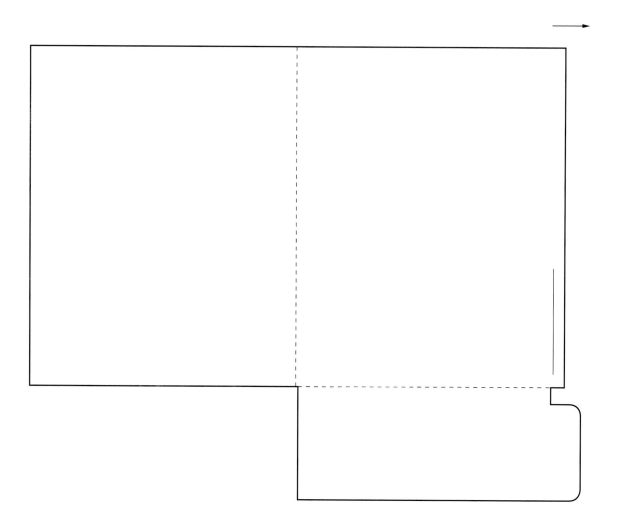

376 Pocket folder with tab

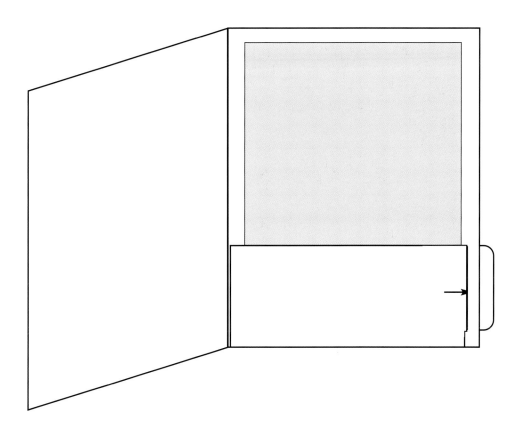

Pocket folder with tab 377

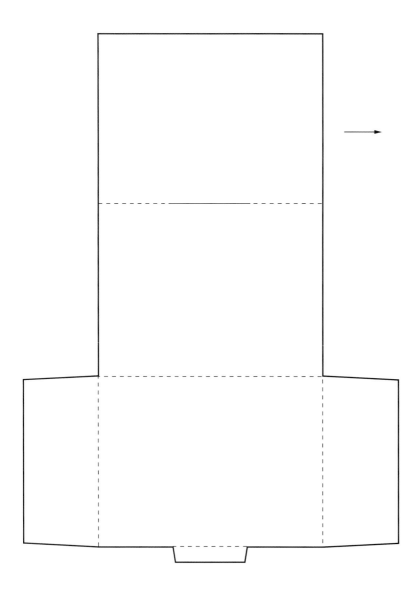

378 Pocket folder with tab lock

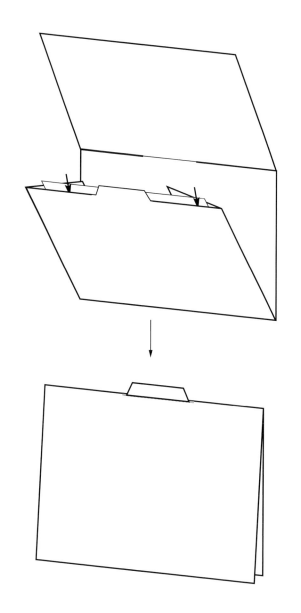

Pocket folder with tab lock 379

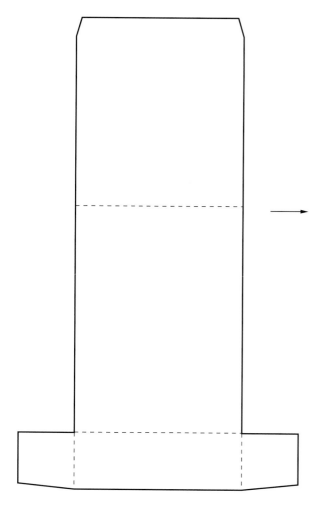

380 Pocket folder

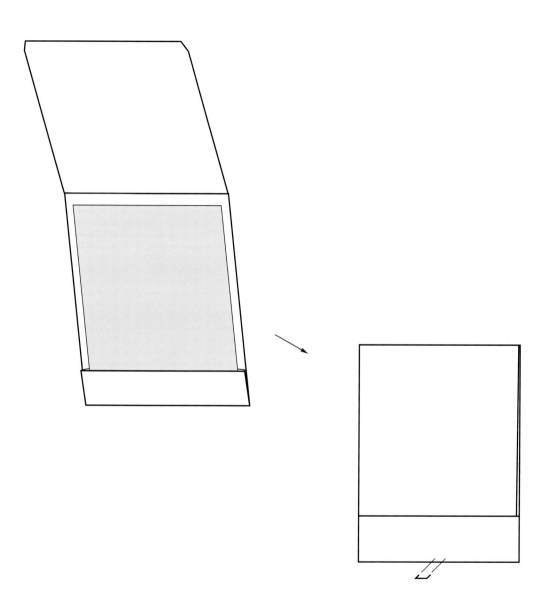

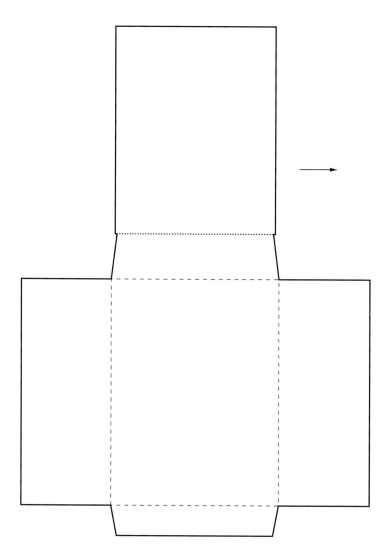

Envelope and form combination

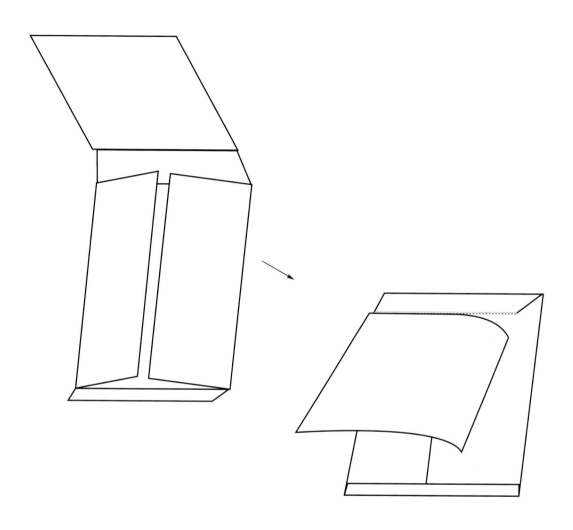

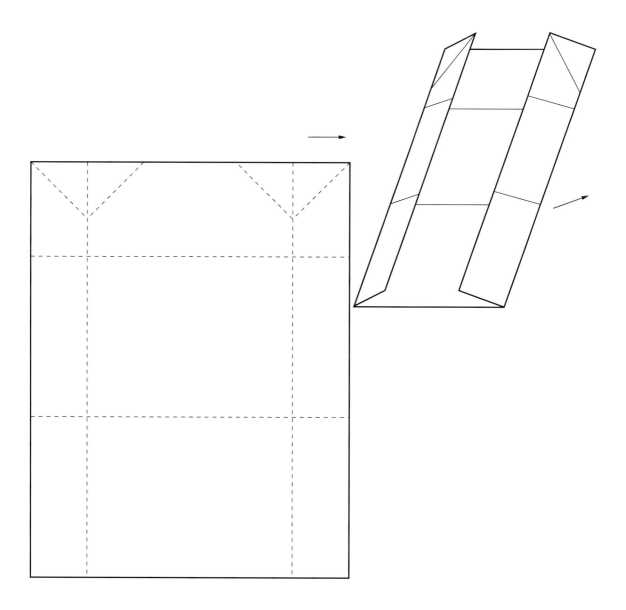

Folded envelope

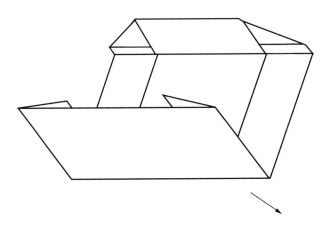

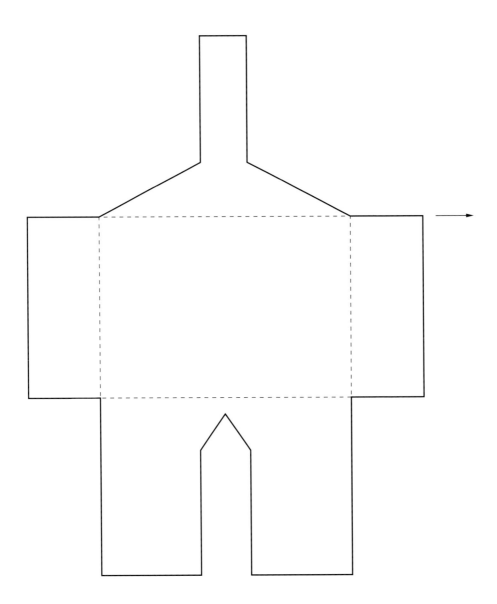

Envelope

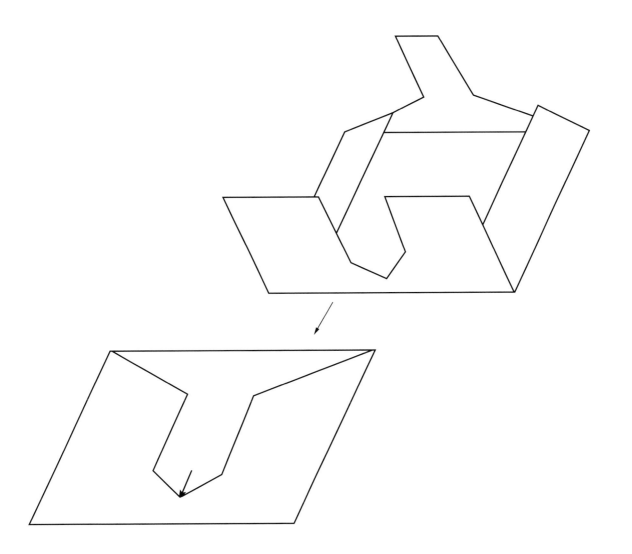

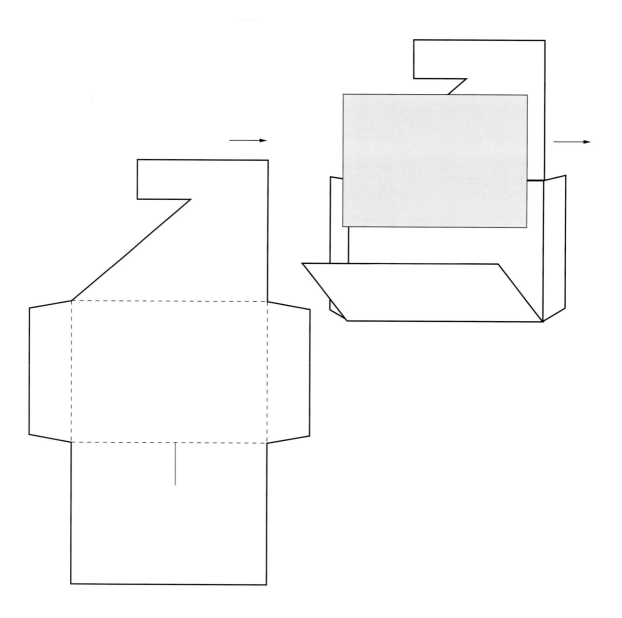

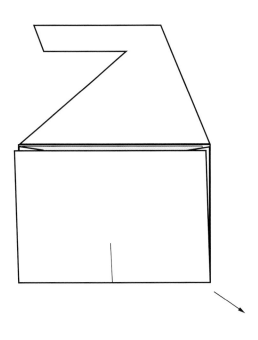

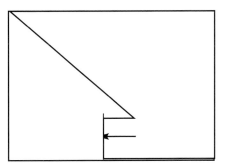

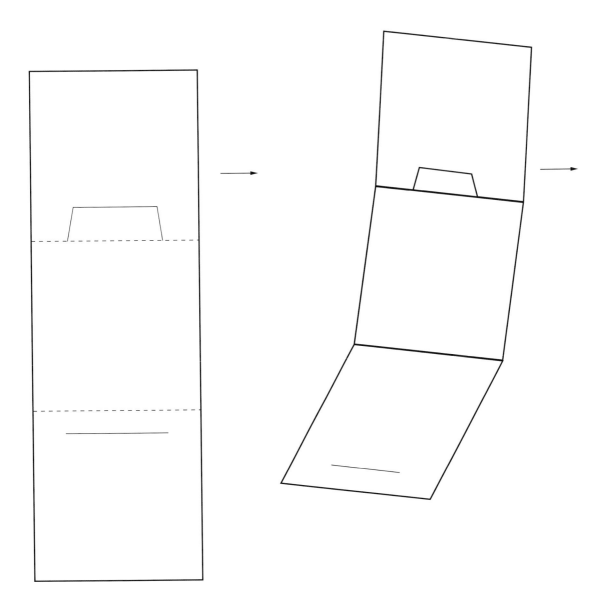

Self-locking card

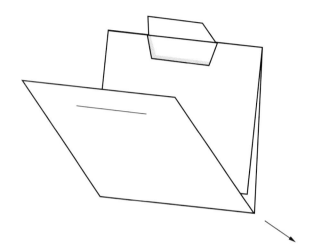

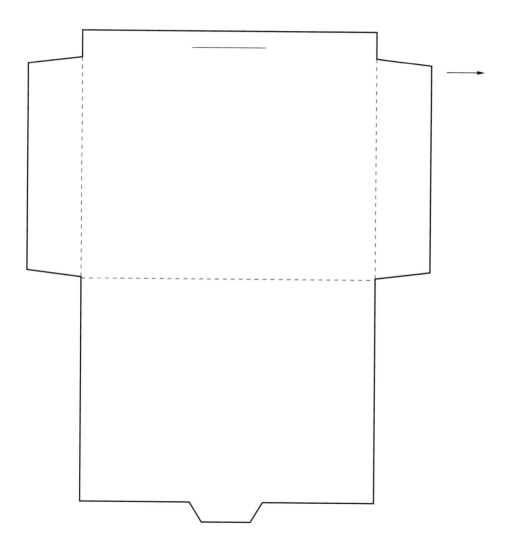

392 Self-locking folder

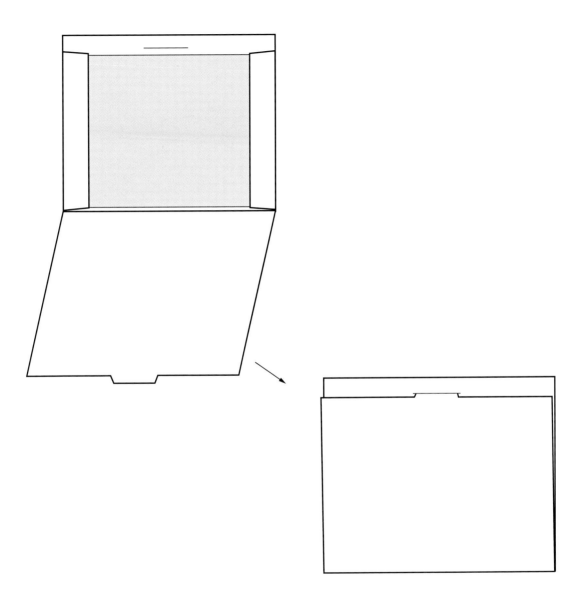

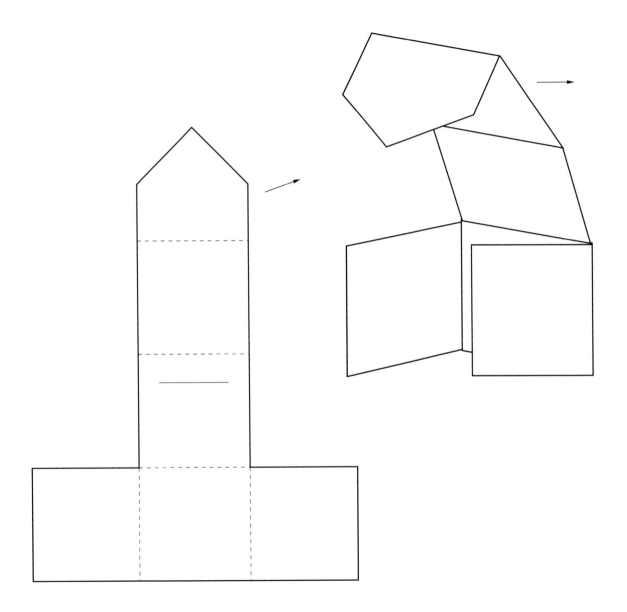

Self-locking card

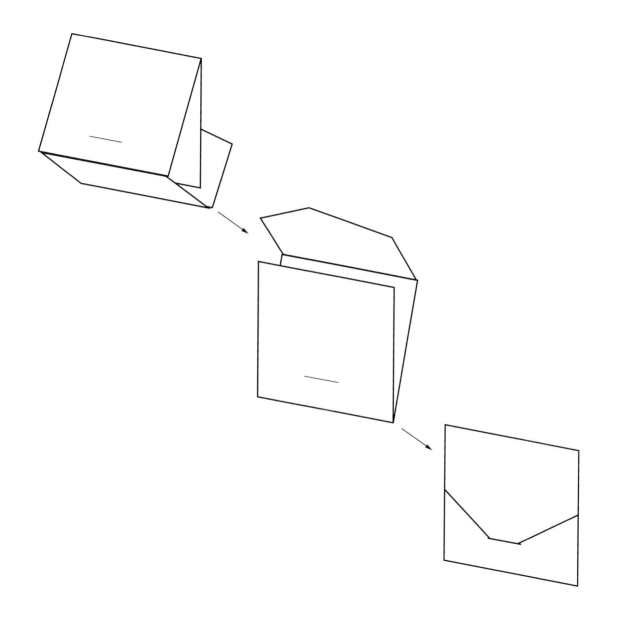

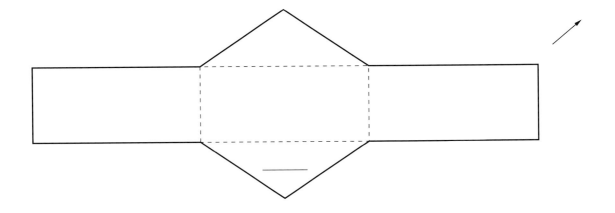

Self-locking card

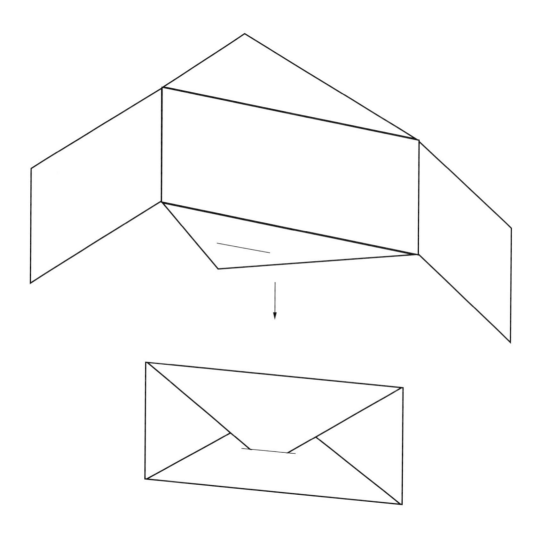

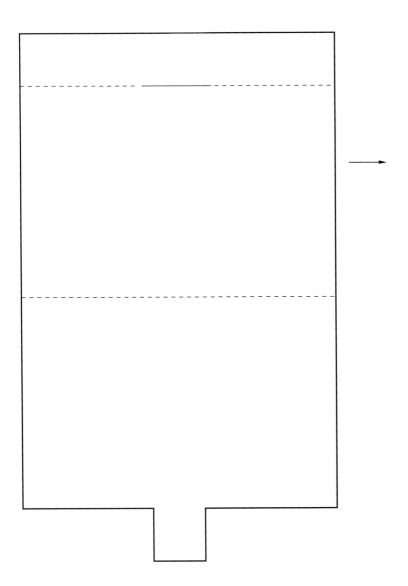

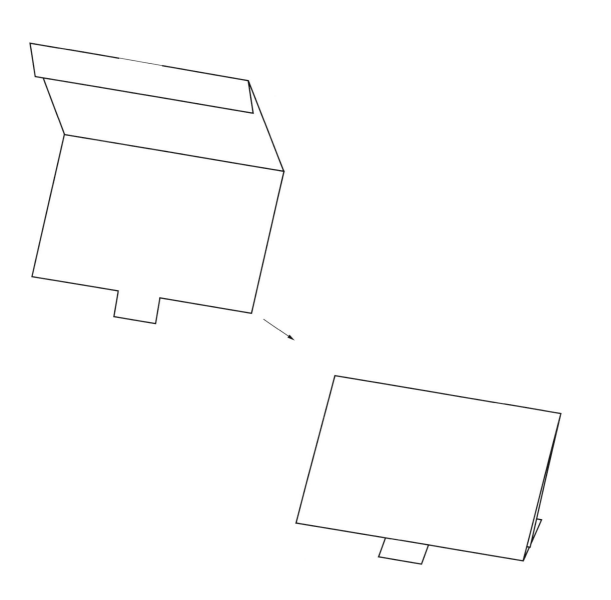

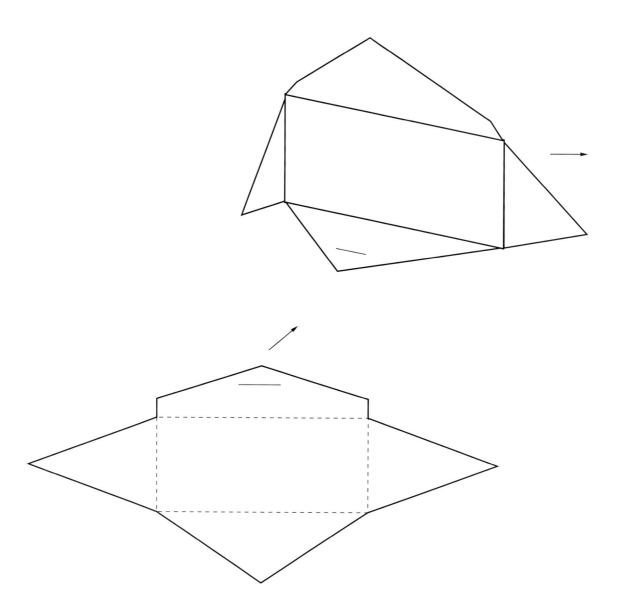

Self-locking envelope

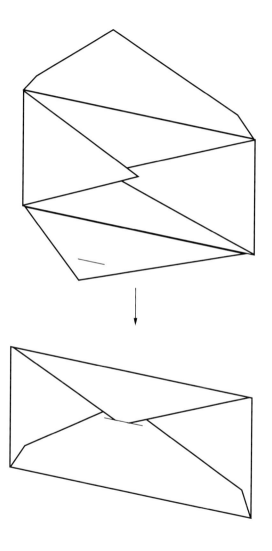

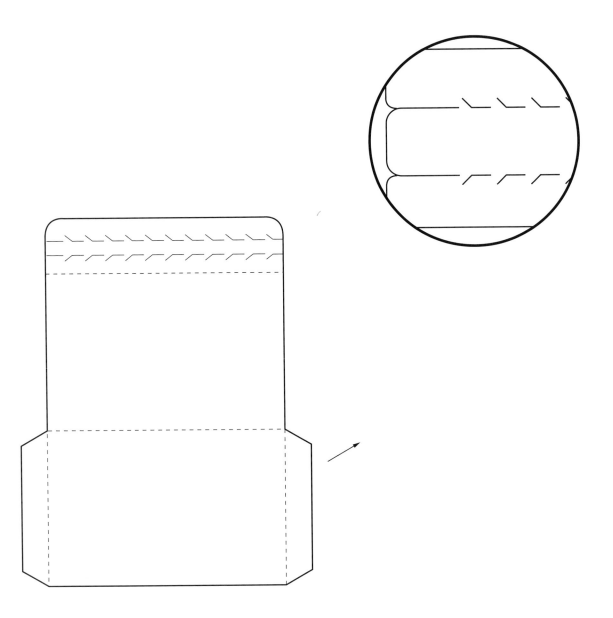

Pull-tab mailer

+

404 Self mailing booklet with letter

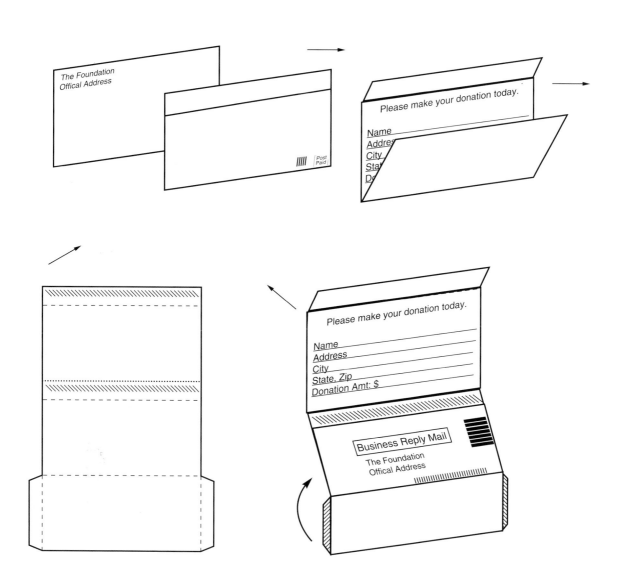

406　　One-piece return envelop mailer

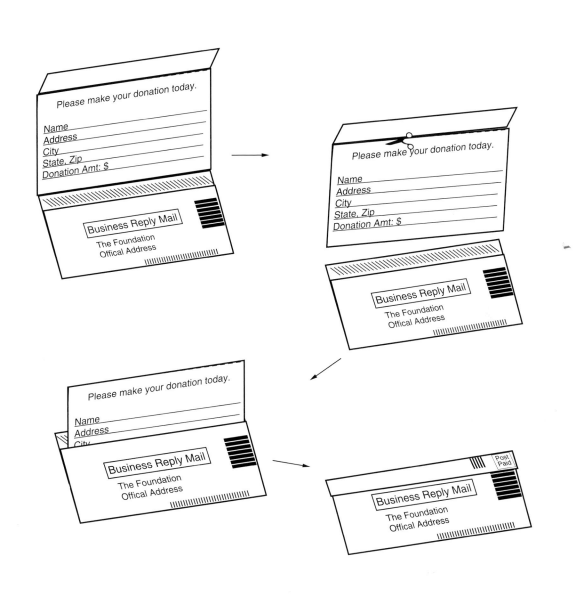